ABORIGINAL ART
AND SPIRITUALITY

ABORIGINAL ART
AND SPIRITUALITY

Edited by
Rosemary Crumlin

Collection curated by
Rosemary Crumlin and Anthony Knight

COLLINS DOVE
A Division of HarperCollins*Publishers*

Published by Collins Dove
A Division of HarperCollins*Publishers* (Australia) Pty Ltd
22-24 Joseph Street
North Blackburn, Victoria 3130

First published 1991
Designed by William Hung
Cover design by William Hung
Cover illustration *My Country* 1988, Ginger Riley
Munduwalawala
Typeset in Imprint Roman by Typographical Services
Printed in Australia by Griffin Press

The National Library of Australia
Cataloguing-in-Publication Data:

Crumlin, Rosemary.
 Aboriginal art and spirituality.

 Bibliography.
 Includes index.

 ISBN 0 85924 998 0.

 [1]. Aborigines, Australian – Art – Exhibitions. [2].
 Aborigines, Australian – Religion – Exhibitions. [3]. Art,
 Australian – Aboriginal artists – Exhibitions. I. Title.
704.03991507494

PHOTOGRAPHY
R. Morrison 1; R. Bawden 2, 3, 4, 5, 6, 9; H. Jolles 10-12, 14, 16-22, 26-30, 32-39, 41-44, 46-50,
53, 55, 57, 59-66, 68; G. Freudenthaller 7, 8, 13, 31, 39, 40, 54, 58; G. Sommerfield, 45; J. Brash 70;
G. Hancock 23; M. Kluvanek 24, 51, 52; C. McWhinney 25; J. Parker 15; R. Humphrys 69; R. Oxley 67.

FOREWORD

Australian Aboriginal art is primarily spiritual.

The sacred art of the Aboriginal people, however, goes even further, and expresses the actual laws and rites by which the Australian Aborigines live. It is therefore extraordinarily appropriate that a great exhibition of Aboriginal spiritual art should open at the very heart of the white man's own law-dispensing facility–the High Court of Australia–under the auspices of the Aboriginal and Islander Commission of the Australian Council of Churches.

Geographically, the collection that is the basis of both this book and the exhibition represents the entire continent and its adjacent islands, for the curators travelled wherever they could gather significant examples of Aboriginal art. As one takes into account the magnitude of the exhibition, it seems a miracle that the Australian Aborigines have preserved so magnificently their own sacred and cultural heritage which they demonstrate in their art.

Behind this art lie at least 40 000 years of artistic expression. Aboriginal rock engravings, found in every Australian State, are believed to be the oldest discovered on earth. The images in those rock engravings occur in Aboriginal art throughout the nation.

I hope that this wonderful book will help every Australian and everyone who reads it to understand the importance of looking afresh at the facts and the accessible historical evidence, available in every major library throughout the world.

We Australians need to arrive at a new vision of ourselves as neither settlers nor conquerors, but simply as Australians, since it is vital that we co-exist in harmony, justice and compassion with the earliest inhabitants of the continent, the Australian Aborigines.

Margaret Carnegie, AO, OAM

CONTENTS

LIST OF PLATES

ACKNOWLEDGEMENTS

This book marks a moment in time in the history of Aboriginal art, itself in the process of constant change, evolution and the seeking of a strong voice.
We wish to acknowledge those who have shared in the partnership of the making of this collection and this book—

the artists who have lent work and spoken with us about their own intentions and some of the layers of meaning in the paintings, and who also withheld what was sacred;

the Aboriginal and Islander Commission of the Australian Council of Churches, especially Anne Pattel-Gray, Uniya and Frank Brennan, who conceived the idea and nurtured it;

the sponsors of the Exhibition, among them the Victorian Health Promotion Foundation, Ansett Australia, the Aboriginal Arts Unit of the Australia Council;

the men and women, Aboriginal and non aboriginal, who shared their scholarship and responses to the works in essays, interviews and catalogue entries;

others who facilitated the research, checked data with artists in desert communities and offered generous hospitality in our visits to remote communities... among these persons, Fiona Foley, Marika Banduk and Lin Onus; George Mung, Hector Sundaloo, Teresa Morellini, Denise Casey, Nellie Versluys and Clare Ahern at Turkey Creek; the Mercy community, Michelle Mackenzie and Patricia Lee of the Desert Women's Project at Balgo; Miriam-Rose Ungunmerr-Baumann and the Daly River Community; Gabrielle Pizzi; Daphne Williams of the Papunya Tula Artists, Alice Springs; Colin Jack-Hinton and Margie West of the Museum and Art Galleries of the Northern Territory; Christine Lennard of the Warlukurlangu Artists, Yuendumu; Anne Brody of the Robert Holmes á Court Collection; Gwen and Lance Tremlett and Peter Schaper of Ngukurr; John Kean of Tandanya; Rodney Gooch of CAAMA, Alice Springs;

and then there were those closer to home who read and typed manuscripts, offered suggestions, tolerated endless phone calls into and out of very remote communities. These people can claim this book in that special way—Margaret Woodward, Yvonne White, Jim Briglia, Beverly Waldegrave-Knight.

Rosemary Crumlin and Anthony Knight

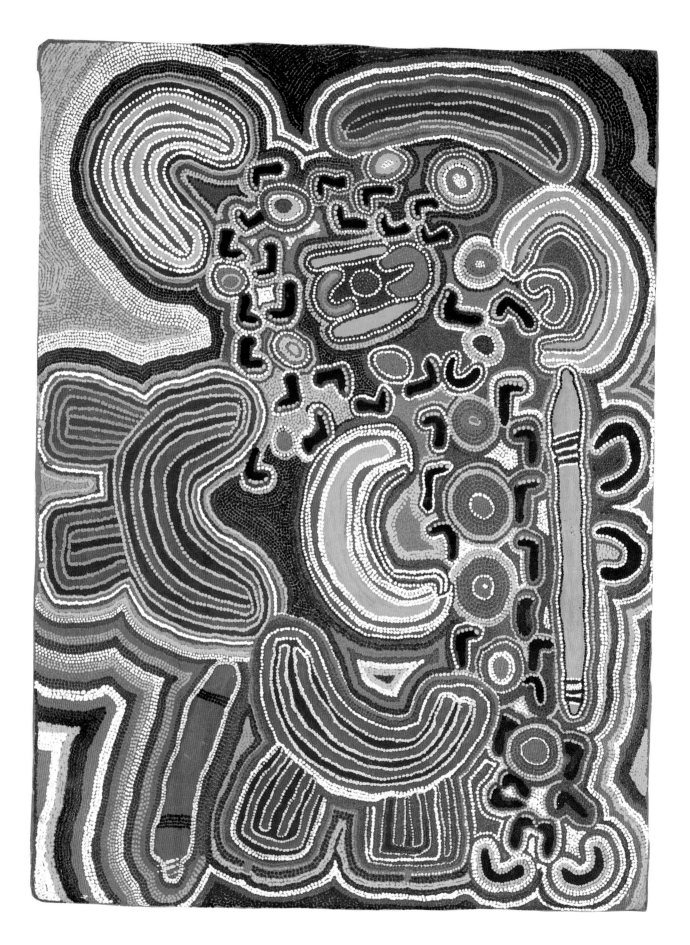

Tjibari

INTRODUCTION

Two women started leaving Mulirayupungu.
They tried to make a shade.
The women tried to make a shade
but it wouldn't stay up.
They got sick of trying to build that shade
so they started travelling.
They went to another rock.
They stayed there painting their bodies.
These two women were
just dancing round.
Next day they started
travelling again
to another soakwater
and that's where they
did the same thing, they painted their body
and that's where they did
the painting and dancing and singing...
The next they went to Wilkinkarra.
Wilkinkarra is a big dry lake
but no trees around.
When you stand in the middle
it's so big
you might think there's water laying
down
for years
but there's no water
it's a salty lake.
So they kept on going
they went and camped at Killikipunda
Those two women camped.
They carried Yawulyu stuff too
so they make themselves
happy when they were travelling
to find the Living Water
so they can settle down there
to find the New Life.
So those two women kept going.
We may be getting closer to
The Living Water they said.
And they gave names
to the country
and they went a bit further down.
They were coming
near the
Living Water.

This is some of the song the Yagga Yagga women of Balgo sang as they brought to life their painting, *Tjibari* (frontispiece). It is a song of search, of adventure, of discovery and of celebration. Like a refrain, the song repeats: 'These two women, they painted their body, that's what they did, the painting and dancing and singing.' They were searching for *living water,* an underground stream that would never dry up. Their journey took them a very long time, during which they changed from children to adults. Theirs was an epic voyage, a search for living water. And when they eventually found it, they went underground as the women sang, and the painting shows, these two ancestors, they went underground and today they are still there.

As I wrote down the words of this wonderful song while Patricia Lee, an Aboriginal woman from Balgo, translated Jemma Napanangka's soft chant, my pen shook. Here was what we had been exploring all these months. Here was what we had been about as we trudged around the desert, as we asked private collectors, 'Can we have that painting off your wall, and can we have it for six months?'; as we begged the Warmun community at Turkey Creek, 'Let it go to the exhibition; let George Mung's *The Pregnant Mary* go. It is not yours, you know, it belongs to all of us, you cannot keep it hidden.' This is what we had been about as we sat on the red earth in searing heat in Balgo and Daly River and Ngukurr; as we strained to listen to Aboriginal men gently opening up their paintings, telling us what they thought we were ready to hear. We had been in search of living water and we did not know it.

The decision to begin the exhibition which accompanies this book was easy enough to take. The first step of a journey often is.

Frank Brennan, the Director of Uniya, approached me with the following idea: 1991 is an important year in Australia, it is the year when the World Council of Churches will hold their Seventh World Congress in Canberra. Did I think it would be possible to bring together some religious works by Aboriginal artists so that those coming from more than 300 countries, as well as those Australians going,

would be able to touch some of the greatness of these people? 'Their art,' he said, 'is their voice.'

I hesitated. I thought he envisioned a collection of Christian art done under the close aegis of conscientious missionaries. If it was to be that, I was not interested. Too fresh in my memory were the appalling but well meaning kitsch of so many Australian and European churches. Then, casually and over dinner, I mentioned the proposal and my reaction to Gabrielle Pizzi, who has worked closely with Aboriginal art for many years. Her advice was that to do it, and to curate it tightly, would be a great service to the people. I talked with others—Margaret Carnegie, Anthony and Beverly Waldegrave-Knight, Judith Ryan, Bob Edwards, Jim Briglia, Margaret Woodward. The response was always the same. Do it; don't confine it to Christian art. All Aboriginal art is deeply spiritual and religious. It is time an exhibition looked at that. Do it.

Frank Brennan talked with the Aboriginal and Islander Commission of the Australian Council of Churches and other Aboriginal groups. Their response was the same.

Criteria for selection

Anthony Knight shared my growing enthusiasm for the possibility of the exhibition and this book. We would curate the exhibition together, consult frequently with Aboriginal people, try for funding for an Aboriginal curator. I would edit the book, he would take prime responsibility for the hanging of the show. We would select works and together walk the journey of the exhibition.

The first serious steps we took saw us in remote Aboriginal communities in search of art that could stand alongside the best the twentieth century could offer.

This was one of the criteria we had agreed upon together. The works in this exhibition were to be able to take their place among great art. This is obviously a notoriously difficult and subjective goal in any Western collection; with Aboriginal painting it is not only difficult but also controversial. We would judge the excellence of the works by their impact upon us; we both bring a depth of visual experience and were willing to 'risk our arm', but we also knew that Aboriginal people do not judge the success of their works by any Western aesthetic yardstick. Theirs is a narrative art. Its primary purpose is usually to tell the story of a particular site or event that has been entrusted to them. In their eyes the work is good to the extent that it does this truthfully and that it is by someone who has the authority to do it. In a real sense, the story belongs to the community, who entrust it to a particular painter or group of painters.

The second criterion we established for selection was even vaguer. The works were to communicate a spirituality—a sense of meaning beyond the obvious, a connectedness through the layers of the work. They were to be works that were symbolic in the richest sense of that word—they were to open up and point to meanings beyond the literal. This criterion, so hard to describe, is often easily recognised in a work of art. And Aboriginal art, especially that by the elders in the groups, those *who have the Law*, easily communicates this sense of power and confidence.

Lastly, we planned that the exhibition would represent the whole of Aboriginal painting today, but that it would not be definitive. It would not represent every geographical area, nor every group in Australia; it would not set itself to make an authoritative statement about Aboriginal art; it would not seek to be a review or a retrospective. We hoped that if we could bring together some splendid works, both traditional and Christian, a new dialogue might begin—between the works themselves, between the works and the viewer, between the works and those we invited to reflect on them in writing. Out of that dialogue might come some new criteria, some new ways of seeing and understanding.

Finding and selecting works

Firstly, we had to find the art. Finding great traditional Aboriginal paintings would not be difficult. The last ten years have blessed Australia with what are recognised as superb moments of twentieth century art. Such art is in private collections and in state and national galleries throughout Australia. But we wanted to show works that had not been exhibited too often before, and this would require a special kind of search and the building of special relationships to borrow, exhibit and reproduce the paintings. This was particularly so if we were to include any works which met the criteria and which were in some way 'Christian.'

Much traditional Aboriginal art is done by Aboriginal artists who are also practising

Christians; many others, especially the older ones, have spent time in mission stations; others remember the encouragement they were given to make artifacts and paintings for sale. But few, or so we thought at the time, were expressing their traditional spirituality and their Dreaming in a way that was inclusive of the Christian story. Or if they were, the work did not get into state and commercial galleries.

The week before Easter we began a journey into remote Aboriginal communities literally to see what we could find that was Christian and Aboriginal. I was not hopeful, the weather was sizzling, and it did look for a while as if Christianity were not an inspiration for great Aboriginal art. Balgo, on the edge of the Great Sandy Desert, gave us hope. In the Church were at least a dozen huge banners, still in use for liturgical ceremonies (Plates 29 and 30). But it was in Turkey Creek that we heard our hearts beating.

Turkey Creek is in the East Kimberleys. We flew in the tiny mail plane from Balgo – low over the Bungle Bungles and the Argyle diamond mine and on to the tiny, dusty airstrip. The Warmun community at Turkey Creek is predominantly Catholic, yet it is a traditional Aboriginal community. Its elders are traditional men and Christian leaders. Some of them are artists of great stature. At least two are also Narpuny men (a Kija word evoking the mysterious, the numinous, the spirit).

We stood in wonder before George Mung's carved wood sculpture, *The Pregnant Mary* (Plate 15), laughed with him as he talked about the country and the journeys he had made, listened in awe while Hector Sundaloo, erect, white-haired but with a voice hardly above a whisper, told us of the *Young Joseph and Mary*

(Plate 17) and of the Holy Spirit which accompanies each person throughout life – male for the male, female for the female – and of the young Christ lying dead upon a tree platform awaiting the rites of burial. And so much more.

They left us then, George and Hector, to get ready for the Passion Week rituals. They had hymns to write and practise, stories to tell to the children and paintings and carvings to be lifted from the walls in the room where we were to be carried in procession, as they are each year. It was a Christianity that was new to me – old, but new.

It is difficult to encounter Aboriginal art over a long and intense period of time without becoming polemical or at least political. To stand before any good art is a rare opportunity; to be able to listen to the artist and then go back again to the art is different again. But to go into the desert, to sit on the red earth, to fly over the Bungles and Fitzroy Crossing and to look down at the giant painting-like topography, then to meet up with the artists and sense their depth, insight and gentleness as well as their earthiness and humour, is at least a deeply moving human experience which some identify as spiritual and religious.

Aboriginal art is so embedded within an ancient and complex culture that to touch it is to share the journey of the Balgo ancestors who set off in search of living water, and kept stopping along the way to dance and sing. But when they found the living water they named it, and the song finishes:

and they went underground
and they are there today,
they found the Living Water

Rosemary Crumlin

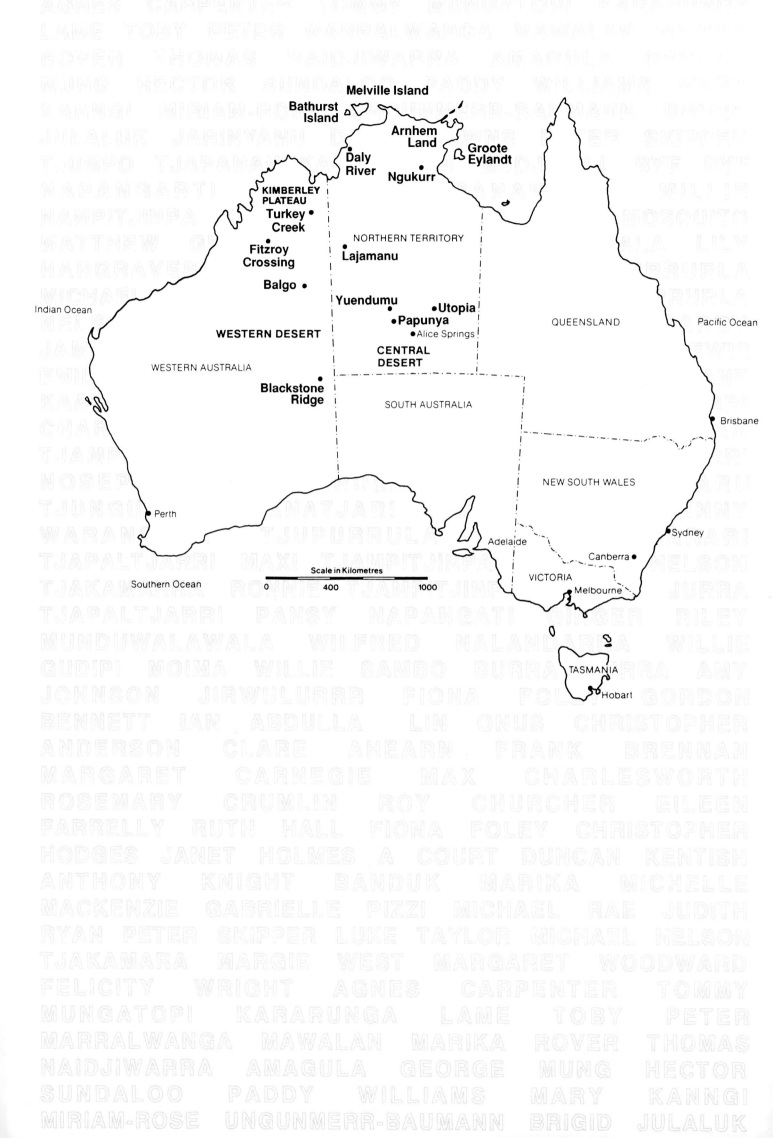

THE ART

The works of art are the focal part of this book. Everything else takes its meaning from them, for this is primarily a book of art, although art with a distinctive theme.

The works are grouped geographically, both for ease of identification and because geography, or rather land, is integral to Aboriginal self identity and so to their art. To have seen, felt and smelt the land is to already recognise something of the art. Each cluster of works is preceded by a short introduction by a person with academic competence and lived experience in the particular area. The introductions differ in style, and sometimes in length, but the brief suggested to each writer was the same – to introduce the art of the area in a way that was personal, yet inviting, without being intrusive.

BATHURST AND MELVILLE ISLANDS

How Death Came Into the World

While Purukuparli stayed in the camp, his wife Waijai stole off to meet her lover Tapara, using as a pretext the need to gather food. As Waijai and Tapari committed adultery, the owl (Purikikini) looked on.

Meanwhile, Waijai had left her baby son, Jinani, whom she had carried with her from the camp, under the shade of a tree. But she stayed away too long. The tree shade moved, gradually exposing the baby to the fatal rays of the sun. Returning from her tryst with Tapara, Waijai was grief-stricken to discover her little baby's lifeless form. She went slowly and sadly back to the camp.

When he learned what had taken place, Purukuparli berated his wife for her adultery and for her neglect of his son, Jinani. As a sign of her guilt and remorse, Waijai covered her pubic area with her hands. In sympathy with her daughter's shame, her mother covered herself in a similar manner.

Then Tapara came and asked to have the dead boy so that he could restore him to life. Purukuparli refused, saying, 'No. Now that my son is dead we shall have to follow him. Everyone will die.'

Tapara and Purukuparli then began to fight with forked lightning sticks. Purukuparli wounded Tapara many times in the face, causing him to fly up into the sky. Here he turned into the moon, waxing and waning every month as the symbol of man's lost immortality.

Purukuparli then began the first burial ceremony, assisted by the bird, Tokawampini.

He showed the people how to make burial poles and ornaments, and what dances to perform.

After performing the ceremony, Purukuparli took his dead son in his arms and walked into the sea off the eastern tip of Melville Island. The site is marked by a whirlpool, which swallowed up Purukuparli and Jinani.

At Yipanari, off the eastern tip of Melville Island, a whirlpool marks the place where the ancestral hero Purukuparli drowned himself, with the body of his young son Jinani clutched in his arms. This tragic act concludes one of the Tiwi's most important myths, one which explains how death was brought to a previously immortal world.

For the Tiwi, death is the focus of one of their most important rituals, the Pukumani ceremony, first performed and taught to them by Purukuparli. This, together with the initiation and life-sustaining Kulama ceremony, provides the focus for Tiwi religious belief and artistic practice.

The Pukumani ceremony as decreed by tradition is a complex series of performances which culminates in the final stage, called iloti. For this, the mourners decorate themselves in elaborate designs and sing and dance for several days to ensure the departure of the dead person's spirit to its final resting place. As the ritual draws near the end, elaborately decorated and carved burial poles are set up around the gravesite; these are abandoned, like the person's body, and left to decay.

An essential part of both the Pukumani and Kulama ceremonies is the creation and performance by each individual of new songs, dances or designs. This is regarded as necessary to the ritual and an important way of achieving personal prestige. According to tradition, Purukuparli decreed that people should use their personal experience for artistic inspiration in this manner.

The designs painted on burial posts or bark surfaces are very rarely naturalistic, and interpretation of the designs by the artist is necessary to decode the myriad of meanings that the symbols contain. Some paintings relate to the artist's totem or Dreaming. They can also allude to mythological events through the illustration of perhaps one or two elements—such as the painting of the sun, which refers indirectly to the death of Jinani in the Purukuparli myth.

More commonly in Tiwi art, individual elements of a design are given random interpretations, such as dots for water, lines for tracks, and so on. The absence of mythological meaning for many designs is related to the artist's individual creativity and to the lack of any formal relationship between ancestral or totemic beings and the designs. As a result, and unlike many mainland groups, the Tiwi do not utilise their art in a revelatory way, to express deeper levels of religious meaning. Their art system, in this respect, is more open. Consequently, women as well as men participate in the creative process, although traditionally a woman would only carve or decorate a ritual item if her husband were unable to do so.

The flexibility of the Tiwi artistic system and its ability to incorporate the new have resulted in the successful incorporation of new media in recent years. In 1969 the Tiwi were the first Aboriginal group to establish a successful silk-screen printery – Tiwi Designs – which was followed by Tiwi Pottery – the first and only successful pottery in a remote Aboriginal community. In the traditional art and craft area, men and women artists have developed their carving skills to include the production of animal and figure sculptures as well as pukumani poles. Designs are now painted upon flat pieces of bark as well as on the customary pukumani bark baskets. More recently, artists at Melville and Bathurst Islands have also begun to paint their designs with European paints onto paper and canvas, allowing artists a new range of circumstances in which to give expression to their customary knowledge and personal experiences.

Margie West

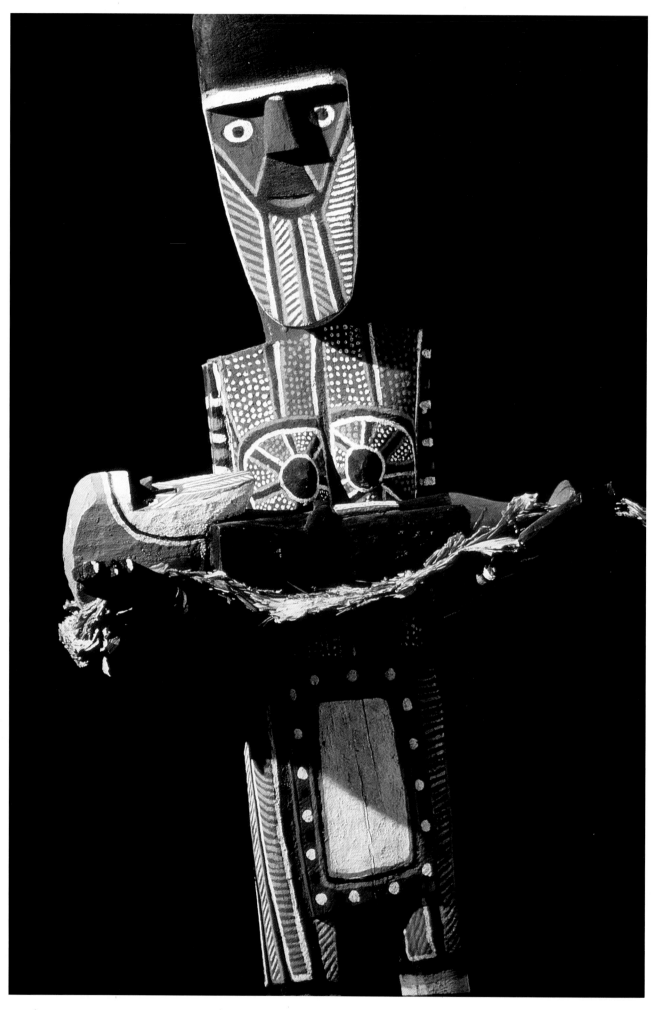

Plate 1 *Purukuparli Story* unknown artist

Plate 2 *Sun shining on Jinani c.*1970, unknown artist

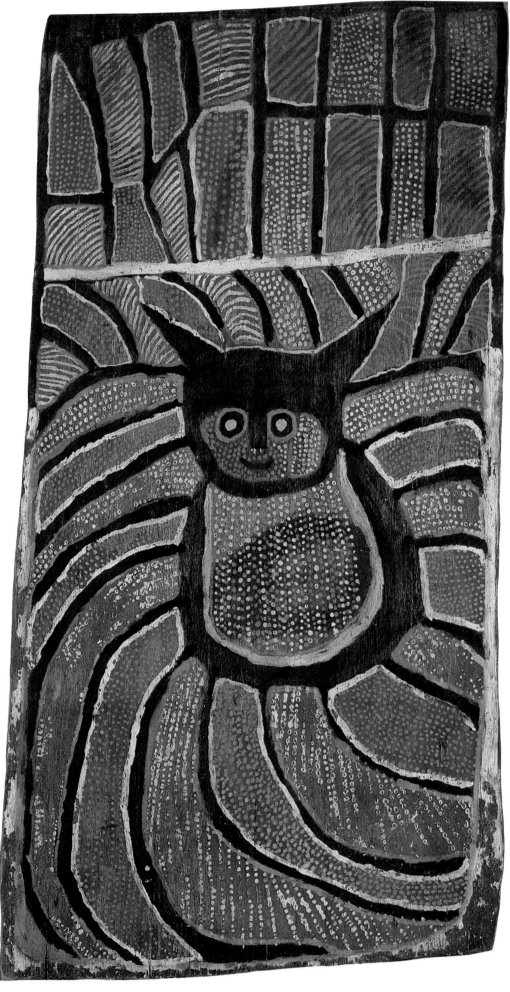

Plate 3 *Purikikini the Owl c.*1969, Agnes Carpenter

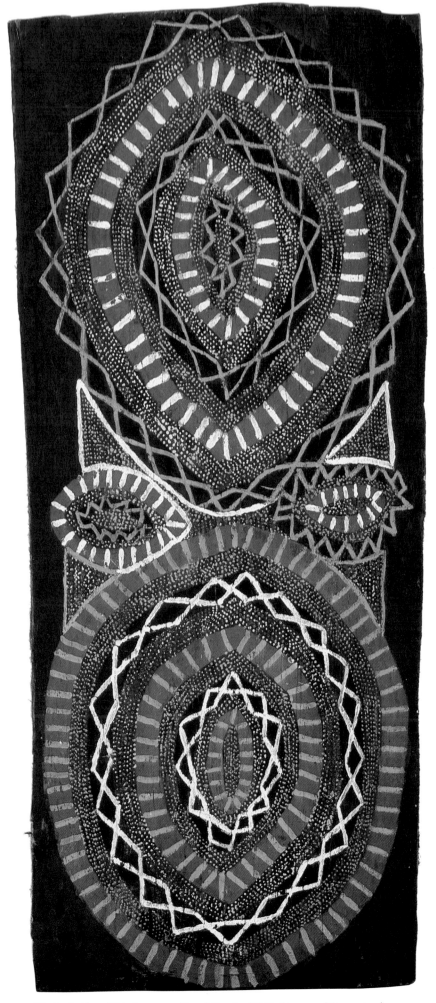

Plate 4 *Sun Shining on a Coral Reef c.*1970, Tommy Mungatopi

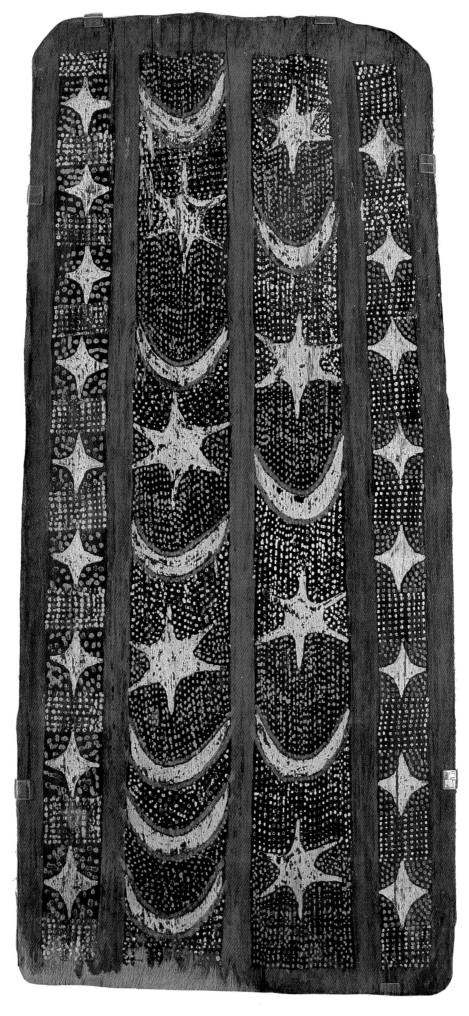

Plate 5 *Moon and Stars c.*1968, Tommy Mungatopi

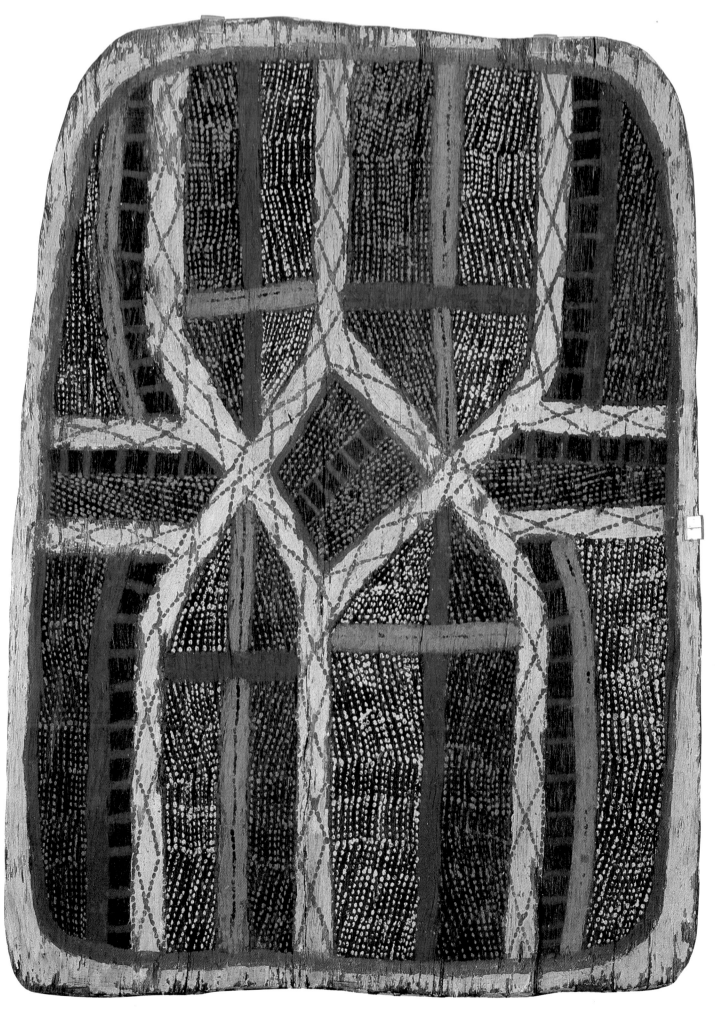

Plate 6 *Crocodile Painting c.*1965, Kararunga (Lame Toby)

ARNHEM LAND

Basically, the Arnhem Land art that we see today reflects the history of the settlement of Arnhem Land. The art comes from the towns and the established craft centres at places like Oenpelli, Maningrida, Ramingining, Yirrkala. The Mimi Arts and Crafts Centre in Katherine sells southern Arnhem Land paintings. Some work, largely acrylic painting on canvas, is being done at Ngukurr in the Roper River area. Art is produced in other smaller communities but is usually collected and brought into the art centres in the towns.

What is sold reflects a variety of styles. We can think of differences in art styles as being analagous to differences between languages. It is important to understand both the underlying rules and structures that provide form and discipline, and the culturally-dictated meanings that reflect and inform both art and discourse. People often talk rather simplistically of east Arnhem Land, central Arnhem Land and west Arnhem Land art. East Arnhem Land art styles tend to indicate different clans, while in west Arnhem Land the art styles reflect the close-knit family groups that live together. In central Arnhem Land we can speak of a number of styles related to different language groups. We need more detailed research on the gradients of stylistic difference. The development of style is a long-term process, and Aboriginal people will indicate in their own works the features they share with those of other groups while at the same time pointing out the differences. These stylistic changes take place over thousands of years, and can be thought of as dynamic systems that reflect new relationships, just as language does.

It is important, too, to attend to the ways in which the works speak to the spirituality of the people. One example is that of Peter Marralwanga, *Two Yawk Yawk Spirits* (Plate 7).

Within an Aboriginal group, what these works have to say is one of the reasons for their great significance. They speak to the group's understanding of its place in the world. Part of what we have to recognise in Arnhem Land art is the very complex, layered way that meaning is developed; an intricate symbolism accommodates the secular or profane understanding of the world and helps to link that understanding with a deeper, spiritual dimension. In Arnhem Land, people speak of an obvious meaning of the world, the *outside meaning*, but as they progress through life, they start to understand hidden relationships; these meanings are described as *inside meaning*. In Aboriginal culture, one moves from understanding the outside to understanding the inside.

So it is with an artist like Marralwanga, who often paints Yawk Yawk, associated with a Yelelban site near where he lives. At this site, where the spirits are said to be like women but are also like fish living in the waterholes, Marralwanga can paint figures as women with fish's tails. When I went to this site with him he explained to me that the fish in the waterhole were Yawk Yawk, but that Yawk Yawk could also be thought of as female ancestor beings, creator beings, who walked through this country and made the features of landscape. He explained that the weed in the waterhole was the transformed hair of these women and that the vines growing on the trees near the waterhole were the feathered strings they carried. When Marralwanga paints Yawk Yawk, he can choose to represent the transformative potential of these creator beings: he can show their long hair looking like water weed, and he can show the women turning into fish. Marralwanga uses paintings to reveal and make public these original creative actions.

A non-Aboriginal person, I can begin to understand the spiritual dimension of these paintings, because certain knowledge has been revealed to me by Marralwanga. I can understand that what he is showing in his paintings is the underlying spiritual relationship between otherwise distinct physical manifestations of the Dreaming.

I believe that we can begin to learn the *outside* aspects of spirituality in the works, but I don't feel that non-Aboriginal people can progress to feeling this spirituality in exactly the same way as the artist.

Luke Taylor

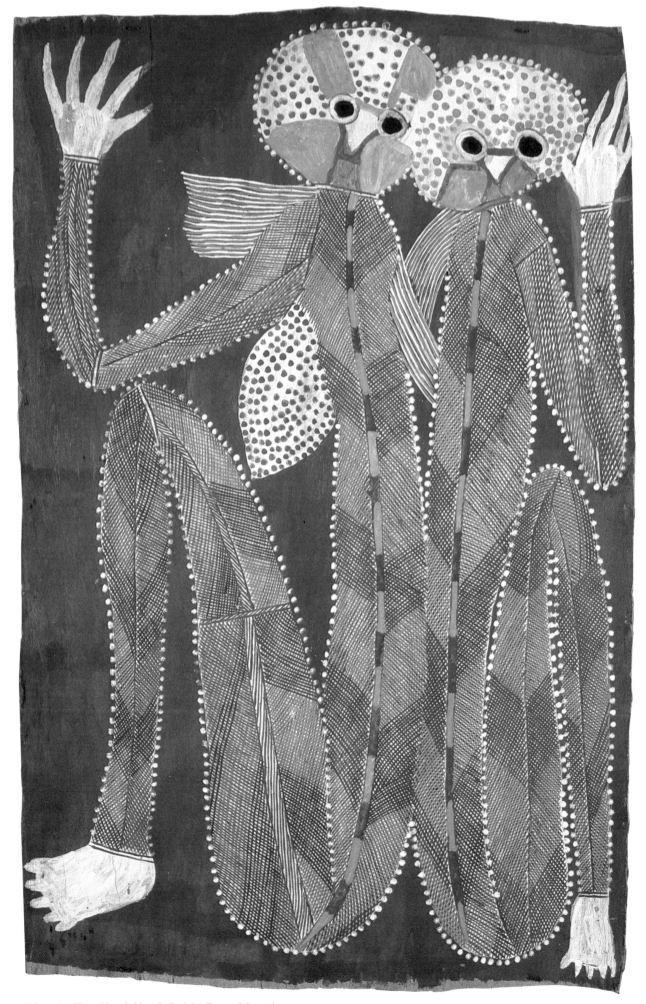

Plate 7 *Two Yawk Yawk Spirits* Peter Marralwanga

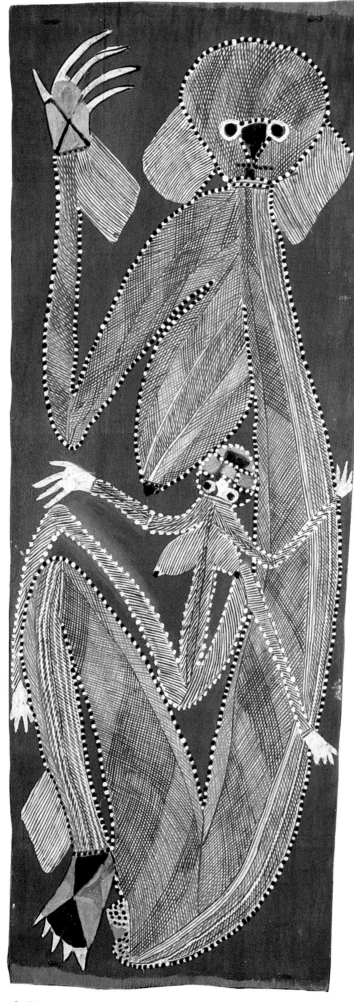

Plate 8 *Yawk Yawk and her Daughter* 1983, Peter Marralwanga

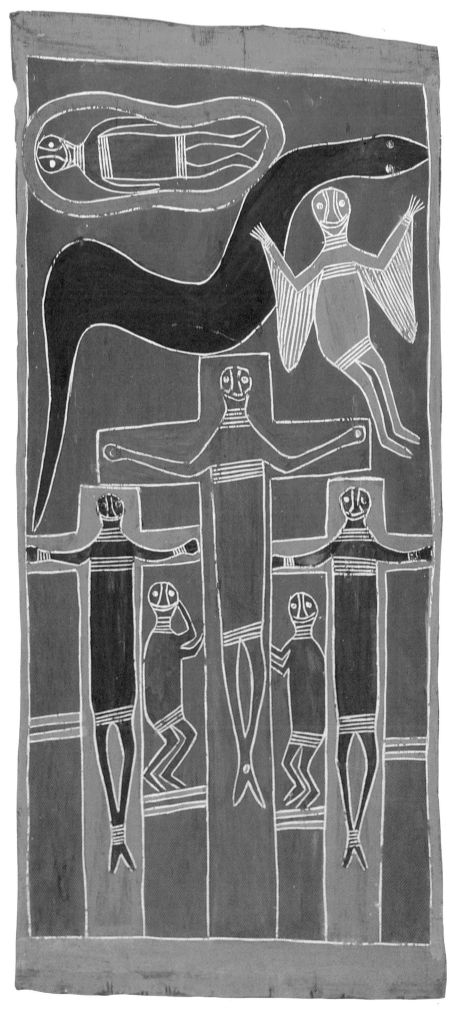

Plate 9 *Crucifixion c.*1968, Mawalan Marika

GROOTE EYLANDT

Twentieth century Groote Eylandt bark paint-ing developed separately from that of Arnhem Land, largely because of geography. Groote Eylandt, named by the Dutch explorer Tas-man in 1664 (Cole, 1985), is situated on the western side of the Gulf of Carpentaria about fifty kilometres off the coast of Arnhem Land. The Christian Mission Society (CMS) estab-lished its Emerald River Mission there in 1921 for Aboriginal children from the mainland (Cole, 1988); from the 1930s it concerned itself primarily with the welfare of the Aboriginal people on the island; in 1978 it handed over the mission complex and its administration to the Angurugu people (in response to the by-then-deposed Federal Labor government's policy of self determination for indigenous people). The island economy was cash-based, its primary source of money the manganese mine leased by Gemco (a wholly owned subsidiary of BHP), and the traditional culture and values of the people had been eroded by sudden and massive change.

The contemporary history of Groote Eylandt bark painting is inextricably linked with the social and, in the early days, mission history of the people. The missionaries encour-aged the painting of barks with secular themes, and often collected and sold them. These barks were small, with animals, plants and birds painted in red ochres on the natural surface; there was rarely an attempt to link the motifs to each other or to the edges of the bark. In the 1940s and 1950s a manganese wash was often used, and the figures were drawn finely on this ground with red and yellow ochres and white clays. The figures were often filled with short dashes of colour—a distinctive, decorative characteristic of the art. From the 1960s the figures are larger, and the composition is more likely to be taken to the edge of the bark. Some of the distinctiveness of Groote Eylandt style has been lost now that contact with the mainland is easier and more common.

One of the outstanding Aboriginal leaders on Groote Eylandt during the turbulent years after the establishment of the Gemco mine was Naidjiwarra Amagula. For most of his life he had lived on the CMS mission, as had his father before him; for a considerable time he was also a Christian, a lay preacher and a reader. He was the first vice president of the Angurugu Community in 1978 and subse-quently became its president. Later, disillu-sioned with money and commercialism, and worried by the effects of alcohol and drugs, especially on the young, he led a movement to encourage people to go back to their traditional homeland and to live in the old way. The move-ment failed; the island was too small and the consumer way of life too deeply embedded. Naidjiwarra died a broken man.

The three paintings in this collection (Plates 10 to 12) date from 1964, when Naidjiwarra was a Church leader (Turner, 1988). Their ico-nography is Christian, but in style and feeling they are traditionally Groote Aboriginal. They portray the central event of the Christ story—the Death and Resurrection of the one sent to redeem the people—and they echo, as David Turner has explored, a core theme of the Groote Eylandt myth of Nambirrirrma. The Christ on the Cross is a shining white, as he is when risen; he is signified as a great leader of the people. The drawing and the 'infill' are typ-ical of the area; the composition fills the whole space in a way common in other bark paintings of the period.

These three images, neither wholly Western nor wholly Aboriginal, raise in a dramatic and graphic way the complexities associated with the enculturation of Christianity in an Aborigi-nal society already rich in its own myths of incarnation and redemption.

Rosemary Crumlin

30

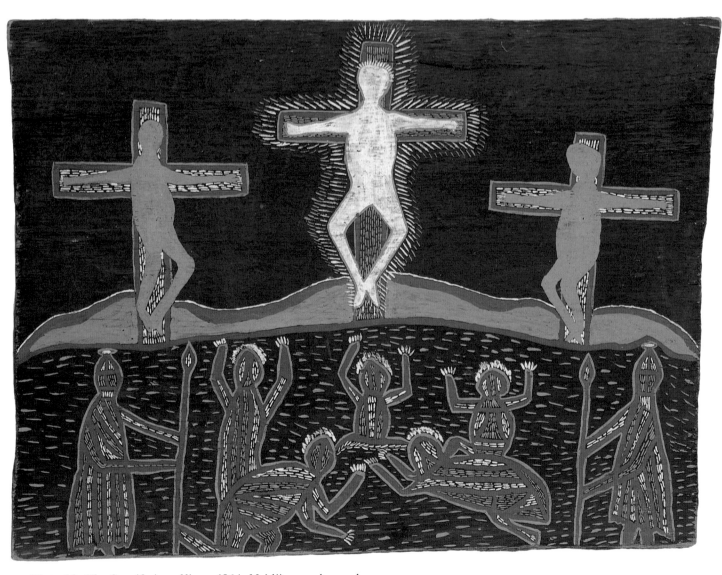

Plate 10 *The Crucifixion of Jesus* 1964, Naidjiwarra Amagula

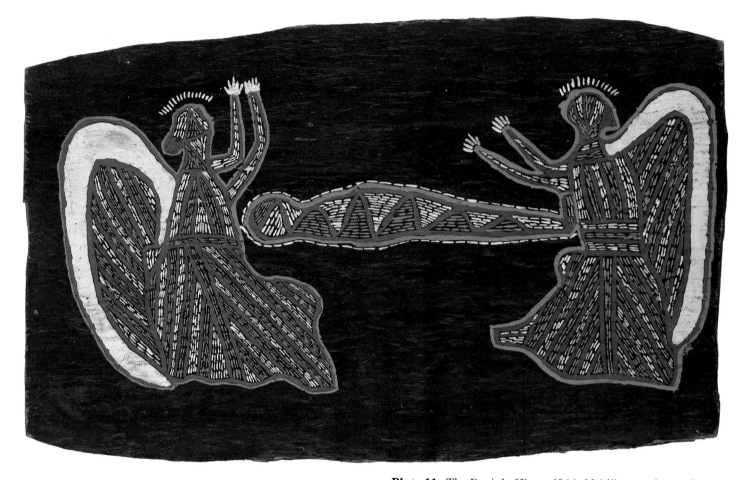

Plate 11 *The Burial of Jesus* 1964, Naidjiwarra Amagula

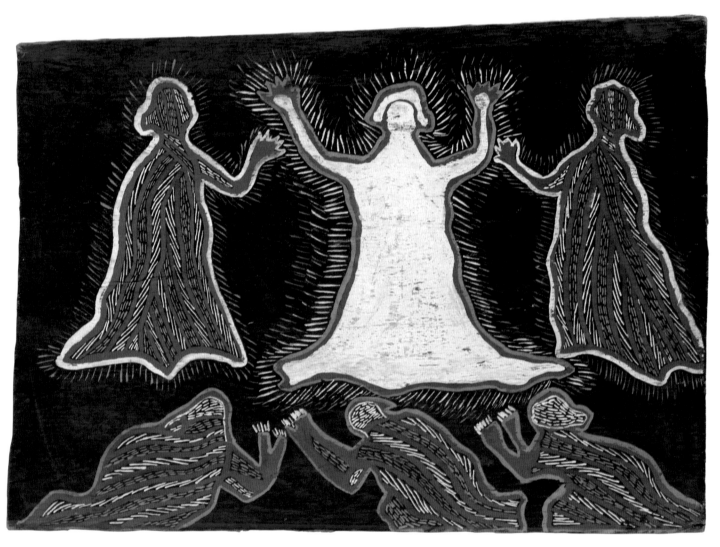

Plate 12 *The Ascension of Jesus* 1964, Naidjiwarra Amagula

TURKEY CREEK

The art of the Aboriginal people of Turkey Creek gives expression to the life-force pulsing through this small community in the East Kimberley region of Western Australia. This life-force is experienced and shaped by a strong relationship to the land, adherence to the Dreamtime Law and a love of culture revealed and sustained artistically in corroboree and ritual, wood carvings and other art forms.

The Warmun people also remember the past: massacres by settlers, forced resettlement, location on a government cattle station in Violet Valley in the 1940s, escape to a more peaceful existence on Texas Downs Station, the introduction of equal pay for Aboriginal station workers in 1965 and the subsequent drifting of Aboriginal people into the area around Turkey Creek. There, until 1980, they lived in shacks made of corrugated iron, in little bough sheds or in old cars. Rarely do the artists of Turkey Creek depict this history of suffering and displacement. Rather, their remembering encompasses the country, various landforms, myths of the area, traditional spirits, flora and fauna, their traditional and Christian beliefs.

In the time of great poverty, the Warmun people used cardboard boxes, pieces of tin, old doors, masonite, even fly screens found in the local dump, as the ground on which to paint. Most of this earlier art had to do with myths linked with the local area. Significant places were depicted in traditional ochre colours, and painted with twigs or matchsticks, or just in paint blown from the mouth. Such works of art were carefully stored, and displayed during corroborees. While the community sang of the mythical sites, chosen dancers performed, holding the paintings aloft on their shoulders.

The establishment of a Bough Shed School in 1979 strengthened community determination that the children would learn to follow traditional beliefs, speak the language and cherish the culture of the people. Artists' works were brought to the school. The children heard stories of the paintings in their own language. The art was prominently displayed. Thus began the collection of art in Turkey Creek.

George Mung, artist, teacher and leader, brought the stories and songs of his country to the children and to the adults teaching in the school. He painted in ochres the landscapes and life of his country. Often he intermingled the shapes of spirits with the flow of rivers. This can be seen in the painting in this collection, *Ord River Country* (Plate 14). Over the years, George has produced many paintings which record his Law stories for posterity.

The tiny community is predominately Catholic. They sustain belief in their traditional rituals and customs, and seem to experience little tension in uniting two belief systems. Paddy Williams' painting, *Christ and the Battle* (Plate 18), demonstrates this harmonious union. Two groups of people are fighting. Through a gap in the line of hills can be seen the Christ figure, the boab tree with a heart on it, urging peace. This blending of beliefs is also evident in *The Dead Christ in the Tree* (Plate 16). Traditionally, the corpses of Aboriginal people were placed on tree platforms so that further Law obligations could be fulfilled. Here Hector Sundaloo places the dead Christ on a tree platform rather than in a cave. In *The Young Joseph and Mary* (Plate 17), Hector uses two white birds as symbols of the Holy Spirit – a feminine Spirit for the young Mary and a masculine Spirit for the young Joseph. The tradition of a young couple's not associating with each other until the approved law is completed also finds expression in this painting.

George Mung is also a skilled wood carver. A favoured subject is the Mother of Jesus. Using axe and chisel he produces such works as *The Pregnant Mary* (Plate 15). For every Mary he carves he also sculpts 'her little mate' as he calls the accompanying bird of the locality. George's other carvings include images of the traditional spirits of the area, usually shaped like birds with very strong facial expressions.

The art of the Warmun community of Turkey Creek reflects many facets of spirituality. The art of Rover Thomas (Plate 13) is inspired by the country. George Mung and Paddy Williams are strong Law men, whose work combines traditional and Christian beliefs. Hector Sundaloo provides a further, distinctive example of an integrated spirituality.

Clare Ahern

Plate 13 *Wolf Creek Crater:* Gundimulul 1987, Rover Thomas

Plate 14 *Ord River Country* George Mung

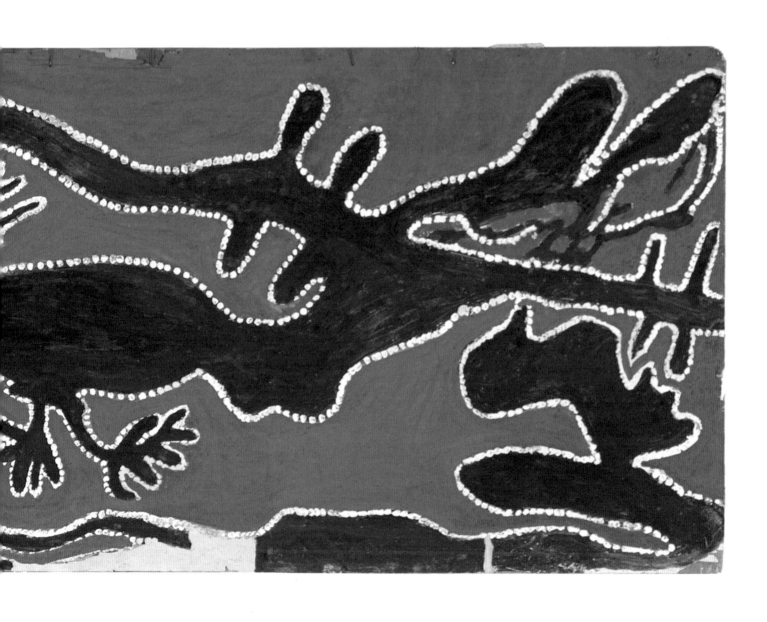

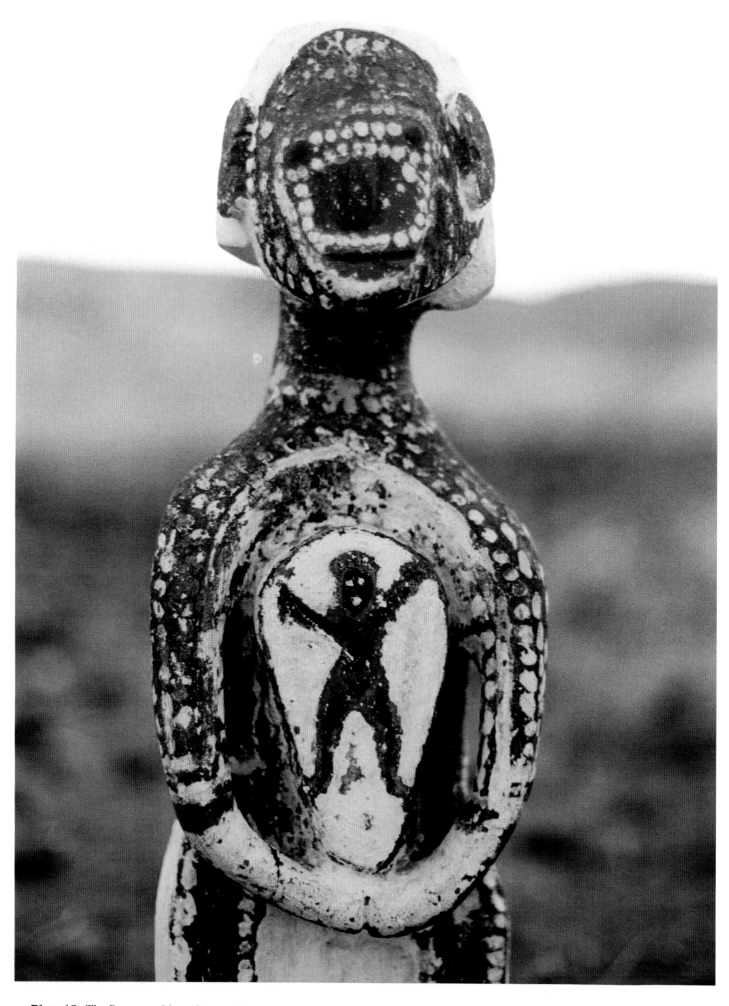

Plate 15 *The Pregnant Mary* George Mung

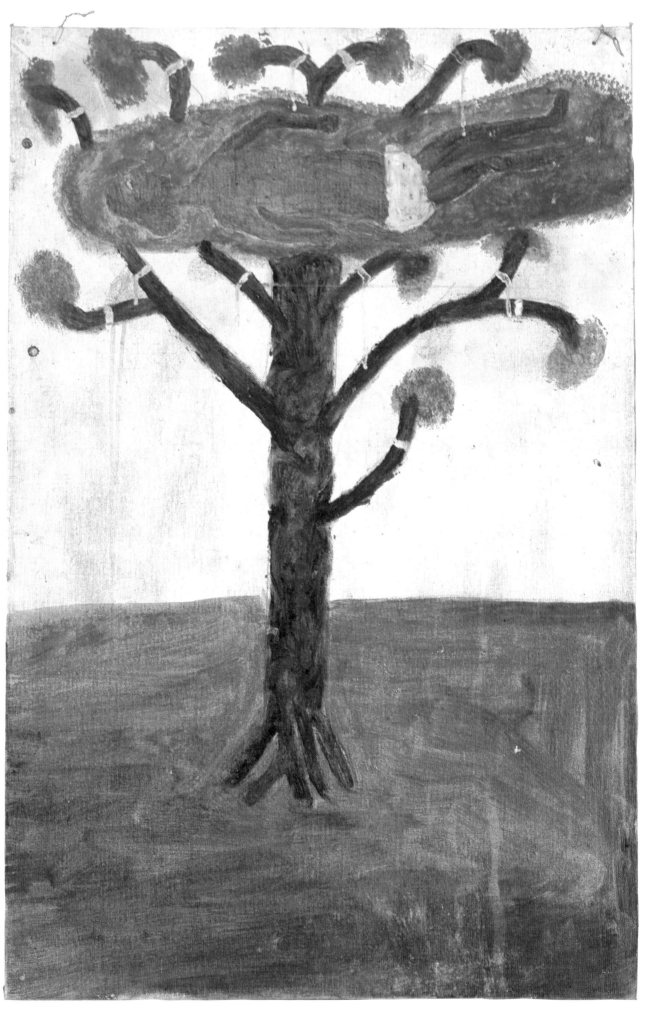

Plate 16 *The Dead Christ in the Tree* Hector Sundaloo (Djandulu)

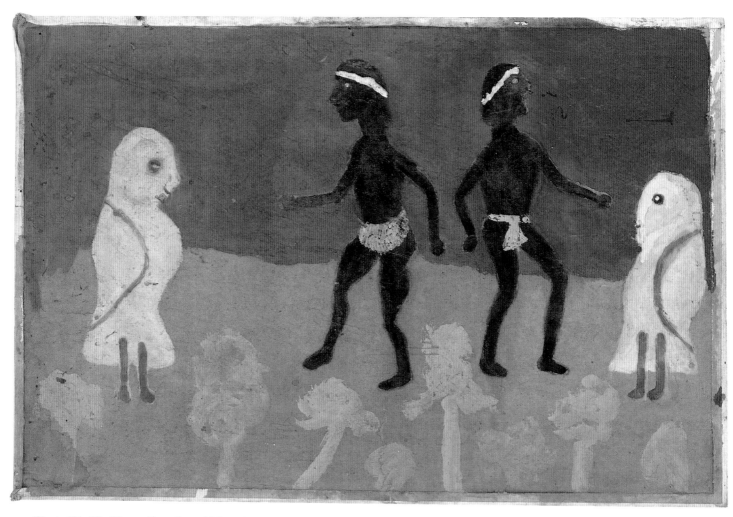

Plate 17 *The Young Joseph and Mary* Hector Sundaloo (Djandulu)

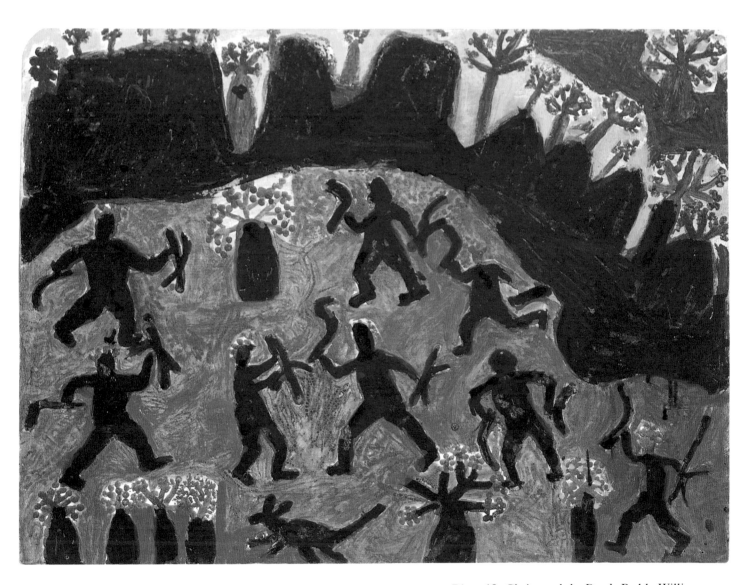

Plate 18 *Christ and the Battle* Paddy Williams

DALY RIVER

The Nauiyu Nambiyu community is situated in lush tropical land alongside the deep-flowing Daly River in the Northern Territory. Huge trees flourish, frangipanni scent the air, parrots descend in raucous flocks to feast on the nectar of the kapok blossoms. In mango time, thousands of black bats make nightly raids to gorge on the golden fruit. This is a land of plenty. Goannas, rock snakes, bandicoots, porcupines and wallabies are still plentiful enough to be part of the diet. Thousands of magpie geese still arrive each year. Bags full of turtles are taken from the billabongs. Yams, waterlily roots and fruits such as wild plum and tomato are only part of the harvest. Crocodiles laze on the river banks and their eggs are gathered for food.

All this is the setting for the myths, stories and symbols of the Daly River (Plates 19 to 22). While the paintings of the Warmun at Turkey Creek reflect a landscape brown and hard, scattered with huge rocks, and the Central Desert myths are often concerned with long ancestor journeys in search of food and water, the art of Daly River rejoices in the abundance of food and water.

Malbien is the traditional homeland of some of the artists. In the Dreamtime, a fan palm grew beside a billabong there. Along came a sand frog. She was pregnant. She asked the fan palm if she could stay in the billabong and lay her eggs. 'Yes', said the tree. Later, a leech came by and sought permission of the palm and the frog to stay in the billabong and lay her eggs. 'Yes', they replied. Next came blanket lizard. She was very pregnant: 'May I stay here and have my babies?' They were firm. 'No, it is too crowded', they told her. The blanket lizard took herself to a nearby hill and found a cave there. Her babies were born. Today you can see the cave in which she remains hidden. Thus Malbien people claim four Dreamings: fan palm, leech, sand frog and blanket lizard.

Most of the artists at Daly River are women, aged between eighteen and eighty. They sit together often and remember – not just the immediate past, like the coming of the Catholic mission in 1956, but reaching back into pre-Christian spirituality. Just as the river runs deep and mysterious, taking to itself something from each region it passes through, so the Aboriginal heritage seems to hold elements common to Christian theology and to the unity of body, land and spirit.

Thus the spirituality of the people is often a mix of traditional rituals and ceremony and more recent Christian story and sacrament. The white church with its *Stations of the Cross* (Plates 20 and 21) by Miriam-Rose Ungunmerr-Baumann, a community leader, is the physical and sometimes spiritual centre of the community. But there is the call to go to the homelands, to touch and gather strength from the land.

There is a darker side to the people's spirituality here. Events are not haphazard. For every effect there is a cause. A death happens, so *pay back*, retribution, often must take place. From paintings, we often learn how the cause is divined. Perhaps an enemy sent an evil wind or a snake to kill a man. A witch doctor will discover who is responsible and send a spirit message to the new victim, who will know that he has been *sung*. Cloud signs in the sky indicate when pay back has been effected. A shooting star travelling across the heavens at night is an omen.

With the formation of the Majellan House Women's Centre in 1987 has come a surge of creative activity. Almost one-third of this small community of one hundred and fifty people paint. Many of these artists also use batik, paint on silks and work at a variety of traditional crafts; and while there is a great diversity in appearance, a distinctive underlying style reflecting the richness and vitality of the land itself is beginning to emerge.

Eileen Farrelly

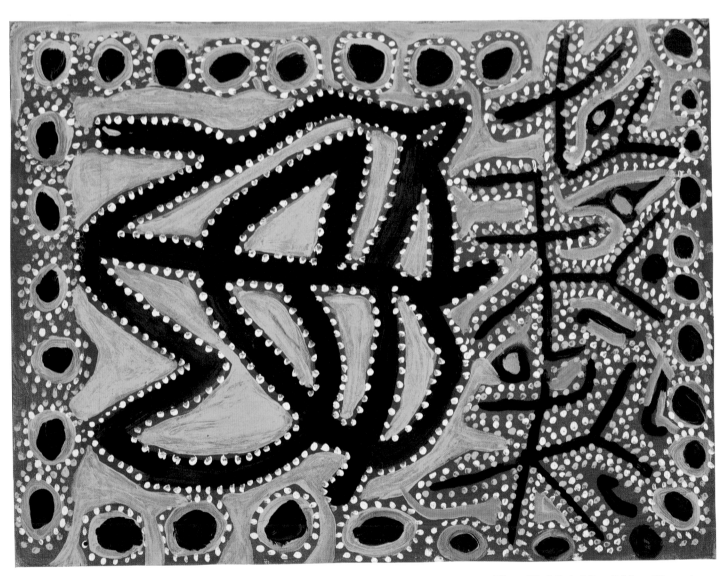

Plate 19 *Mininjtjimuli* Mary Kanngi

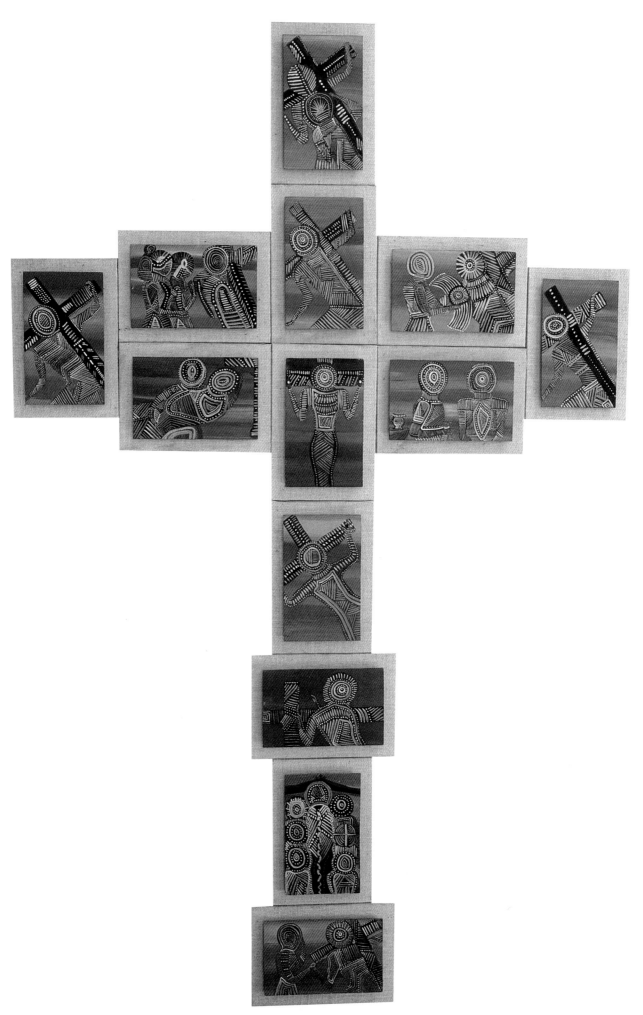

Plate 20 *Stations of the Cross* 1974, Miriam-Rose Ungunmerr-Baumann

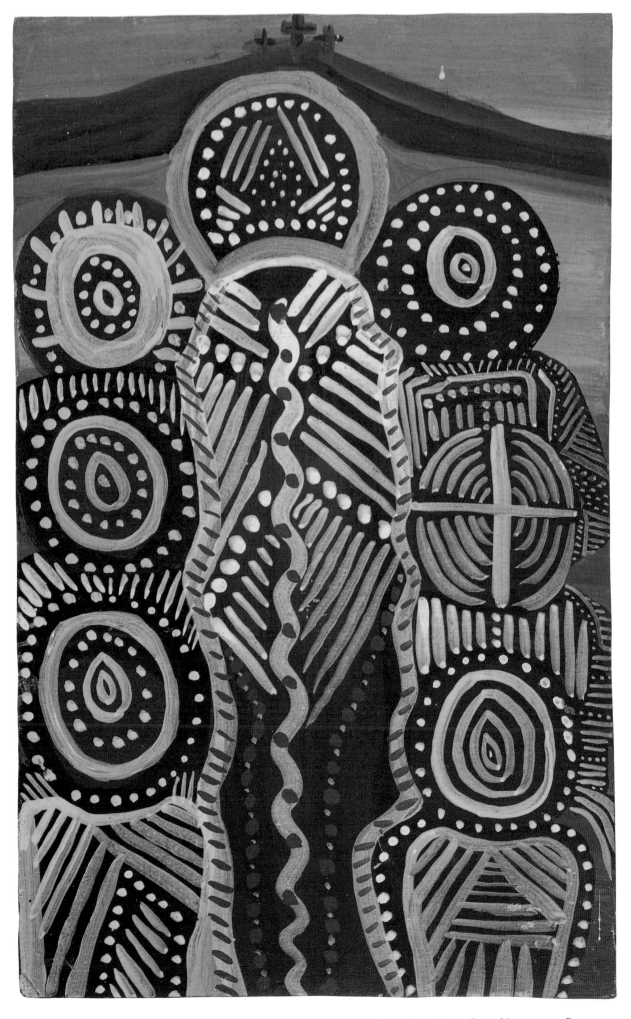

Plate 21 *Stations of the Cross* (detail), 1974, Miriam-Rose Ungunmerr-Baumann

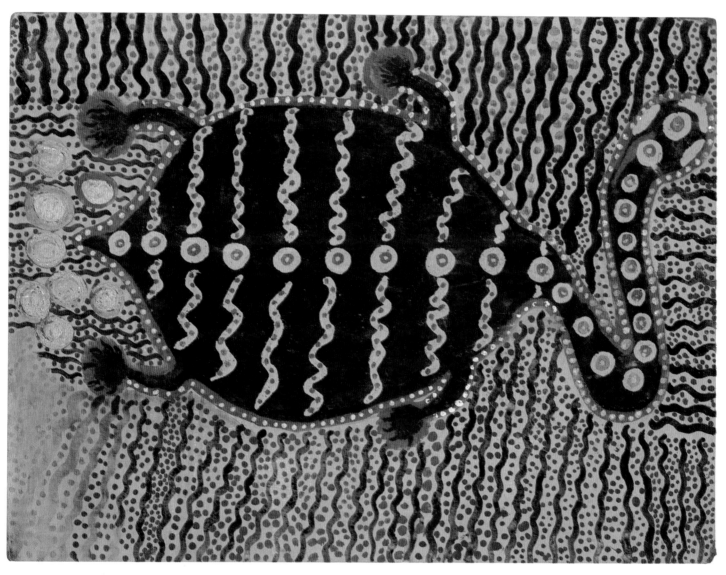

Plate 22 *Turtle in the Water* Brigid Julaluk

FITZROY CROSSING

A small regional centre for the Southern Kimberleys of Western Australia, Fitzroy Crossing developed around a cemented boulder-crossing over the bed of the Fitzroy River.

People from ten different Aboriginal language groups inhabit the region, but Walmatjari is the lingua franca. The original land-owning river tribes were invaded late last century by expansionist squatters. Resistance was brutally crushed, with punitive killing raids and covert murders lasting until at least the 1930s, while de facto slavery underpinned station economics until the 1960s. The early decimation of the river tribes accelerated the northerly drift of desert people out of the Great Sandy Desert. Participating in this exodus, both the artists represented here worked on cattle stations for many years before moving into Fitzroy Crossing in the mid 1960s. The High Court's 1967 Equal Wage determination led to most Aboriginal employees and their families being forced off the stations. Overnight, Fitzroy Crossing became a major population centre offering government assistance, food and shelter.

Early missionaries helped to moderate some of the pastoralists' violence and oppression, offering the hope of the new moral order and an alternative path to spiritual integration. They were also agents of Westernisation, encouraging Aboriginal people to suppress much of value in their own culture, including central features of their traditional religion. Yet careful observation reveals a parallel world of considerable resilience. This is particularly evident in painting, where the artist communicates directly his own interior world, using imagery and explanation to confound stereotypes of cultural passivity and decay.

The two artists represented here are Peter Skipper (from the Juwaliny, on the western side of the Great Sandy Desert) and Jarinyanu David Downs (from the Wangkajunka-Walmajarri, on the eastern side). Both come from only slightly different painting traditions, but their styles appear totally different from each other.

Skipper (Plate 25) uses bright acrylic paints and favours a cartographic perspective, incorporating design-work motifs from shield-carving and body painting with symbolic forms and a semi-realist depiction of water-holes and sandhills. Downs (Plates 23 and 24) uses a mixture of ochres and acrylics, and mostly paints a frontal presentation of Dreamings or Ngarrangkarni men at moments of numinous transformation. Sometimes the images represent dancers celebrating the associated corroborees. Downs' work is quite individual and has about it the dramatic intimacy of cave art in the area.

Both artists paint their own or their parents' country, focusing on the stories and associated sites where their own spirit forms first presented for incarnation as living people. Each paints about personal identity: that constellation of Law, belief and territory that constitutes his individual humanity.

As outlined by Skipper, a person's pre-existent spirit or *murungkurr* appears to its future father in a dream, usually followed by some significant event connected with an animal or plant food. The father-to-be tells his wife about the dream; shortly after, she will be pregnant. The animal or plant involved is the *jarriny* or conception totem for that person. Skipper's *jarriny* is a grass seed, *Ngurjana*. His *murungkurr* is from the Mangkaja owl that sank into Mangkajakura in the Ngarrangkarni. Downs' *murungkurr* was born from the *Ngarrangkarni Piwi*, a mysterious owl man, at once trickster, benefactor and demiurge.

Downs' Piwi paintings have a special quality, celebrating as they do his *Ngarrangkarni* identity. *Piwi Kurlangu* shows the chameleon-trickster, Piwi, pretending to be a young initiate by day and reverting here to an old man by night. Skipper is similarly reverential toward Mangkajakura in his paintings of this waterhole complex. Here he landed as the Mangkaja bird, here he was born in the waterhole, sighted and named by the *Nganpayijarra* (or 'Travelling Two Men') who stand as witness to the beginning of things, creating perceived order out of void. Downs' brooding image of the *Nganpayijarra* captures this sense of pervading iconic witness–the ultimate ground of proof predicating the reality of all *Ngarrangkarni* stories. Similarly, his *Moses, God and the Ten Commandments* (Plate 23) acts like an iconic reverberation, underpinning the truth of the Christian Story. Downs is unique in this recurrent theological quest to draw out commonalities that hint at transcendent unity between all men and their various systems, to 'make him whole lot one family' (Downs).

Duncan Kentish

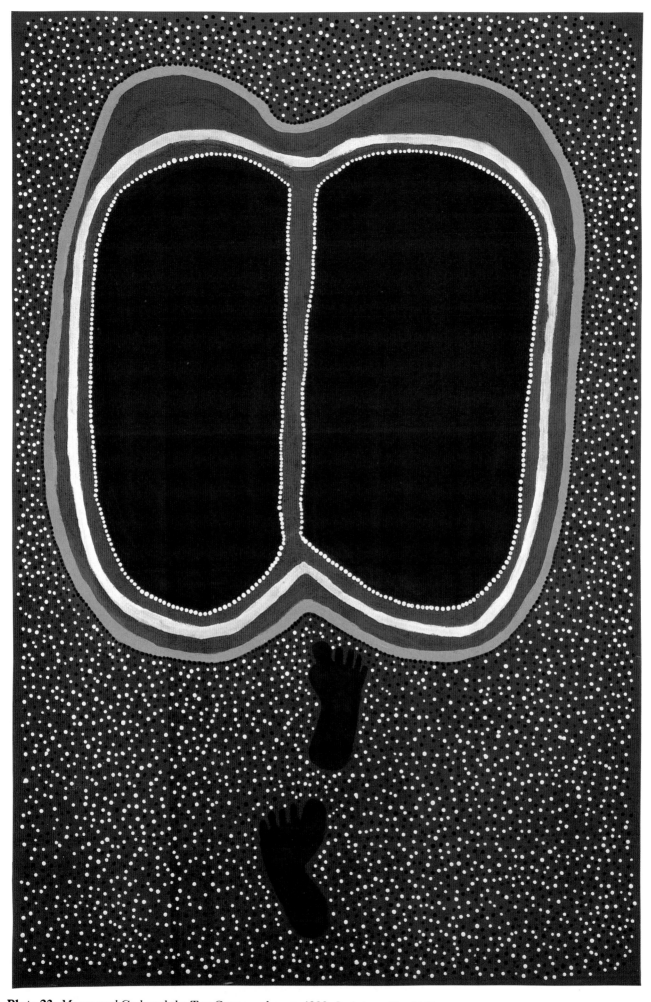

Plate 23 *Moses and God and the Ten Commandments* 1989, Jarinjanu David Downs

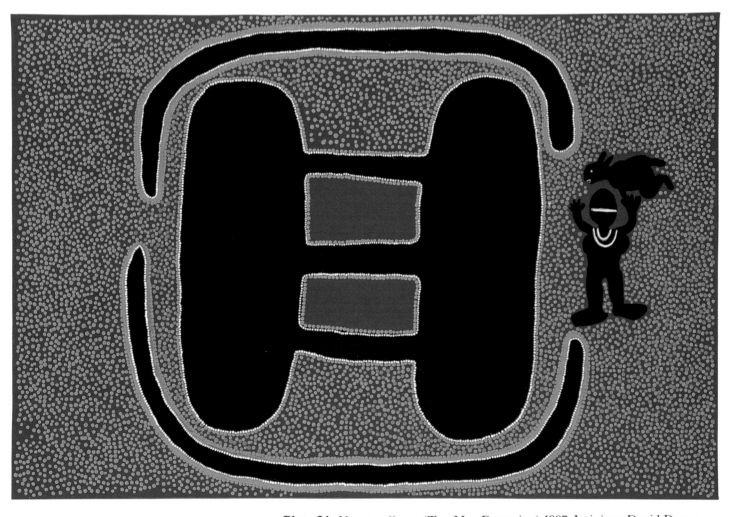

Plate 24 *Nganpayijarra* (Two Man Dreaming) 1987, Jarinjanu David Downs

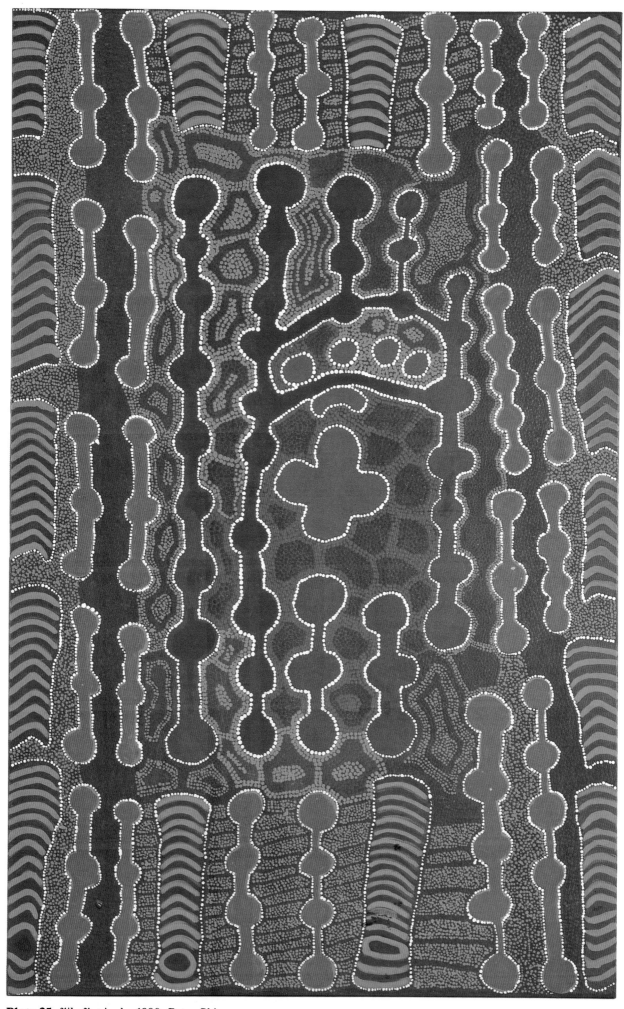

Plate 25 *Jila Japingka* 1990, Peter Skipper

BALGO

Balgo art comes from the three Aboriginal communities of Balgo, Mulan and Billiluna. These lie on the north-eastern fringe of the Great Sandy Desert in Western Australia, where the sweeping spinifex-covered sandy plains of the desert merge gradually into the more rugged Kimberley terrain with its seasonal river systems. The people living here have come from all directions: the Warlpiri people from the Tanami Desert to the east; the Kukatja from the south towards the Gibson Desert; the Walmatjari, who live in lands that surround the Canning Stock Route, from the west; and the Tjaru from the northern country now covered by pastoral stations. Today these people continue to live in groupings based on their traditional heritage, although more regular and permanent intergroup contact has led to some of the older distinctions breaking down.

Balgo was the first community to be established, when some German Catholic priests went out into the desert in the 1930s, with the aim of establishing a buffer community for nomadic peoples drifting northwards. The latter were attracted by stories of permanent food and water supplies and of the goods the white men had to offer. Clashes occurred as Aborigines speared cattle and white men fenced off waterholes. Balgo offered an alternative. Over the years, the Aboriginal people lived side by side with mission staff, developing gardens, farming animals, building a school and caring for the sick.

Affairs changed in the 1970s. A cattle station was bought and handed back to the Aboriginal people. From this, the two communities of Mulan and Billiluna were established. Balgo ceased being run as a Catholic mission and gained Aboriginal community control. Catholic Brothers and Sisters remained, concentrating their energies on education. A school already existed at Balgo, and in 1981 an Adult Education Centre was established as well. This venture encouraged art and craft activities and supplied materials to the young men and women who attended. People were aware of painting developments at Papunya, and some of the older men had already begun using any available paints, boards and scraps of canvas to transmit their totemic designs. With the regular supply of materials and the encouragement of non-Aboriginal people from Broome and Perth, a veritable explosion of painting activity began at Balgo. The works were collected and recorded. Many were eventually shown at an exhibition at the Art Gallery of Western Australia in late 1986. Following the success of this, an approach was made to the then Aboriginal Arts Board for funding of an arts coordinator's position, and the artists' cooperative called 'Warlayirti Artists' was established.

More than 150 artists were active in 1990, a little over half being women. People of all ages paint. Importantly, among these are about fifty men and women who are in their mid-fifties and over, and whose formative years were spent in the bush with little contact with white civilisation. For these people, traditional Law is still absolutely central. Their art reflects this heritage; it has an authority and dignity which speak knowledge of the land and its mythological associations, and of enduring traditions.

Kukatja-speaking people make up about half of all the artists, with Walmatjari, Warlpiri and Tjaru each numbering about fifteen per cent of the total. About 500 works, executed with acrylic paints on stretched canvas, are invoiced out each year and are now sold right around Australia as well as overseas. Balgo works are held in the State Galleries of New South Wales, Victoria, Queensland and Western Australia, as well as in the Australian National Gallery in Canberra. Balgo art now holds a major place both in the lives of the three desert communities and in non-Aboriginal Australia's appreciation of desert cultural traditions and the aesthetics of contemporary Aboriginal art.

Diversity, a great strength of Balgo art, derives first from differences within the community of artists. The desert Kukatja people tend more toward the less obviously figurative than do the Kimberley Tjaru people, who are more likely to show animals, hills and people in their paintings. Men's works usually deal with mythological associations with place; women are more likely to show the foods and camp sites that they used. The different cultural environment in which the younger artists—those in their twenties and thirties—have grown up is reflected in works that show more attention to design and execution than do the works of older people. While cultural, gender and age differences contribute significantly to the rich-

ness of Balgo art, equally significant is the constantly evolving character of what has never been a static art form. While its foundations are rooted in timeless traditions, current artistic activity takes place in a highly socialised environment where people continually see each other's work, visit other Aboriginal painting communities and are exposed to new influences via, for example, school, the Church and television. Amid this continuing exchange of ideas and insights, Balgo art evolves responsively, reflecting the rapid pace of change.

The Balgo works included here demonstrate both the power of tradition and the search for fresh expression. *Wilkinpa*, by Tjumpo Tjapanangka (Plate 26), tells of men's Law as it is in the desert, and is linked to the important Tingarri ceremonial cycle which is secret/sacred and not to be shared with the non-initiated. The work is personally charged for the artist: he and his family members were born (and/or died) there; it offers a panoramic view of the country and its many ephemeral claypans, each area associated with songs, dances and sacred designs that the artist and other men of his generation know by heart.

Bridget Mudjidell's *Kunakulu* (Plate 27) is similar to Tjapanangka's work in its reference to the artist's personal ancestry, its bird's eye view of an area and its related ritual ceremonies. It shows, too, many wild foods the women collect and the campsites that they and their families use – things of natural concern to women. While women's Law is as important and strong to women as men's Law is to men, it tends to be less secret. In some of their Law ceremonies, women are now using paintings such as *Kunakulu* to communicate to younger and visiting women something of their country and its Law. They dance and sing to these paintings and refer to them in explaining the significance of their ritual activity.

These two works were done recently under the auspices of the Warlayirti Artists' Group. In contrast, a series of banners were created in the early 1980s for the Catholic church at Balgo. Two of these are represented here. Both were done by men in their early twenties and they show an obvious cross-fertilisation of Aboriginal and Christian imagery. Matthew Gill in particular (*Motherhood*, Plate 30) did a large number of works based on biblical themes and these received considerable attention. He is technically the most proficient of all Balgo artists and the most adventurous in his approach to art. For example, *Motherhood* hangs behind and around a statue of the Virgin Mary inside the Balgo church and incorporates the mother's womb and eggs in its imagery. These are very novel introductions in a still semi-traditional community.

Last Journey of Jesus (Plate 29), by Greg Mosquito and Other Balgo Men, is novel in its cross-hatching and x-ray view of animals, both more typical of the art of Arnhem Land. Nevertheless, the idea of a path's being followed, and of places along this route where special and important things happened, is close to traditional beliefs and fits in easily. Thus the banner exemplifies how these people, with their own very strong cultural traditions, approach the Christian stories and rituals as a way of understanding and dealing with the very different values and behaviours of the non-Aboriginal Australia that surrounds them.

Michael Rae

Plate 26 *Wilkinpa, Artist's Country* 1990, Tjumpo Tjapanangka

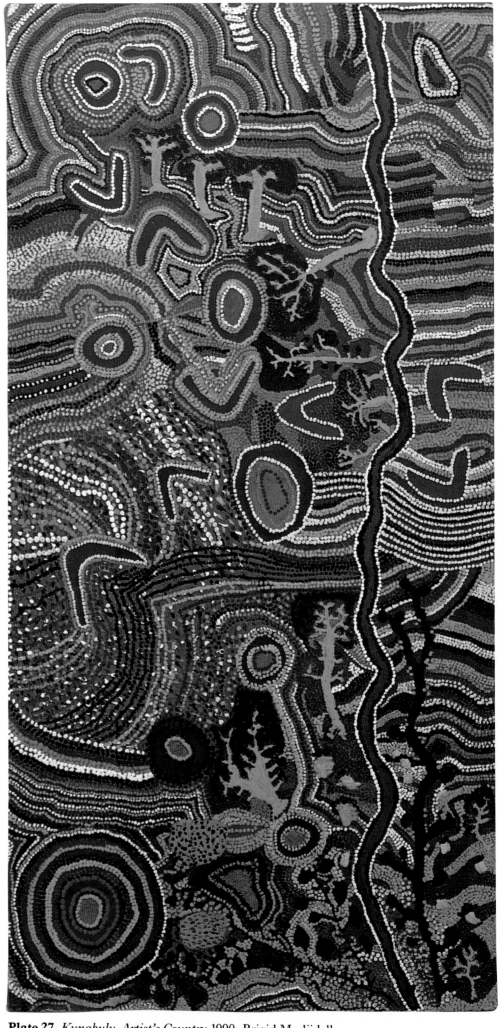

Plate 27 *Kunakulu, Artist's Country* 1990, Brigid Mudjidell

Plate 28 *Tjibari: A Women's Healing Song* 1989, ByeBye Napangarti, Jemma Napanangka, Millie Nampitjinpa, Kunintji Nampitjinpa

Plate 29 *Last Journey of Jesus* 1982, Greg Mosquito and other Balgo men

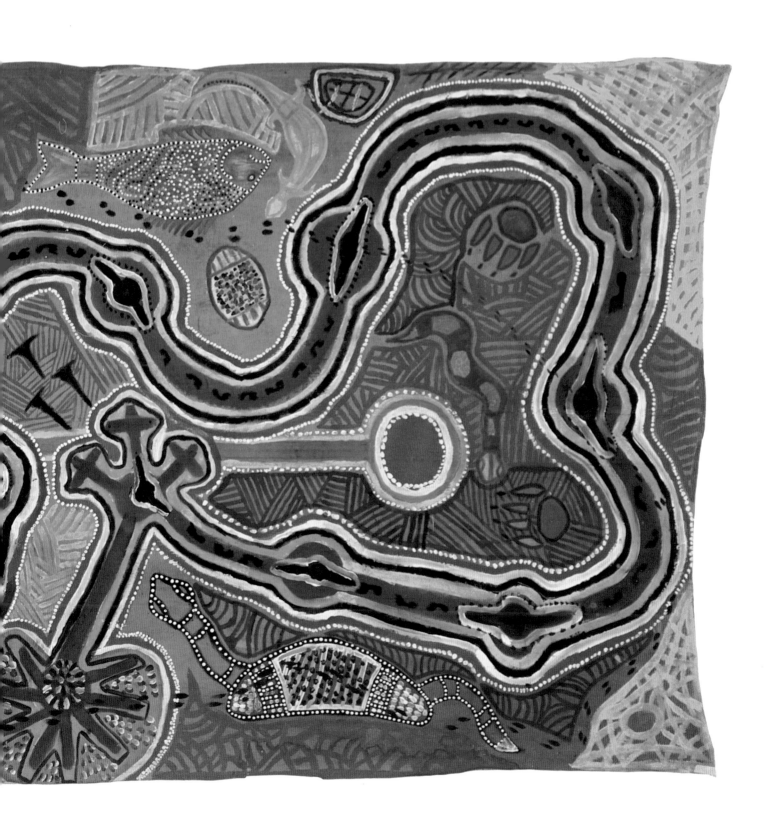

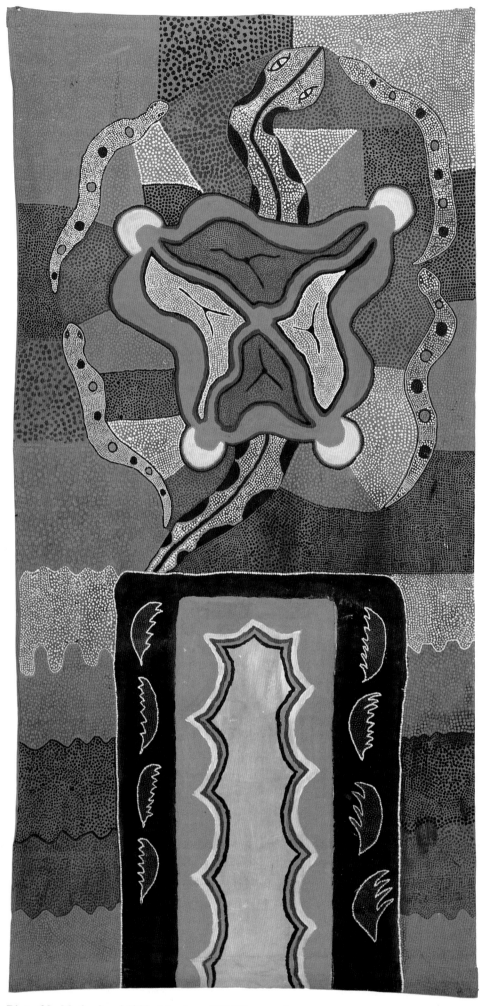

Plate 30 *Motherhood* 1982, Matthew Gill Tjupurrula

LAJAMANU

The Lajamanu Aboriginal community (originally named Hooker Creek) is situated on the edge of the Tanami Desert, midway between Alice Springs and Darwin in the traditional country of the Gurindji people.

The settlement was established in 1949 by the Native Affairs Branch of the Federal Government, when twenty-five Warlpiri people were trucked there from Yuendumu. In 1951 a further 150 Warlpiri were added. Unable to live away from their Dreaming sites, the people all walked back to Yuendumu, a distance of some 400 kilometres. There were two further resettlements and Aboriginal walkbacks to Yuendumu (1958 and 1968), before the Warlpiri residents were prepared to accept the new community at Hooker Creek.

In about 1974, Abie Jangala (Plate 31), boss of the Water-Rain-Clouds-and-Thunder-Dreaming, said in interview:

When I look at my people now and think how it was when I was a boy, I can see many changes. We are wearing clothes now, we buy food in the shop, drive cars, and when we go hunting we use rifles instead of spears and boomerangs. But all that is not important. Our own law and our own ceremonies are still important to us, and if I go to dance my corroborees I leave my clothes, car and rifle behind and go to the ceremonies as my forefathers have done for thousands of years. (Northern Territory Department of Education, 1985:12)

Like other Central Desert acrylic painting, Lajamanu art was once confined to ceremonial and ritual objects and designs, and for longer than other groups the seniors at Lajamanu resisted the call to sell their works and to translate the sacred stories into paintings on canvas. As recently as 1982, Maurice Jupurrula Luther stated:

We will never put this kind of painting onto canvas or onto art board or onto any permanent medium. The permanence of these designs is in our minds. We do not need museums or books to remind us of our traditions. We are forever renewing and recreating these traditions in our ceremonies. We are not and do not ever want to become professional painters. (Musée d'Art Moderne, 1983:49)

In 1985 the position changed. The Lajamanu elders decided that, properly used, painting could be a potent means of holding on to their sacred custody of the land, of maintaining their strong cultural identity and of enabling others to realise their worth. Their decision to translate their ritual designs to canvases for sale was thus a conscious political act.

Both men and women came to the first painting sessions in March–April 1986. The men, elders such as Abie Jangala, Joe Japanangka James and Peter Blacksmith Japanangka, began to record the Dreamings over which they had custody and to confirm their charters to particular tracts of land. Their works sing with the strong simple rhythms of the wholeness of life, the interrelatedness of sacred and secular, and of plant and animal.

The Warlpiri women, such as Lily Hargraves Nungarrayi (Plate 32), Peggy Napaljarri Rockman, Topsy Nampijimpa Robertson and Llona Napurrurla (Plate 33), painted equally strong and vibrant pictures of their own ancestral designs and rituals. These works signalled that Warlpiri women manage their own affairs and secret ceremonies and that their rituals enshrine their role as nurturers of people, land and relationships. To 'read' the work of these women simply in terms of their role as gatherers of bush tucker is to misunderstand the social structure of the Warlpiri.

The best Lajamanu canvases have the feeling of a people *painting up big for ceremony* with a minimum of fussiness. Instead of pipeclay, charcoal, red and yellow ochre, we confront pink, purple, sometimes green: cartoon colours of a changed environment, but the expression of an abiding belief system.

Judith Ryan

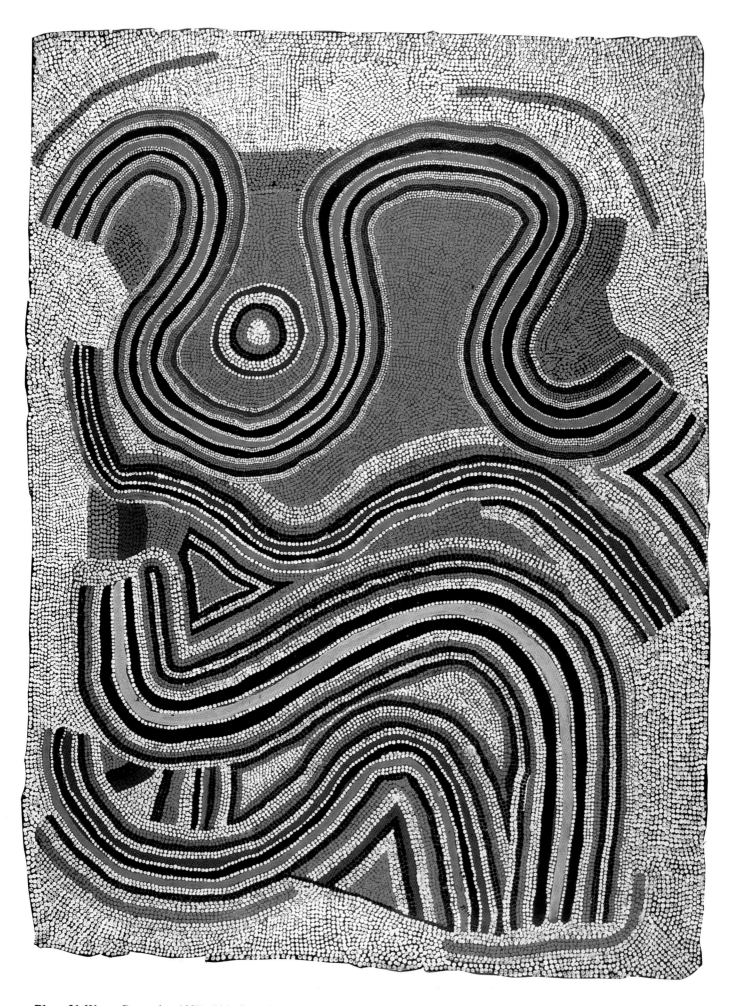

Plate 31 *Water Dreaming* 1987, Abie Jangala

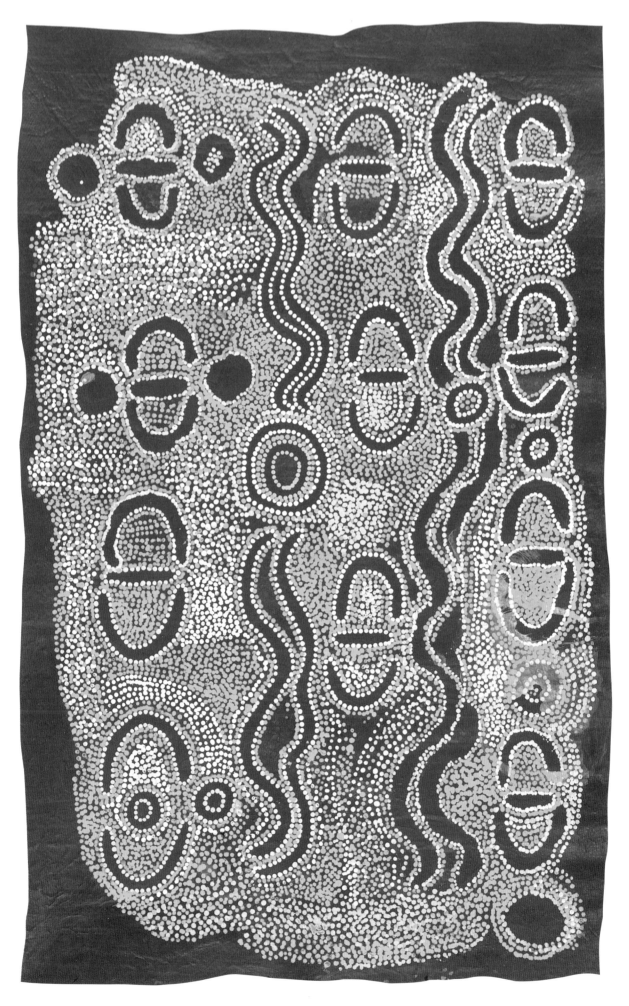

Plate 32 *Bush Tucker* 1987, Lily Hargraves Nungarrayi

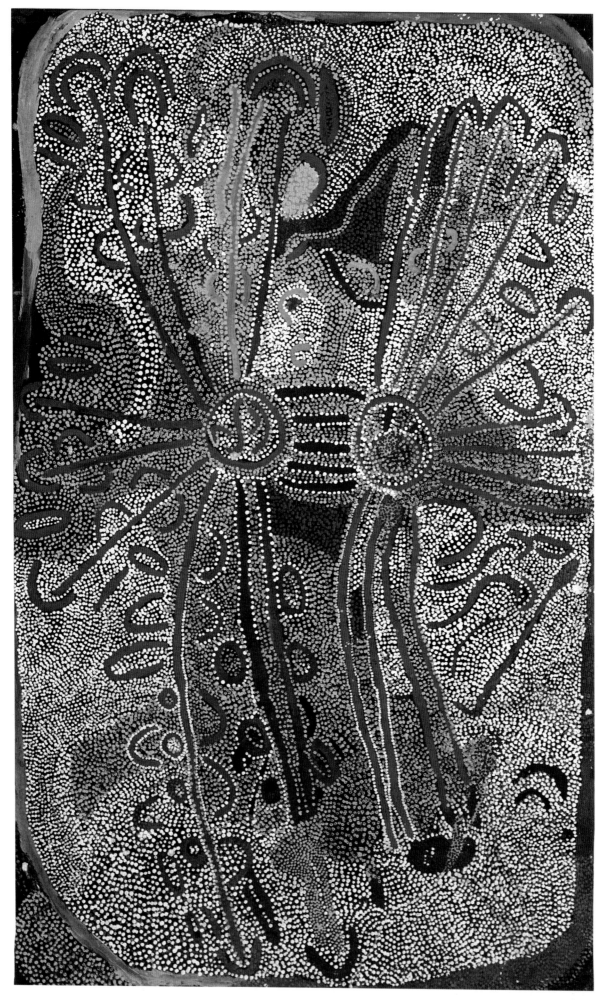

Plate 33 *Bush Tucker Dreaming* 1989, Llona Napurrurla

YUENDUMU

Having had an association with Yuendumu since 1986, and aware of the major challenge of describing the artists and evoking some sense of place, I can offer only a personal response to Yuendumu art. My experience has been of encounter with a culture at once confusing and invigorating, with beliefs and values alien to much that I have unknowingly absorbed from my own culture over the years. My being employed to act as an advocate for the contemporary art of the Warlpiri people of Yuendumu, and to be a go-between for that culture and the rest of the world, has brought me face to face with important cultural and political issues.

Some of the forces acting upon life in Yuendumu today are outcomes of historical phenomena, such as colonisation. Significant issues include displacement, cultural imperialism, ill health and the introduction of non-Aboriginal religions.

A superficial look at Yuendumu reveals very little except the enormity of the gulf between Aboriginal and non-Aboriginal cultures in Australia. Yuendumu is by no means remote. It is a short, half-dirt 300 kilometre dash up the Tanami Road north-west of Alice Springs. Compared to many other Aboriginal communities, Yuendumu is positively suburban, with its sealed roads and random patches of new kerbing, its telephones and fairly regular power supply. The whitefellas live within fenced yards with lovingly cultivated lawns and even the shabby besser-brick houses that are a remnant of an earlier whitefella housing policy are in orderly rows. Yuendumu even has its own housing association now, which constructs new housing for Aboriginal people.

Despite this, Yuendumu is not a pretty place. There is rubbish everywhere; there are vandalised houses, mangy dogs, and seeming abandonment and disrepair. Yet beautiful works of art are produced on the ground in the dirt here; and the 'big name' artists have no apparent material assets or trappings of success.

Aboriginal cultures do not yield up their meanings simply or easily. Theirs is knowledge and understanding to which we can only gain access over time, if at all. Insight into Aboriginality and Aboriginal concepts seems to involve being in and among people, absorbing information rather than seeking to study it. Behind the barren appearance of Yuendumu one finds, then, a vibrant, complex culture, and a sturdy sense of community and belonging.

The Yuendumu artists whose paintings are shown here are all elderly men, born in the bush in the days before the establishment of Yuendumu as a Baptist mission. Many of the artists are active Baptists. The old men have all been involved in Warlukurlangu Artists, a group which buys and prepares materials for artists and then arranges the sale of finished works. This task includes recording the 'Dreaming' story for each painting.

To each artist, his painting is more than an individual act of self-expression. In painting their Dreaming stories, the artists re-emphasise their commitment to the areas of country for which they are responsible. In English we have no words to translate accurately the Warlpiri words used to express relationship to the land and Dreaming. The closest approximation, perhaps, is that a Warlpiri belongs to/originates from/has a religious relationship with, his or her country. Ownership, the right of exclusive access, has no meaning for them.

Every painting by the Yuendumu artists has some story. The works by Warlpiri artists are an expression of the life force and spirituality of their culture. While the artists are willing to explain the public meanings of their paintings to anyone who is genuinely interested, what they communicate depends on a range of factors: what is public, the level of interest, the enquirer's relationship with the artist, the perceived maturity of the questioner. There are many levels of meaning in any painting, and a given story is rarely if ever definitive.

Slowly, misconceptions in mainstream Australia and overseas about Aboriginal cultures are being eroded. One of the ways this is being achieved in recent years is through contemporary Aboriginal art. The artists of Yuendumu, especially the old men represented here, have made an important contribution. May respect and appreciation for their art and culture continue to grow.

Felicity Wright

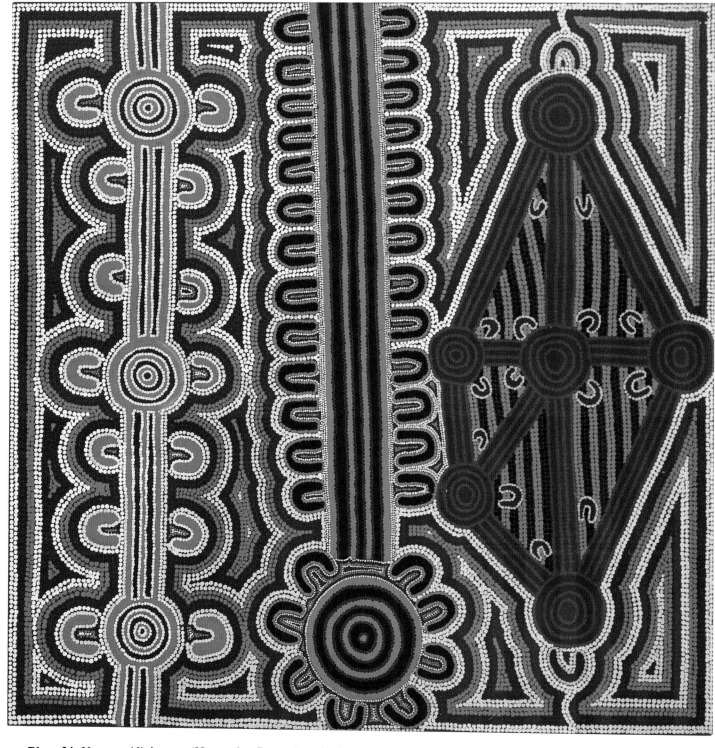

Plate 34 *Yurrampi Jukurrpa* (Honey Ant Dreaming) 1989, Michael Japangardi Poulson

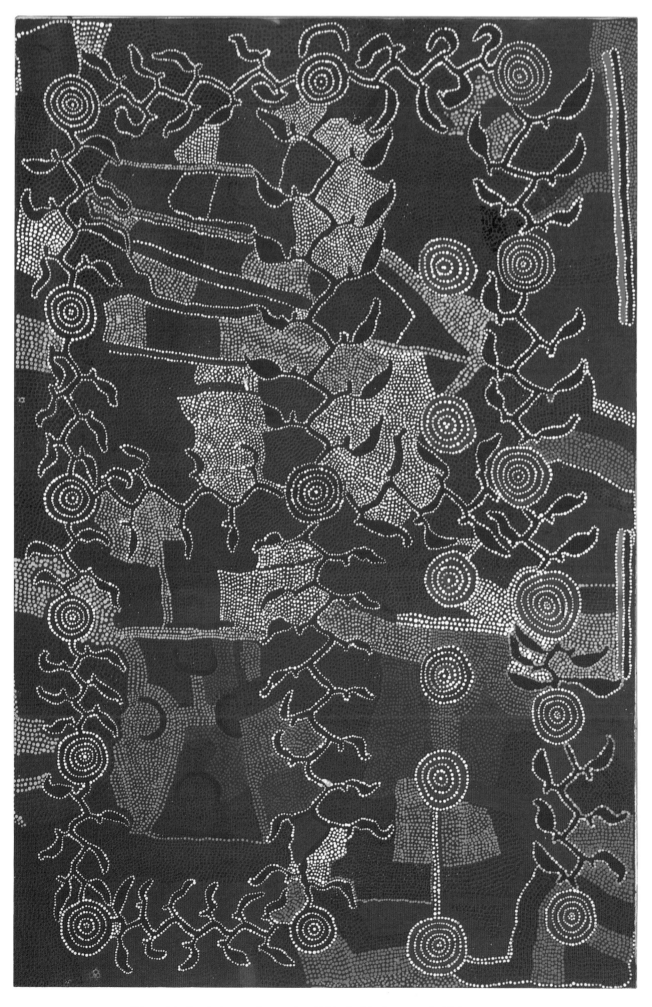

Plate 35 *Bush Potato Dreaming* 1988, Paddy Jupurrurla Nelson and Paddy Japaljarri Stewart

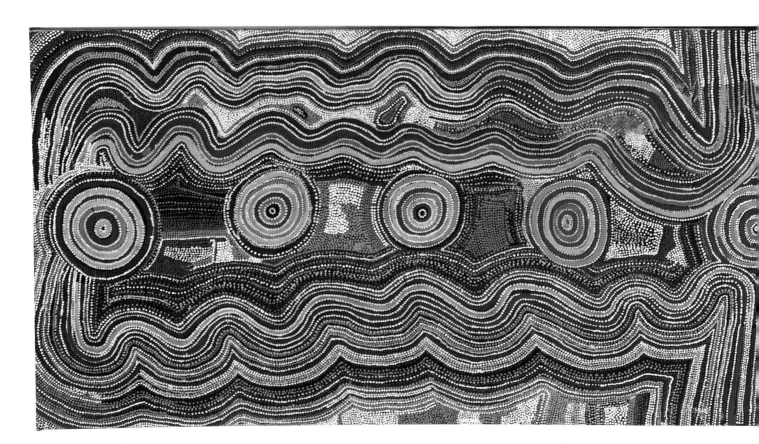

Plate 36 *Rain/Water Dreaming* 1989, Darby Jampijinpa Ross

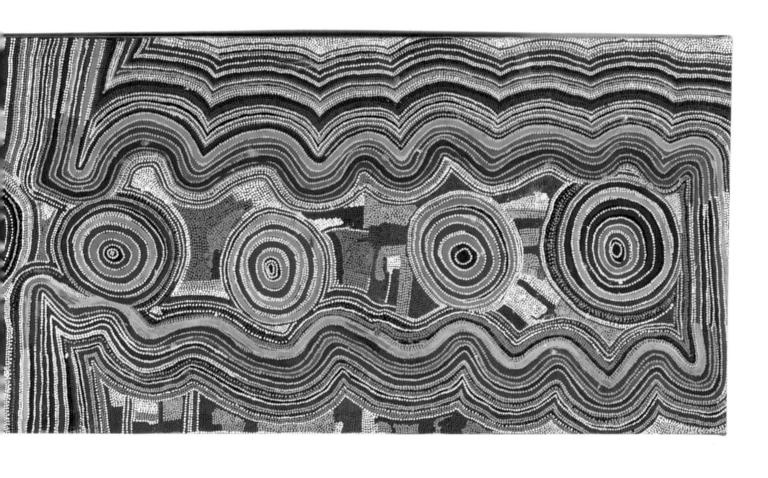

BLACKSTONE RIDGE

Situated between the Gibson Desert to the north-west and the Great Victorian Desert to the south, Blackstone Ridge is one of several communities in the Western Desert, Ngaanyatjarra Lands, that grew out of the Warburton Mission to the west and the moving of the people from the Woomera Rocket Range to the south-east.

These very diverse communities of people have no immediately apparent homogeneous art style or production, except small carvings and the Hermannsburg style of European-derived landscape painting.

The three paintings included here may be among the first produced in Blackstone Ridge in response to an initiative by the principal of the school to encourage the adult men and women to paint as a potential source of income.

On my visit there as an art consultant, I introduced large canvases, bulk acrylics and other materials – oil paints, coloured inks, and so on. I remember laying out a large canvas before a group of young women, expecting that they would work on it as a joint project. They began to do this when an older woman, a keeper of the Law, known only to me as 'Mrs Benson,' observed this and stood back, dis-associating herself from the randomness of what was being painted.

After a few hours, she sat down and began painting in a very particular way. The younger women stopped and watched. For two days she worked, colour against colour, shape against shape, until the whole canvas vibrated with colour. All the Aboriginal women understood the story and recognised the transfer of women's ritual body painting.

Blackstone Ridge proved to me that Aboriginal people are deeply visual, with an instinctual feeling for shape and colour. They share mythologies and recognise and understand which of these reveal place and story. The lower levels of these paintings were never disclosed to me as an outsider, European and male. I could not expect them to be. But some of the imagery was already familiar – the circles of the water-holes and soaks, the way lines of the tracks (*song lines*, as Bruce Chatwin has written) crisscross the continent. Familiar, too, was the ease and facility of the painting.

Blackstone Ridge painting is just beginning. The works of Kebbe Nelson (Plates 37 and 38) and of Whisky Lewis (Plate 39) are among the first to come out of this community. The future of these artists and the creative vitality of the group will depend in large part on the coherence of the traditional people themselves and on their need to reveal in this way their different myths and ceremonies. To do this, they will also need materials, as well as a degree of management by persons with these skills who also have an appreciation and some understanding of traditional Aboriginal ways.

Roy Churcher

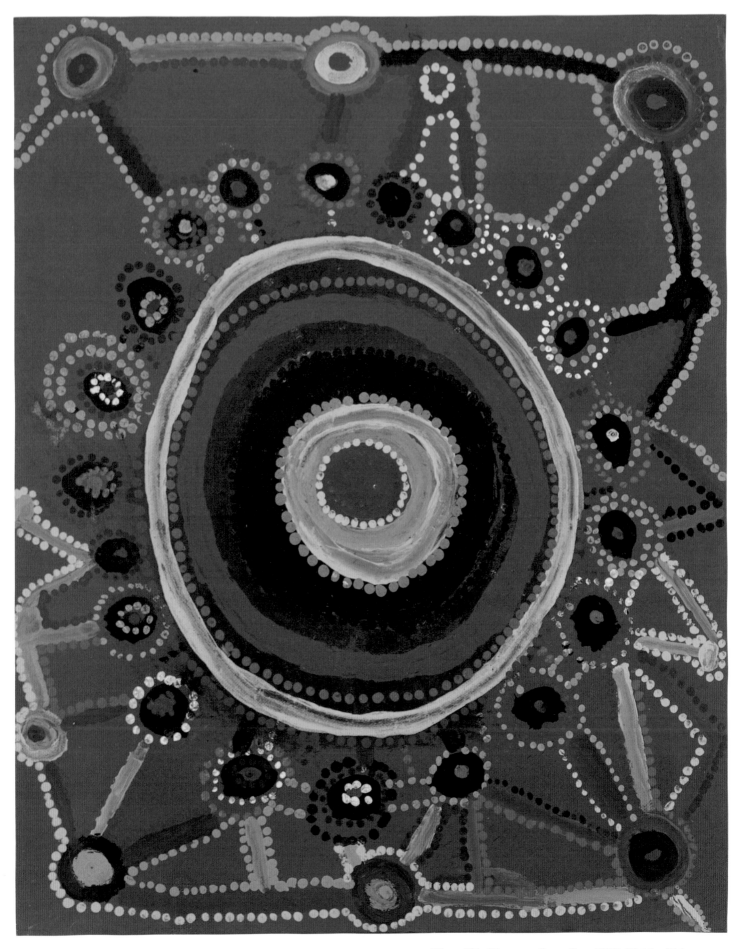

Plate 37 *Bigwater Campfires* 1990, Kebbe Nelson

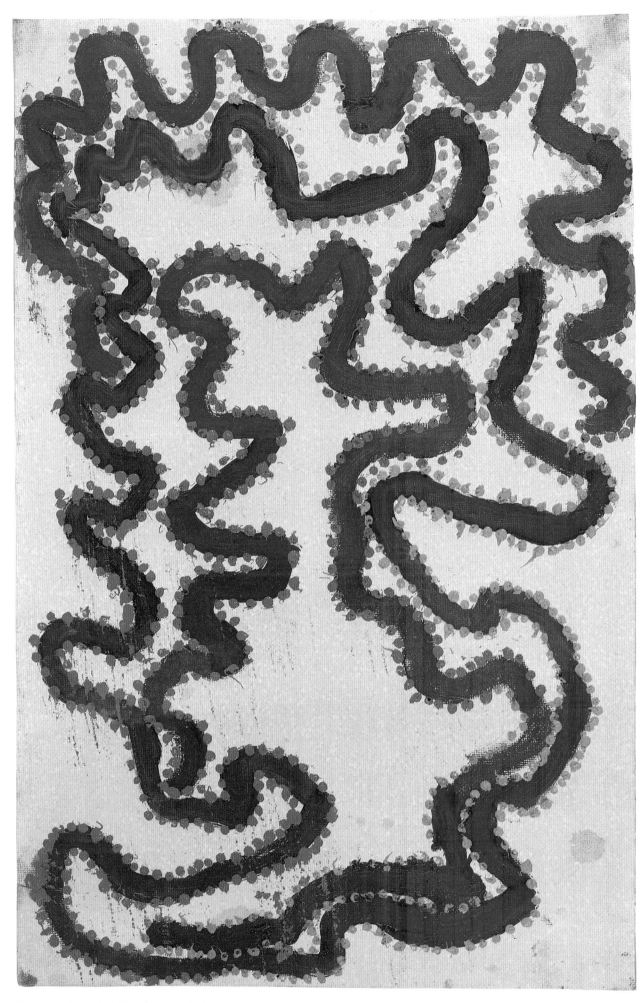

Plate 38 *Untitled* 1989, Kebbe Nelson

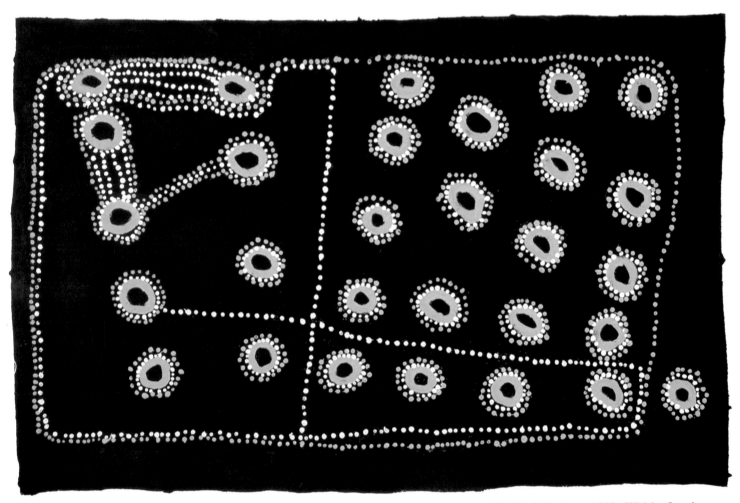

Plate 39 *Wati Kutjarra* 1990, Whisky Lewis

UTOPIA

I had first seen the art from Utopia on the white walls of the Australian National Gallery, a long way from where I now sat. I was now actually in Utopia, three hundred kilometres from Alice Springs, sitting on a piece of tarpaulin, surrounded by shy, smiling women and children. In the background, on the deep red earth, were a few tin houses and some bough shelters. One of these sheds was the artists' house and held their batik equipment, but there was no sign of the long silk batiks, and they were what we had come to see. Slowly, from cupped hands, a rectangle of silk emerged, and grew to reveal a fantastic image. It fluttered in the breeze, lit by the afternoon sun. This was Utopia.

Utopia silks date back to 1977, but the symbols, stories and myths they portray go back many thousands of years. It was also in 1977 that these Anmatyerre and Alyawarre people began moving back to their traditional land (Utopia Station) which they reclaimed as owners in 1979, under the Aboriginal Land Rights (Northern Territory) Act. Utopia is less a single settlement than a web of small family groups living on outstations. But the art draws on a common body of knowledge—the sacred sites and the distinctive body painting associated with their religious rites and ceremonies. Stylistically, there is great diversity, from traditional desert art to a naturalism that resembles the Western landscape tradition.

Of great significance in the history of the art of Utopia has been the Aboriginal organisation CAAMA (Central Australian Aboriginal Media Association), members of which have moved around the outstations, supplying materials, encouraging the artists and then successfully marketing the work in key outlets. Because of this the Utopia artists, predominantly women, were able to move to using acrylic on canvas as a new form of expression.

Two of the most powerful Utopia artists of the present time are Lyndsay Bird Mpetyane and Emily Kame Kngwarreye.

Lyndsay Bird Mpetyane's art (Plates 41 and 42) is both bold and strong. His work derives its power from the stories of which he is the custodian. Over the past few years his paintings have extended from very simple designs to these more complex, shimmering surfaces. He has included plant, animal and other objects in his compositions, but it is his constant experimentation with the potential of acrylic paint and his confidence to work on any scale which has allowed him to explore his subject so fully. In his *Old Fella's Dreaming* and *Young Fella's Dreaming*, he links a network of simple forms to make a complex and potent statement about the traditional, spiritual relationship between the young and the old in his society.

Emily Kame Kngwarreye is a diminutive, vital woman in her eighties. She began working in acrylics on canvas only in the last couple of years, yet her work is highly sought both in Australia and overseas. When I first saw her work in 1987, I was excited by its power and diversity. It appealed, I think, to my Western aesthetic sense and brought to mind the paintings of Ralph Balson and some abstract expressionists. Yet she was a traditional desert woman, many worlds away from them. Her works, she says, are about *everything*; they are about all that is important to her—emu, sacred grass, seeds. Her Anmatyerre Dreamings (Plate 40) are five panels created from the ancestral myths of her Alhalkere country.

The appreciation of their work in the contemporary Western art world has been a source of great pride for the artists of Utopia, and the whole community has benefited from their success.

Christopher Hodges

Plate 40 *Alhalkere Dreamings* 1990, Emily Kame Kngwarreye

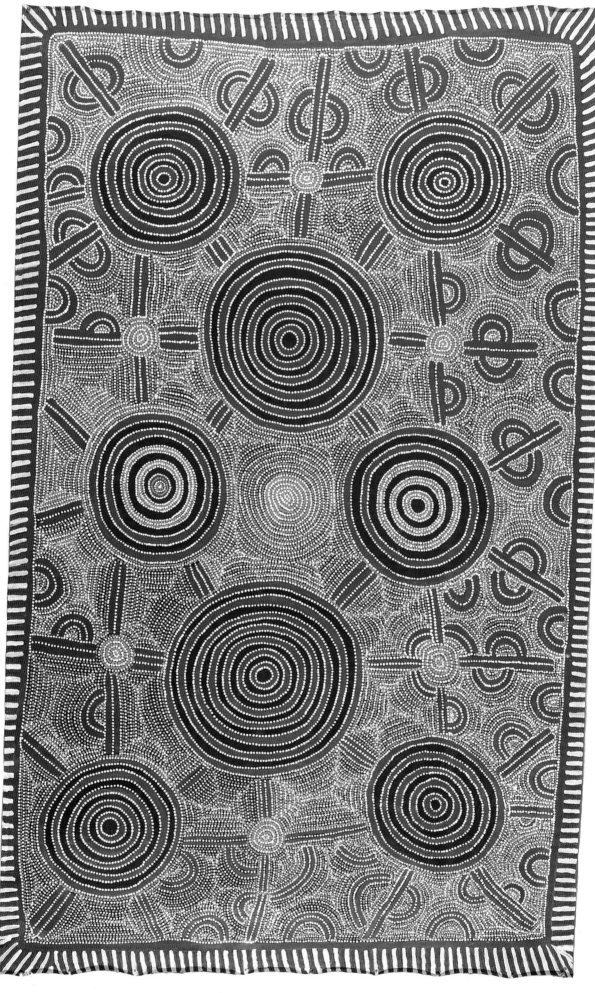

Plate 41 *Initiation–Old Fella's Dreaming* 1989, Lindsay Bird Mpetyane

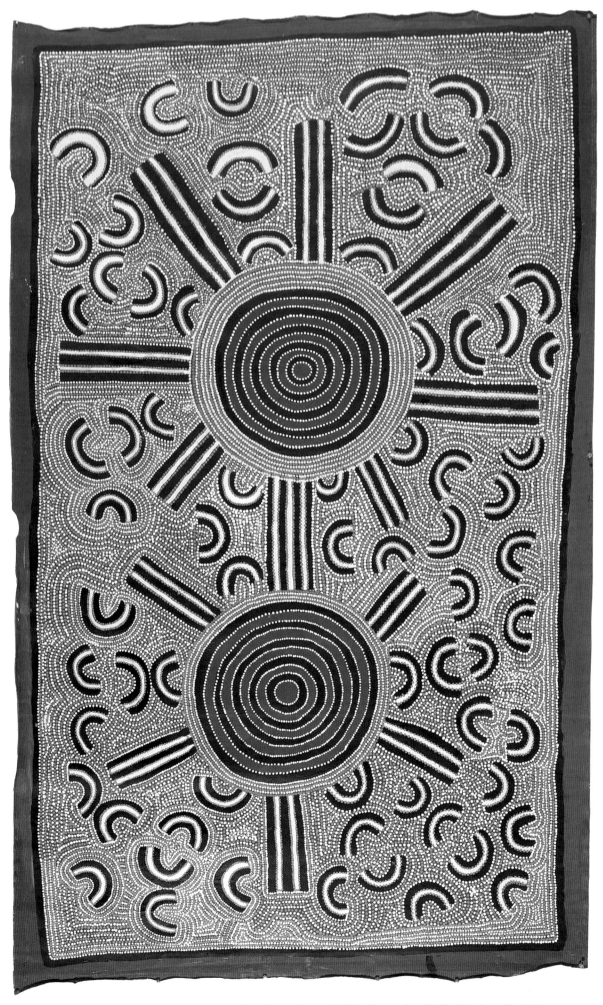

Plate 42 *Initiation – Young Fella's Dreaming* 1989, Lindsay Bird Mpetyane

PAPUNYA

The Papunya art movement had its uneasy genesis in 1971 (Bardon, 1979). It was born out of the misery of a deeply spiritual people who had been ruthlessly torn from their tribal lands in the Central Australian Desert in the 1960s and taken to Papunya, a government settlement 260 kilometres north west of Alice Springs. Papunya was established by the Australian government in 1959 in an attempt to facilitate the assimilation of tribal Aborigines into an Australian lifestyle. The Pintupi, Warlpiri, Luritja, Aranda and Anmatyerre people were encouraged to leave their tribal lands and sacred sites, to abandon their hunter-gatherer lifestyle, and to live at Papunya. The brusque interruption to their tribal ways had a deeply alienating and profoundly disturbing effect.

In 1971 a number of people at the settlement became involved in a project in which mythological events and beliefs were transposed to hardboard and masonite, using poster paint. The artists found their inspiration and subject matter in the ceremonial ground, body and rock paintings that form an integral part of Aboriginal ritual and Law. This means of cultural expression and reaffirmation offered the desert people a way of extricating themselves from the downward spiral of spiritual despair into which they were inexorably drawn. In the following years the artists advanced to using canvas and acrylic paint, and became increasingly adept at painting on the larger surfaces that approximate more closely the dimensions of ceremonial ground paintings.

My own close association with these artists dates back to 1982, when I began exhibiting their work on a regular basis. From the beginning I found that I was constantly drawn to the powerful and cohesive Pintupi paintings, which communicate a strong sense of cultural integrity and appear anchored by a profound religious core. It was only after becoming exposed to the art movement that I realised that the paintings to which I was attracted were painted by men who held vitally important tribal positions and were instrumental in the instruction of young Aboriginal men. These are powerful and heroic paintings, charged with authority and religious knowledge. They spring from the world's oldest continuous culture, whose very essence is one of deep religious commitment and obligation. The Pintupi are renowned for their strict adherence to, and practice of, religious Law, and it is this intrinsic spirituality which gives their work its philosophical purity, power and eternal truth.

Ronnie Tjampitjinpa (Plate 57) commenced painting in the early days of the Papunya Tula art movement and has gradually developed into a powerful Pintupi artist in the classic mould. His dotting technique is rich and sensuous and, unlike the majority of desert artists, he closely joins the dots. The consequent ebullient build up of paint creates a feeling of pulsating spiritual vigour. His paintings have a heroic quality that recalls the powerful works of the Pintupi elder, Uta Uta Tjangala.

Warlpiri artist Pansy Napangati (Plate 59) is remarkable both for her use of colour and for the striking vitality and explorative diversity of her work. Blues, greens and pinks jostle intriguingly, creating a nervous energy that excites the eye. She is an artist who constantly surprises and experiments, her close contact with European Australians freeing her to search for new rhythms and frontiers, but always within the confines of Aboriginal traditions.

Papunya art stands alone, having no direct link to any other art movement or school. Its similarity to Op art and Minimalism is intriguing but purely coincidental. Yet Aboriginal art is increasingly viewed in the context of contemporary abstract art, and is proving to be highly competitive on that level. It is an art movement that truly belongs to the twentieth century but, to appreciate its full richness—contemporary in aspect but so essentially Aboriginal in inspiration—it is imperative that it be viewed, judged and enjoyed not only on its colour, composition, balance and form but (more importantly) on the degree to which full mythological detail has been adhered to in its execution.

The brilliant phenomenon of the Papunya Tula art movement is a triumphal cultural statement by the once near defeated people of the Central Australian Desert. It symbolises the resilience and creativity of Aboriginal culture and is living testimony to its strength, vitality and continuity.

Gabrielle Pizzi

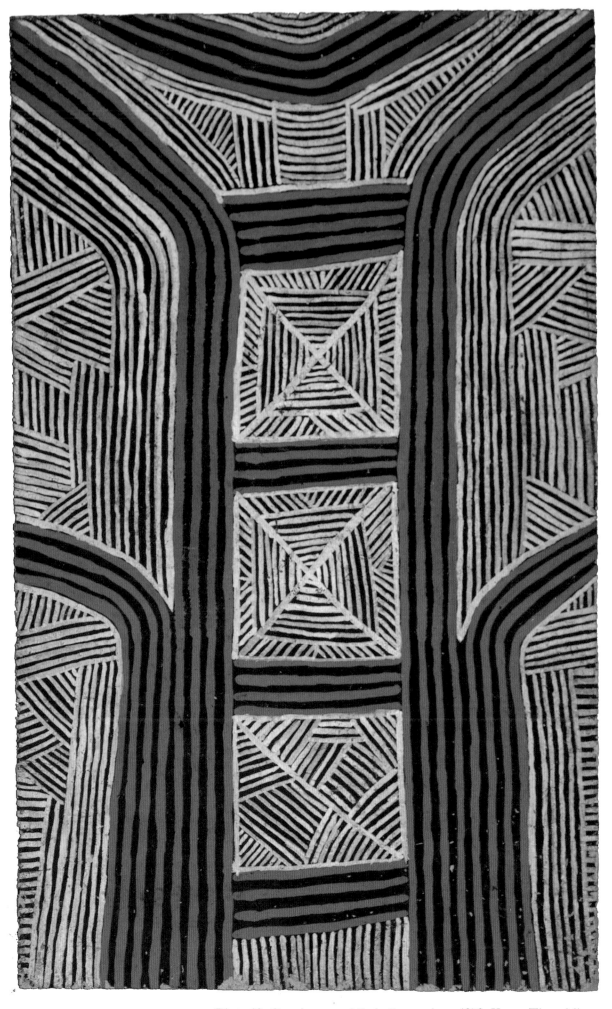

Plate 43 *Corroboree and Body Decoration c.* 1972, Kaapa Tjampitjinpa

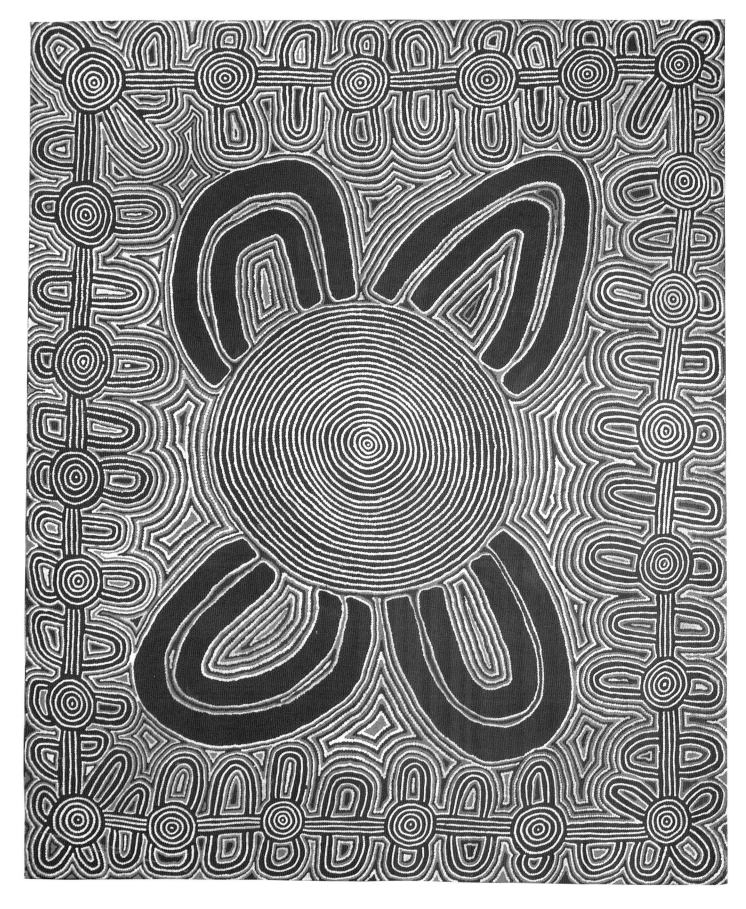

Plate 44 *Tingari Dreaming* 1986, Tommy Lowry Tjapaltjarri

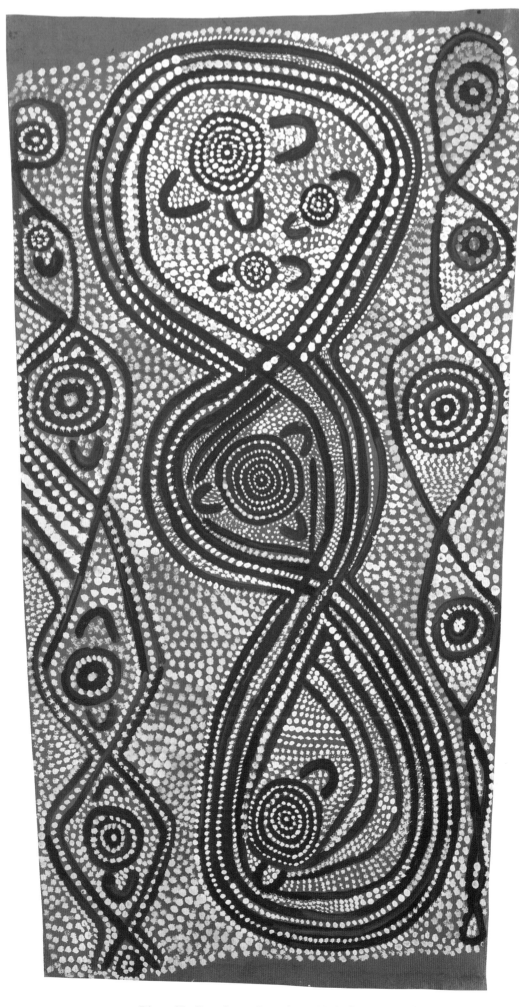

Plate 45 *Corroboree Dancing c.* 1972, Charlie Egalie Tjapaltjarri

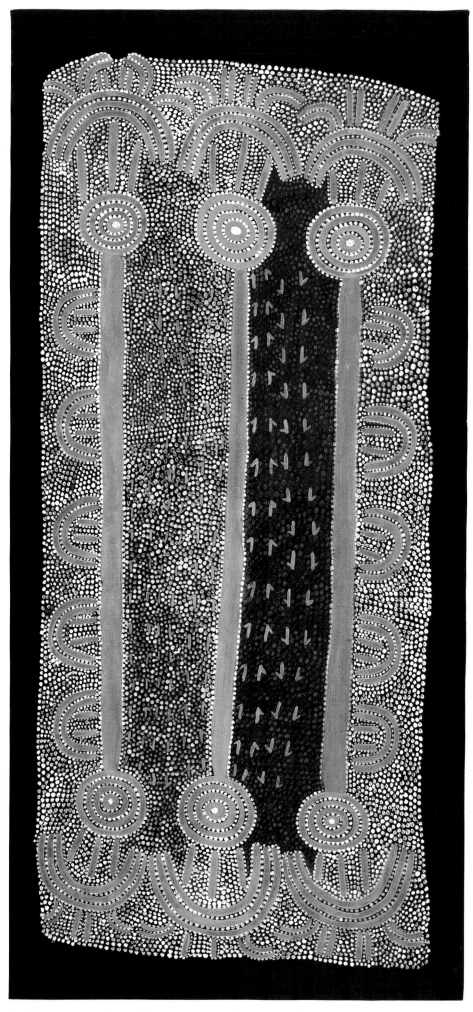

Plate 46 *Untitled c.* 1977, Dinny Nolan Tjampitjinpa

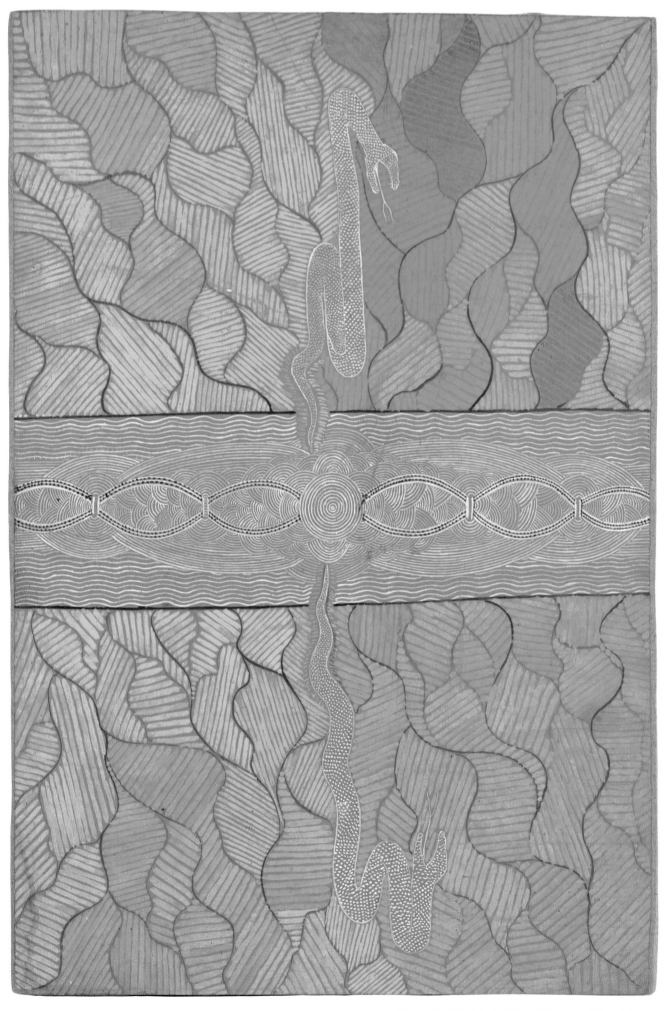

Plate 47 *Untitled* Clifford Possum Tjapaltjarri

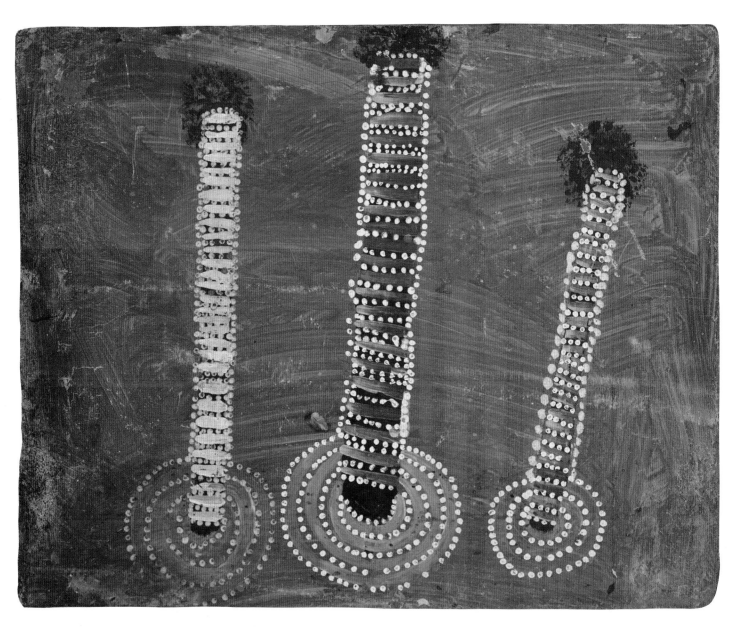

Plate 48 *Three Corroboree Sticks* 1971, Nosepeg Tjupurrula

Plate 49 *Tingari Cycle* 1990, Charlie Tararu Tjungurrayi

Plate 50 *Untitled* 1988, Anatjari Tjakamara

Plate 51 *Artist's Country* 1979, Johnny Warangula Tjupurrula

Plate 52 *Untitled* 1987, Mick Namarari Tjapaltjarri

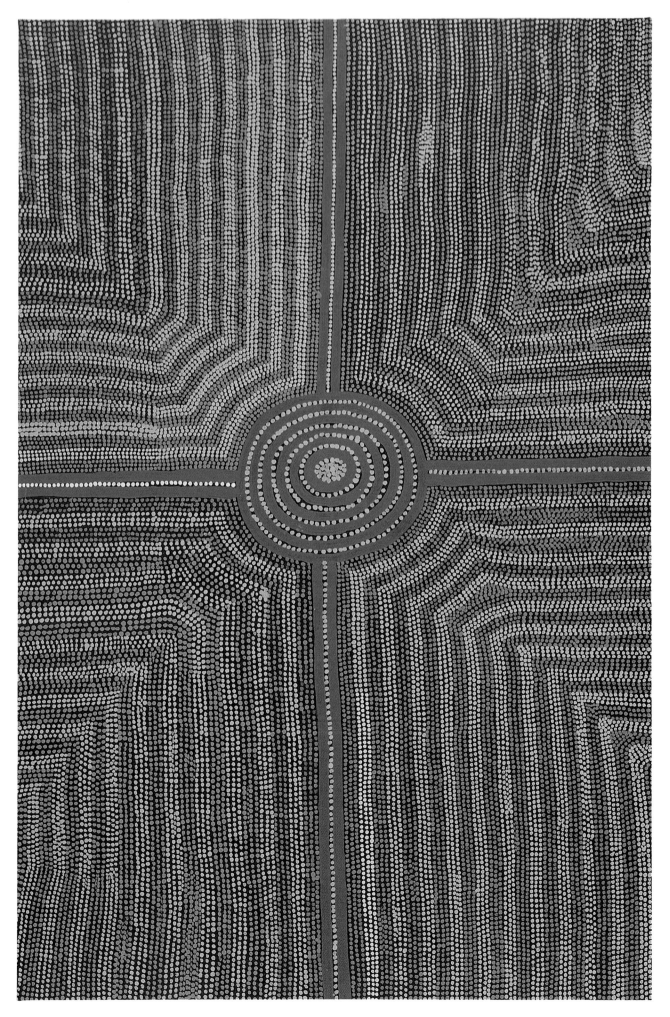

Plate 53 *Untitled* 1987, Mick Namarari Tjapaltjarri

Plate 54 *Flying Ant Dreaming* 1985, Maxi Tjampitjinpa

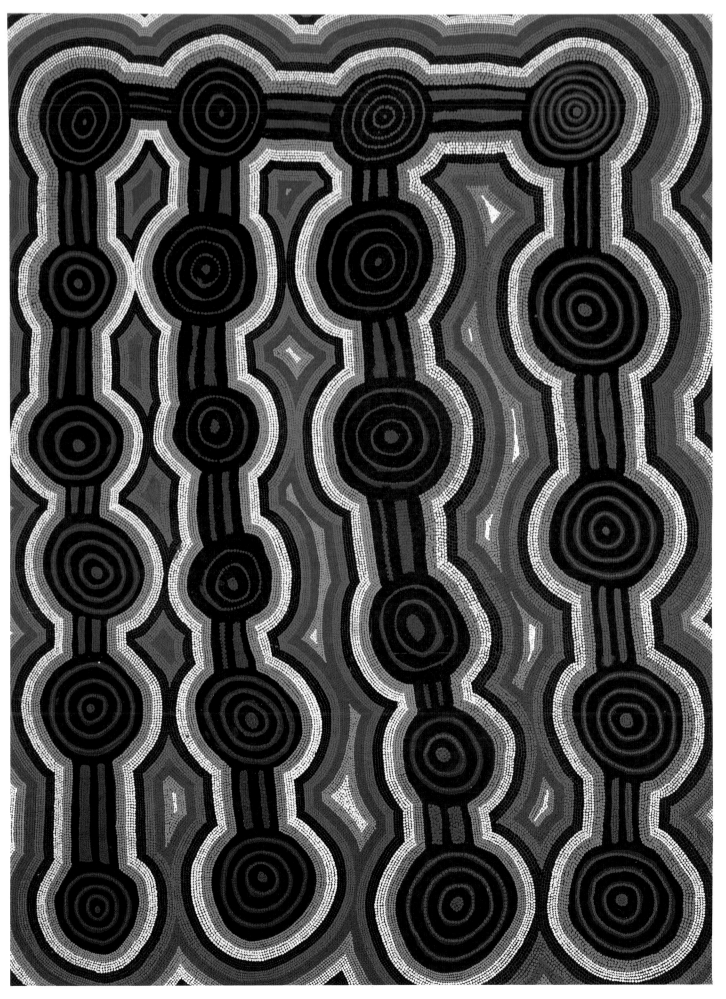

Plate 55 *Untitled* 1988, Uta Uta Tjangala

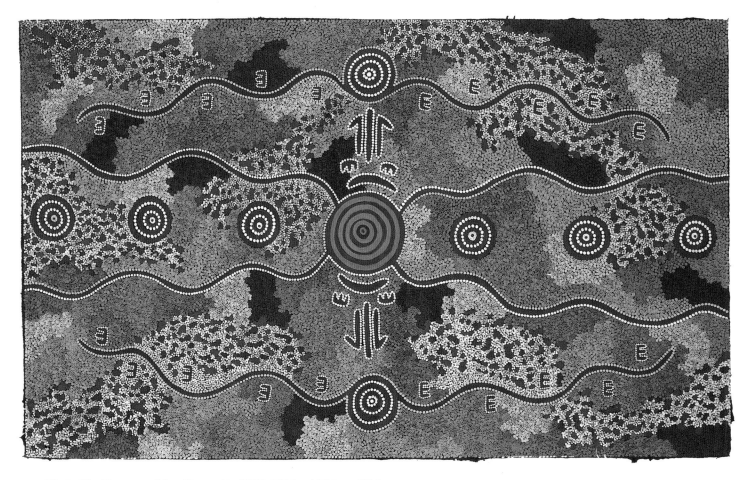

Plate 56 *Kangaroo Men Dreaming* 1988, Michael Nelson Tjakamarra

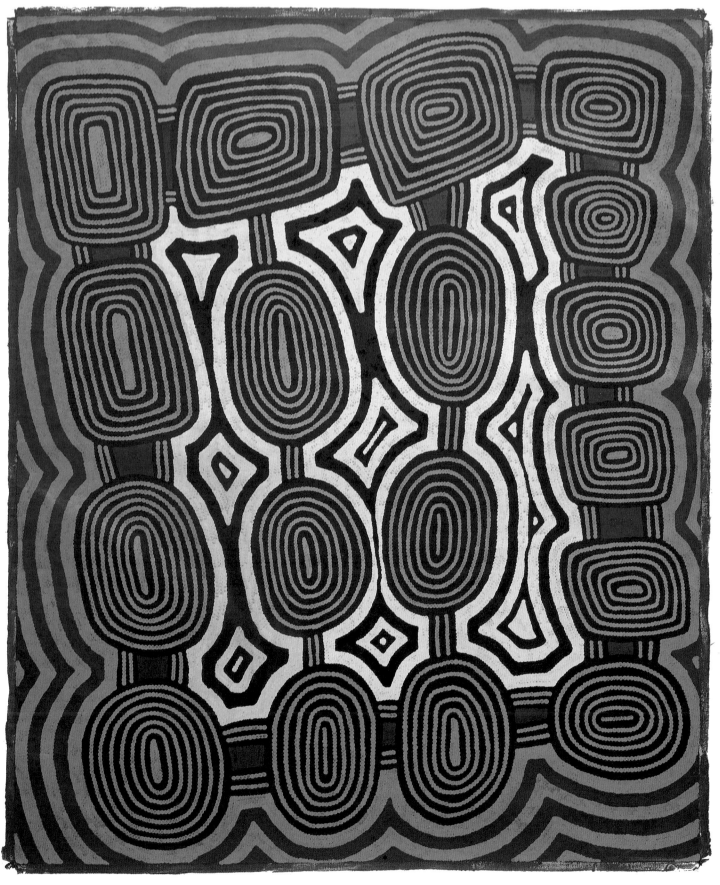

Plate 57 *Water Dreaming at Marpurrinya* 1989, Ronnie Tjampitjinpa

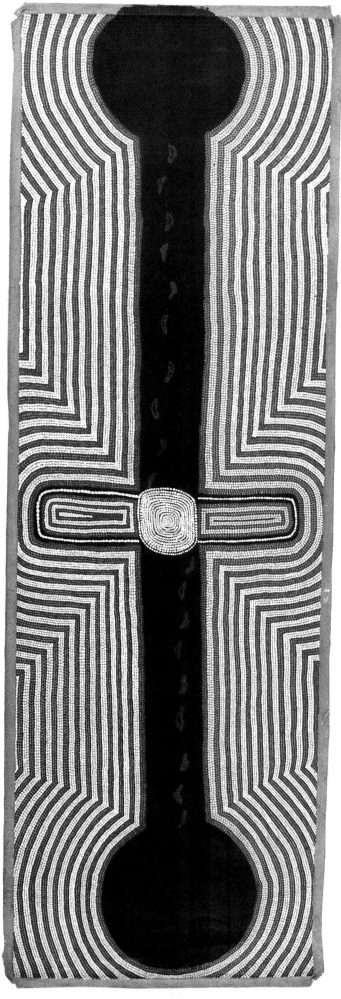

Plate 58 *Women's Dreaming at Patji* 1987, Joseph Jurra Tjapaltjarri

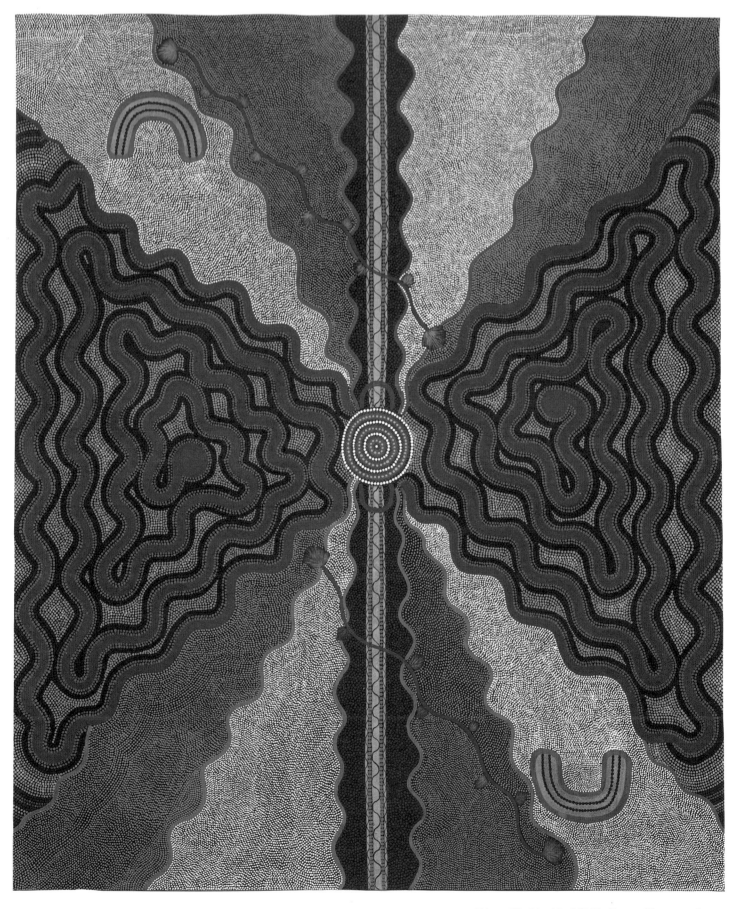

Plate 59 *Untitled* 1989, Pansy Napangati

NGUKURR

The experience of driving through kilometres of burning country on my first visit to Ngukurr was astonishing. The fire was deliberate. It was the season for that Aboriginal land management practice which ensures regeneration. A surreal experience, this, particularly at night and for someone coming from an area where bushfires are viewed with horror. Then, on to the lush area around the Roper Bar, a natural ford, and very beautiful.

Ngukurr, 'a place of many stones', is about thirty kilometres further downriver–a small Aboriginal town. The main street, signposted in Kriol, winds around gentle hills and passes the Council buildings, the old mission house and the faintly Romanesque stone church on top of the hill. The old mission building is still used and is one of those rambling top end houses, very comfortable and used by the Aboriginal minister as his office and a linguistics centre.

Further along, there is an old painting shed, the murals on its side similar to the Ngukurr paintings shown here. Inside the building, the former hospital, tattered first-attempt paintings flap around on the walls (the artists now paint at home or on outstations). Then it is past a very popular and basic basketball court to the Roper River–impressive, tidal and sluggish, the source of barramundi.

There are few white people at Ngukurr: teachers, the store people, and the linguist lay-missionaries who are recording stories and translating the Bible into Kriol.

Ngukurr is now a government settlement, but this was not always so. The first Roper River mission was founded by the Victorian Church Mission Society in 1908. By 1909, there were almost 200 people from more than nine different groups and languages, who had come seeking safety and protection.

The history of the Roper River area before the founding of the Mission is marked by a policy of aggression to the point of the deliberate extermination by European settlers of the indigenous peoples: 'white people hunted us there', Barnabas Roberts, an old Alawa man, recalled. 'Shooting people like birds. O terrible times we used to have' (Hercus and Sutton, 1986: 66). This persecution reached its climax when the London-based Eastern and African Cold Storage Company bought up deserted properties and unoccupied leases of almost fifty thousand square kilometres, and embarked on a systematic war of extermination.

After a century of attempted destruction and realignment of cultural heritage, Ngukurr art is now emerging with great creative energy and a rich diversity of style.

The artists represented here include Ginger Riley Munduwalawala, Willie Gudipi and Moima Willie, and Sambo Burra Burra.

Ginger Riley Munduwalawala (Plates 60 and 61) has been painting his story since about 1987. He tells me now that he has almost painted his story out and so will soon be finished. Central to his myth is the area around the Four Arches, about forty-five kilometres inland on the Limmen Bight River. The Four Arches were formed by the snake, Bandian, as he writhed and circled through the land. Sometimes Bandian appears in the paintings as two snakes, Garimala (male snake and female snake), which are transformed into Wawalu, the rainbow serpent. In another manifestation, the serpent becomes a fire-eating dragon which rises from the sea to kill people.

Willie Gudipi and Moima Willie (Plates 63 and 64) have been painting since 1987. Their paintings centre on the rite of circumcision and the ceremonies surrounding dead men's stories. Willie is very old and thus is much respected.

Sambo Burra Burra (Plate 65) is one of the most active painters. His work, with its cross-hatching and x-ray images, reflects the Arnhem Land bark tradition. Both Burra Burra and his wife, Amy Johnson Jirwulurr (Plate 66) revere the narrative in their works, retelling its key elements over and over again. 'Same story, different people', as Sambo Burra Burra said.

Anthony Knight

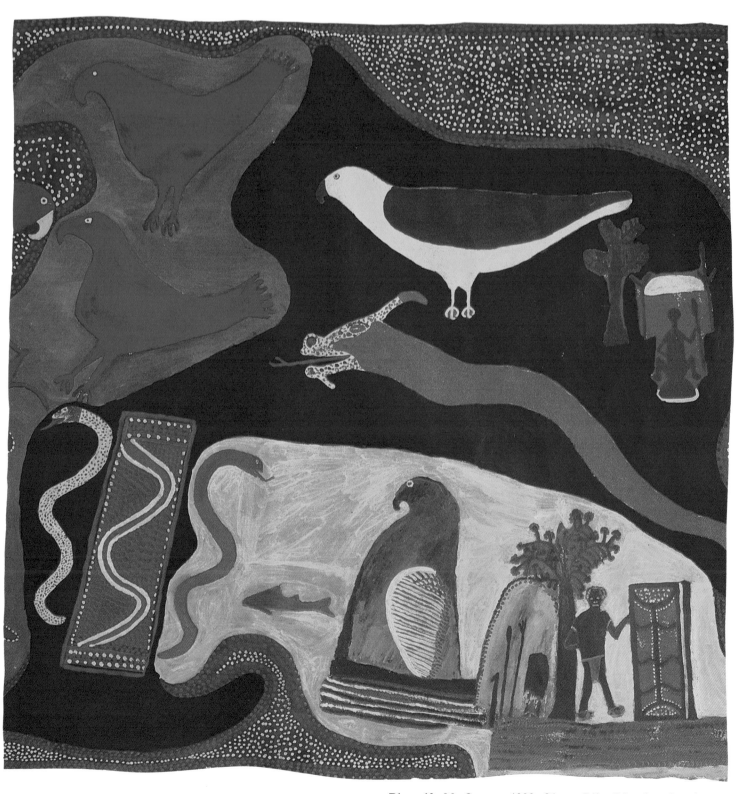

Plate 60 *My Country* 1988, Ginger Riley Munduwalawala

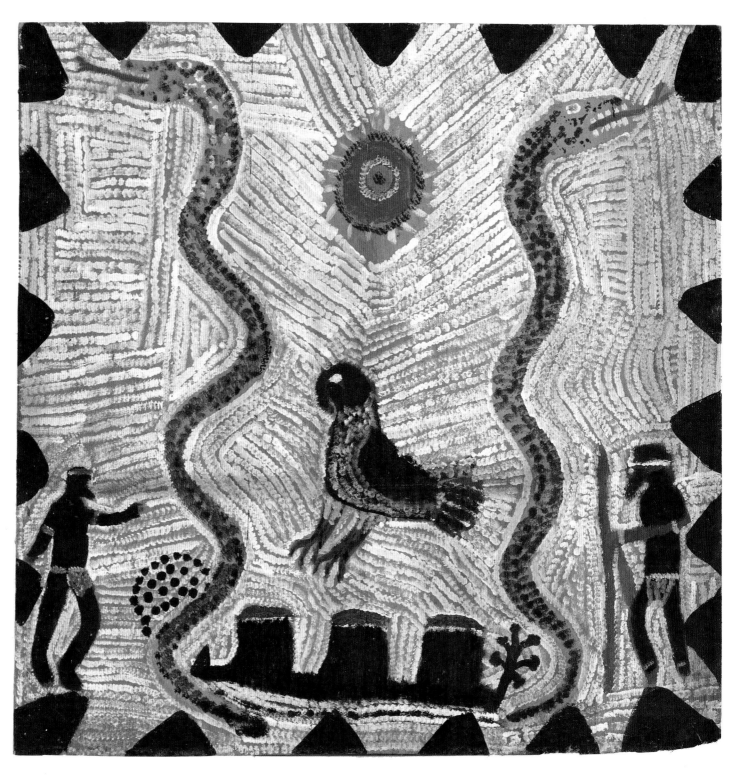

Plate 61 *Keepers of the Secret* 1988, Ginger Riley Munduwalawala

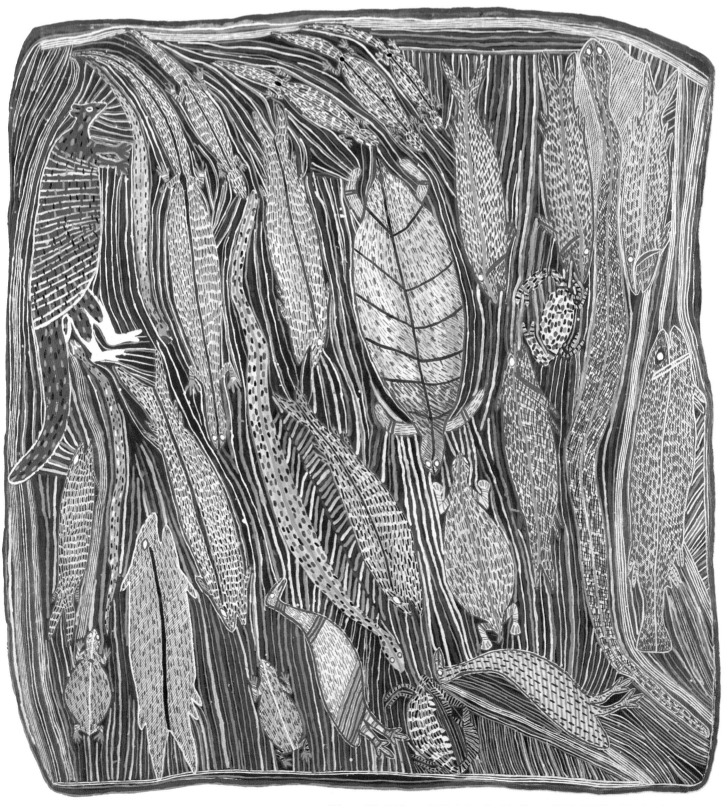

Plate 62 *Fish and Birds in the Shallows* 1989, Wilfred Nalandarra

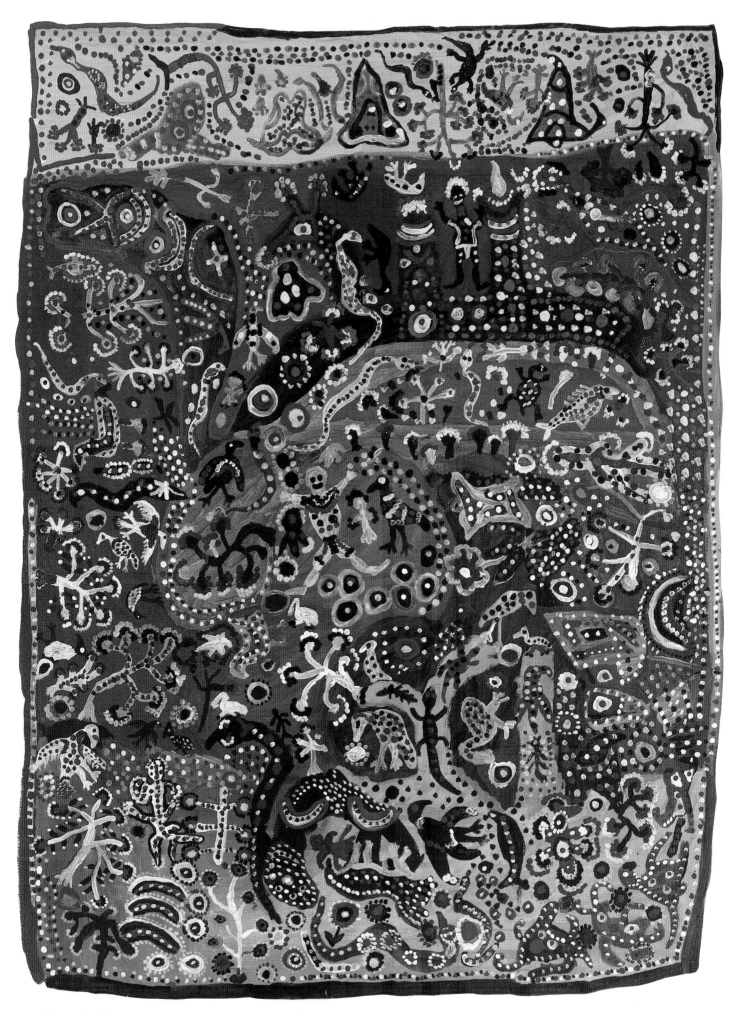

Plate 63 *Circumcision and Mortuary Stories* 1990, Willie Gudipi and Moima Willie

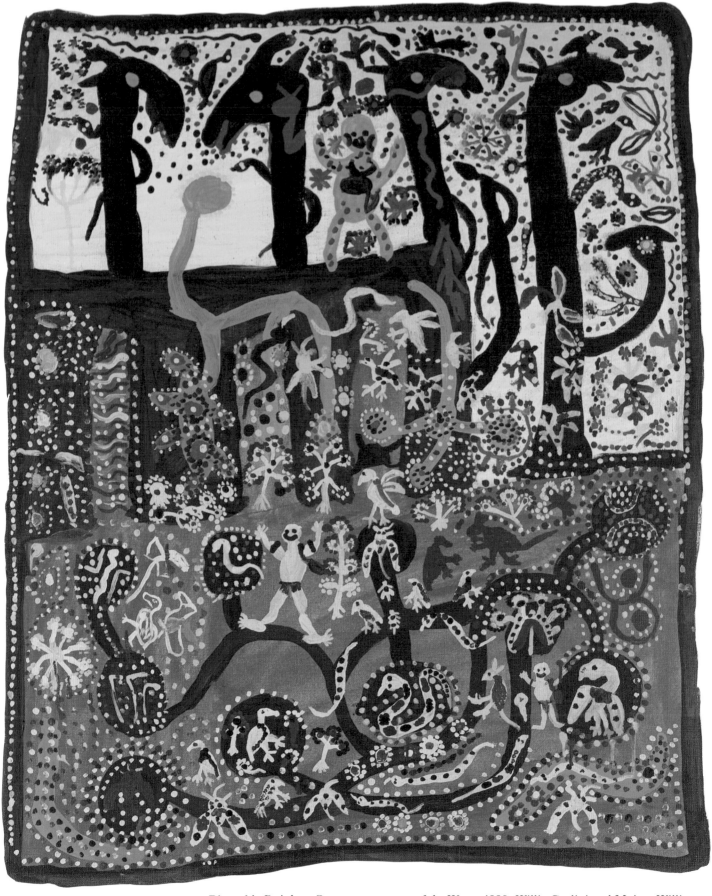

Plate 64 *Rainbow Serpent comes out of the Water* 1990, Willie Gudipi and Moima Willie

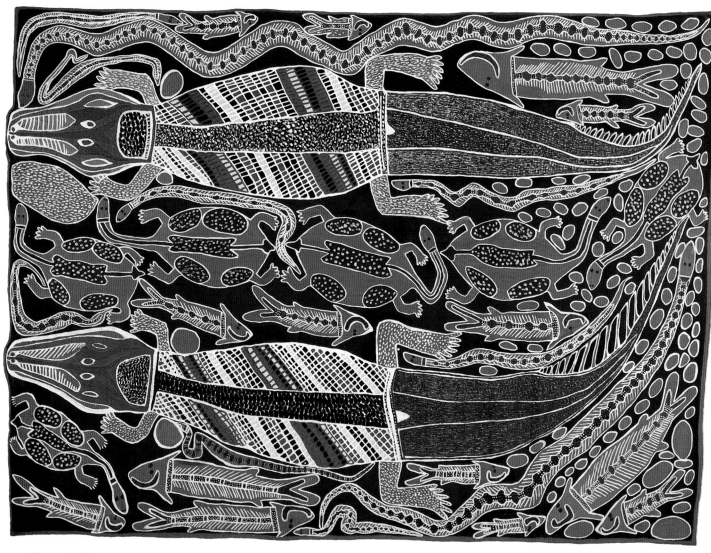

Plate 65 *Circumcision and Dead Men's Stories* 1990, Sambo Burra Burra

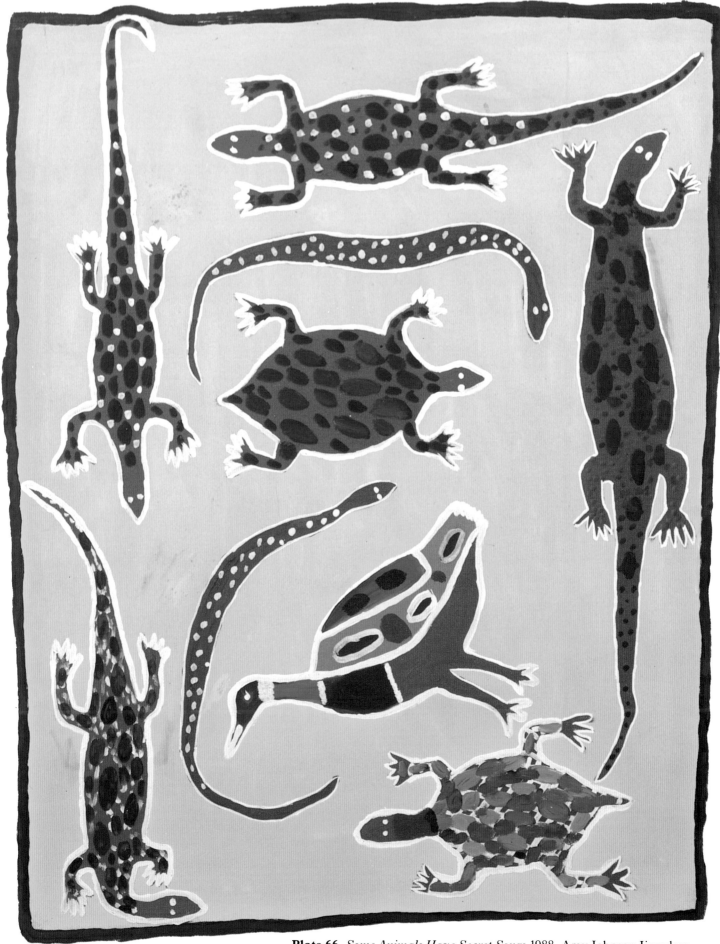

Plate 66 *Some Animals Have Secret Songs* 1988, Amy Johnson Jirwulurr

URBAN ART

There is growing interest in the work of those Aboriginal artists who are working in cities. If my works, and those of artists like Lin Onus, Gordon Bennett and Ian Abdulla, seem different from the paintings of other Aboriginal artists, perhaps this is because our upbringing is different. However, I would challenge the assumption that urban art is not 'traditional'.

East Coast people were colonised before the so-called traditional people of the Northern Territory. Although in this process a part of our culture was taken away forcibly, we still have very strong links with the country from which we come; the stories told to our grandparents are still passed on and are our common history. If the history we share with traditional groups in the Northern Territory has not been sustained so successfully, this is a consequence of their remoteness rather than of any abandoning or devaluing of tradition.

It is impossible to ignore the fact that our culture is still vital to us. I have real trouble saying 'urban.' Where I come from is a coastal and rural town. Most of the major centres like Sydney and Melbourne are really coastal areas. Instead of speaking generally of urban art, I believe it would be helpful and true to recognise different people's countries. I am a Butchulla person. I think that artists working in the city should be identified in terms of their people's country.

Certainly my own choice of symbol reflects what I consider 'traditional.' A lot of my imagery about ceremony draws on my being allowed to go into Arnhem Land – a considerable privilege for me as a young woman. Instead of drawing the dancing as it is happening, I make images in my head and they are put down in a few days' time like a map from an aerial perspective. So they are quite abstract and event-oriented. I also use bones a lot; this image relates to the middens on Fraser Island, which are significant to my people, the Butchulla people. Bones, like the pippi shell heaps, signify that there was a traditional people there for thousands of years who must not be forgotten.

This is not to deny a difference involved in *reading* traditional and urban art. A lot of us who are working in the cities have gone to art school. For instance I attended East Sydney Technical College and the Sydney College of the Arts. There I learned about people whose work I might otherwise never have come to know – artists like Klee, Miro, Richard Long. Educational experiences such as this probably contribute to the fact that non-Aboriginal people often seem to read our painting more easily than they read traditional Aboriginal paintings.

The political aspect of our work is often noted. Traditional Aboriginal works are just as political as urban art but not so easily readable. For instance, the land rights flag is familiar to non-Aborigines so that they can tune in immediately. But in bark painting land rights claims are also quite often present: most of the time, the cross hatching (*rrark*) indicates clan ownership and land ownership for the family. Perhaps urban art appears more directly political because its meaning is more evident to non-Aboriginal viewers.

I am concerned personally about many current political issues. In the first eleven years of my life we lived in Queensland at Hervey Bay. But people there couldn't accept my parents' mixed marriage, so we went to Sydney. My mother has been a strong influence, showing me the kind of strength needed to compete on equal terms with non-Aboriginal people. I suppose my own determination to achieve educationally reflects that influence.

I care about Aboriginal people. I think the Black versus White struggle is much influenced by history, and that there are destructive things happening now with traditional groups of Aboriginal people as well as with those in the cities. Young people are being self-destructive; instead of being creative, they turn aggression in on themselves. At the same time, however, some people in the southern areas are turning our history and struggle into more creative avenues, and are expressing our response in the arts. I'm realising increasingly that you must take people for what they are.

So, yes, urban art is political. But you need to go beyond stereotypes. A Western, male-oriented art culture does not pick up the strong presence of Aboriginal women addressing issues such as fertility, having children, being female. White audiences find that hard. Images of angst are easier to get into, somehow.

Fiona Foley

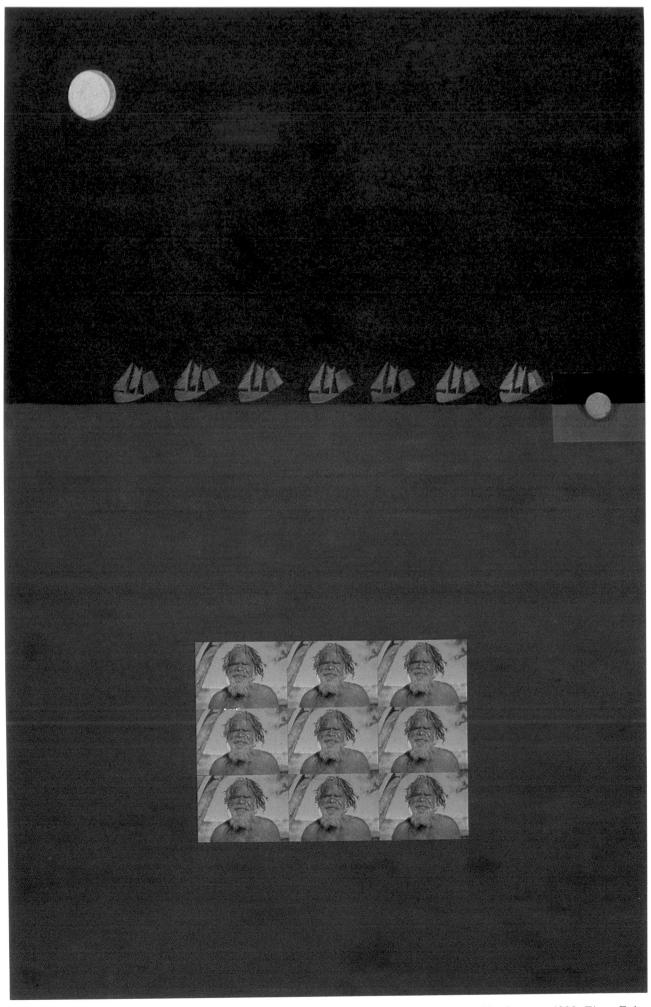

Plate 67 *1788: Enter the White Savages* 1988, Fiona Foley

Plate 68 *Perpetual Motion Machine (Mimi Figures by Guningbal, Central Arnhem Land)* 1988, Gordon Bennett

Plate 69 *Swan Reach, 1956* 1990, Ian Abdulla

Plate 70 *Maralinga* 1990, Lin Onus

TALKING ABOUT THE ART

These pieces are meant to open up areas around aspects of the works in this collection. In one sense they can be seen as a prism through which to view the works; they offer too an opportunity to stand for a while in someone else's shoes and to see through her or his eyes. In another sense they offer an opportunity to enter into a dialogue with someone else in front of the paintings. I invited a philosopher, an anthropologist, a weaver of story, myth and symbol, and some collectors of Aboriginal art to reflect on the art, consider the questions it raised for them and then to respond.

The first essay is from Max Charlesworth, Professor of Philosophy at Deakin University (Victoria), co-editor of *Religion in Aboriginal Australia* and co-author of *Ancestral Spirits: Aspects of Aboriginal Art and Spirituality*. Professor Charlesworth looks at the religious sources of the art, at historical shifts in academic understanding of Aboriginal religion and social structure, and at the power of the life-force (Dreaming) which informs their lives and art. He raises the critical issue of the differences between European Australian and Aboriginal art and what happens when the works, expressions of a whole religious and spiritual world view, are bought and sold in much the same way as other European and Australian art.

Because, until recently, almost all research in Aboriginal art has been carried out by scholars whose primary academic discipline is anthropology, I asked a leading Australian anthropologist who has spent considerable time with Central Desert groups, to respond to the works and to outline some of the ways Aboriginal people themselves view their art and expect others, outsiders to view it.

In this conversation Dr Christopher Anderson, anthropologist and Curator of Social Anthropology at the South Australian Museum, reflects also on the influence that such intense exposure to Aboriginal people and their art has had on his personal and academic life. Dr Anderson provides a remarkable insight into the art, its myths and symbols and the ways these function in the day-to-day life of Central Desert artists Darby Jampijinpa Ross and Paddy Jupurrurla Nelson.

It is almost impossible to enter into any discussion about Aboriginal art without becoming involved in the vast injustices which have been part of the lives of the people, particularly in those concerned with deprivation of land and identity. At the heart of Aboriginal art is the artists' relationship and identification with the land of their ancestors, who, for them, created the forms and still live there.

Frank Brennan is a Jesuit priest and lawyer who has represented the interests of Aboriginal people in their legal struggle to gain recognition for what is rightfully theirs. He traces some of the recent history of the struggle towards

their recognition in an alien, foreign legal system, and looks at the power their art can have to break down some of the injustices and misunderstandings which exist in the colonial Australian political, legal, religious and marketing systems.

Standing before any work of art is often a confrontation with 'otherness' and the journey to understanding and appreciation can be like a movement from being 'outsider,' 'witness' and occasionally 'alien' to becoming 'insider,' 'contemplative' and 'lover.' Moving through the layers can be exciting, but also dangerous; it requires a willingness to be surprised and to play.

Aboriginal art asserts for most people that they are 'outsider'; many find this quite alienating. Having left the world of story and myth, they scarcely recognise its truth or existence. Dr Margaret Woodward is steeped in the world of the storyteller. She has a depth of scholarship in the areas of arts, communication and justice and is particularly interested in the connections between the layers, the hidden yet real dimensions of the work of art which are rarely explored. She accepted the invitation to become 'outsider' to the works in this collection, to select a few paintings and to allow us to follow her as she approached some of the paintings in this collection, and let the art approach her. Hers is an essay about meetings, and about what happens in those meetings.

What motivates people to become collectors of art? How do they decide what to collect? What happens when your collection contains Aboriginal art? How does it affect your life consciousness? These are some of the questions which I asked three well known art collectors who now specialise in Aboriginal art: Margaret Carnegie, Janet Holmes à Court and Ruth Hall are collectors, enthusiasts and actively involved in Aboriginal art and the opportunities it presents for the Aboriginal people. Margaret Carnegie has been collecting Aboriginal art from the beginning of the current movement in 1971. Long before that she was a committed collector of art, but Aboriginal art is for her a way to understand and to help shape a fairer future for Aboriginal people. Rather as the Aboriginal artist does, she sees the art as an expression of the whole of life and as a strong political statement about rights and justice. But she is an art collector, and her eye is sharp and her judgement astute. The Robert Holmes à Court collection is the largest, deepest and most extensive collection of contemporary Aboriginal art in the world. The late Robert Holmes à Court and Janet Holmes à Court have supported the art in very generous ways, promoting it internationally through a series of excellently curated exhibitions in the United States and Ireland. In this interview Janet Holmes à Court reflects on her place and ideas in gathering together this famous collection. Ruth Hall has a small but impressive collection of Aboriginal art. She speaks of how she was attracted through a recognition of the almost biblical emphasis on story and continuity of traditional values. Her involvement too reaches beyond the art to involvement with the people and their concerns.

The last voices to be heard in this section are those of three Aboriginal artists. Michael Nelson Tjakamarra, Banduk Marika and Peter Skipper speak about art in the context of their lives, tradition and family. Michael Nelson is a Warlpiri and Luritja man who paints at Papunya in the Central Desert, but who travels

widely and has exhibited and performed in New York and elsewhere. He speaks of his responsibility for his tradition. Banduk Marika has now returned from Sydney to her traditional country around Yirrkala in Northern Arnhem Land. She speaks about her father's painting *Crucifixion* (Plate 9), and the way it came to be done. She also raises some critical points about the changes that the church mission brought to her people. Like Michael Nelson Tjakamarra she understands that the importance of art is that it is in the public domain and can influence attitudes. In the last interview Peter Skipper talks with Duncan Kentish about his country south of Fitzroy Crossing around the living water of Jila Japingka, about his birth and the birth of his spirit. The conversation is in Kriol, the version that is spoken in the area. To preserve the natural rhythm of the language, with its style of story telling, the section has been left in the original. It needs to be read aloud to experience its impact and power.

Throughout this whole section rumble some common themes. Each person looks at the art through a prism of his or her own life; each emerges as both 'insider' and 'outsider'; none is unaffected. What does emerge is the power of this art to effect change in those who look upon it and in those who create it.

The Religious Sources of Australian Aboriginal Art

One of my main scholarly interests is in the philosophy of religion and comparative religion–the attempt to compare and translate between the various great religious systems. In the past, comparative religion was confined for the most part to the 'world religions', as they were called–Hinduism, Buddhism, Confucianism, Taoism, Judaism, Christianity, Islam. It is only recently that an approach in the comparative mode has been made to the so-called 'primal' religions, that is, the religions of small localised peoples, often with a hunter-gatherer economic and social structure.

According to the evolutionary perspective that dominated the study of society and religion in the late nineteenth and early twentieth centuries, African, Amerindian, Polynesian, Melanesian and Australian groups were seen as 'primitive' societies with simple and elementary structures and with correspondingly simple and unsophisticated forms of religious belief and practice. Primal religions were viewed as evolutionary relics or fossils, of interest to the antiquarian and the anthropologist but not of relevance to the study of the world religions. Indeed, the idea of seriously comparing Hinduism or Christianity with the religions of the African Dinka or the Australian Arunta, or with Siberian shamanism, would have seemed utterly ridiculous.

All that has now changed and we in the West are beginning, very belatedly, to realise that the religions and spiritualities of the various 'primitive' peoples are of very great richness and depth and that we have much to learn from them. (By way of parenthesis: the word 'religion' is now, unfortunately, a hopelessly compromised term and, in a sense, it distorts our perception and appreciation of these primal belief and ritual systems even to call them religions. Nevertheless, it is the best term available and we have to make do with it while insisting at the same time that primal systems are in many respects radically different from what we in the West recognise as religions.)

These observations have special force when applied to Australian Aboriginal religions. These religious systems are the oldest known to us and it is probable that they had their origins more than 50,000 years ago. The anthropologists of the late nineteenth and early twentieth centuries saw them, as did Emile Durkheim, as the most elementary forms of religious life. (Durkheim's great but misleading work, *The Elementary Forms of the Religious Life*, was based on nineteenth century understandings of Australian Aboriginal culture.) The Australian Aborigines were viewed as the prototypical 'primitives', with the most rudimentary form of technology and the simplest kind of social organisation. Like children, so it was thought, they lived in a kind of dream-world where fantasy and reality, myth and truth, were mixed indistinguishably and where the ordinary canons of reason and logic did not apply. (This is what another French anthropologist called *la mentalité primitif.*) As a result, the religious beliefs and practices of the Australian Aborigines were seen as simple-minded mumbo-jumbo of little relevance for white Australians. In addition, Australian Aboriginal religions were viewed as being essentially static and conservative; they were, so it was thought, frozen in time, wholly resistant to change and to creative development or ecumenical interchange.

We are now beginning to realise how distorted these perceptions of Australian Aboriginal culture and religion are. In actual fact, despite the extreme simplicity of Australian Aboriginal technology, the social structure of Aboriginal groups is formidably complex. One scholar has argued recently that Australian Aboriginal societies have inbuilt mechanisms of fission which prevent them from becoming large and monolithic–incipient nation states– so leading to the need for chiefs and kings and in turn to conflict with other groups. The smallness of Aboriginal groups can be seen not as a sign of lack of cultural development, but as a kind of deliberate cultural choice.

In the sphere of religion and spirituality, the same is true. Far from being simple-minded and infantile, Aboriginal religions are of great complexity and sophistication. They are also open to creative development and adaptation, even innovation, and are certainly not fixed or frozen in time. The vitality of Australian

Aboriginal religions is dramatically brought out in the extraordinary renaissance of Aboriginal art in the last twenty-five years. At a time when Aboriginal communities are numerically at a low ebb and when the tragic dislocation of Aboriginal life brought about by white occupation continues, we have had an amazing flowering of contemporary Aboriginal art, ironically under the sponsorship of the white culture which has been responsible for the oppression of Australian Aborigines for the last 200 years.

As I have already remarked, 'religion' is a problematic term, however it is true to say that Australian Aboriginal art, both traditional and contemporary, is religious through and through: its purpose is religious, its motifs are religious, even its practice is religious. (A distant analogy might, perhaps, be made with early Renaissance art in Europe, where the purposes and motifs of art were basically religious and the practice of art was itself a religious act.) Aboriginal religious beliefs myths and rites provide a seemingly inexhaustible source or reservoir of symbols, images and icons and make them available to the Aboriginal artist.

What is now called 'the Dreaming' (a misleading translation of the original Aboriginal concept) is also a problematic term. However, it is universally accepted and we have to live with it. Nevertheless it is an unfortunate term in that it conveys the impression that the central reality in Australian Aboriginal life is dream-like and not wholly real. In fact, the Dreaming is the quintessence of reality for Australian Aborigines. It refers to the primordial shaping of the earth by the Ancestor Spirits and their giving to each Aboriginal people its moral and social Law. It also refers to the persistence of the spiritual power of the Ancestor Spirits in the land, as well as to the personal life-plan of each individual, which originates in his or her spirit-assisted conception. The Dreaming is not merely something in the past (though it is that) but something that is also contemporaneously active. In Christian theology God did not just create the world in the past: by his power he continually sustains it in being, from moment to moment. The Dreaming is like that: it is a living and present reality continually sustaining and energising plants, animals and human beings. Australian Aboriginal religions are aboundingly vitalistic in that they are centred on the lifeforce that runs through everything, and on energy and spiritual power. They both commemorate that life, energy and power and, at the same time, enable Aborigines to tap into it and to foster or increase it.

The Christian idea of sacrament is a rite that brings about what it symbolises: thus the water of baptism symbolises the washing and cleansing of the soul of the child, and the rite of baptism effects that soul-cleansing. Comparisons are perilous but in more or less the same way Aboriginal religious rites and Aboriginal art symbolise certain realities and at the same time bring those realities about. Aboriginal works of art are not merely objects to be looked at and admired: they have an active religious role of their own.

Though some contemporary forms of Australian Aboriginal art are made for the white European art market, they still draw upon traditional motivations, symbols and images in a deeply creative way. What is astonishing, as I remarked before, is the vitality of those traditional sources or well-springs. It is as though there is a quasi-Jungian reservoir of symbols, myths and images in the Australian Aboriginal unconscious which can be invoked and conjured up in striking new forms. In a very real sense these new forms of Aboriginal art, from Papunya and other places, are animated by the very same spiritual forces as traditional art.

Many Aboriginal artists live in communities where traditional life has been disrupted, and in circumstances of great material deprivation and neglect. And yet they are able to call upon the religious and artistic resources of their clan and their own Dreaming, and to bring forth works of great formal and iconic potency. Looking at the works in this book, one keeps asking oneself: where do these mysteriously powerful forms and images come from? They seem not so much to be invented as to be *found* and brought up from the depths of the soul. Once again, comparisons are dangerous, but one is reminded of the art of the early Renaissance (one thinks of Giotto or Masaccio), where a very different source or well-spring of images, symbols and forms was plumbed.

Can white European/Australian art learn anything from Aboriginal art? Is any kind of translation possible between the two, or are the two traditions so radically different that they have nothing to say to each other? Many Aboriginal artists say that their white clients cannot possibly understand their paintings as

they, the artists, understand them. For the Aboriginal artist the works of art are expressions of a whole religious and spiritual worldview. For the European or Australian client, on the other hand, they are seen, bought and sold in much the same way as the other works that are hung upon the walls of private and public galleries. (The same situation obtains, of course, with most medieval works of art that originally had a religious meaning and use, but now have a very different meaning for those who view and buy them.) Nevertheless, the fact that these works do speak so powerfully to white people, both in Australia and in the United States and Europe, shows that there is some possibility of ecumenical interchange between the two traditions. Some of the paintings in this book also point this way. One cannot predict what form this symbolic interchange may take, but one can perhaps expect that it will be a very fruitful one.

Nietzsche once remarked that beautiful things teach hope, and certainly one feels that the beautiful things collected together in this book are very hopeful objects for all of us, both white and Aboriginal.

Max Charlesworth

Of Myth and Symbol, and Art in the Everyday

An interview with Christopher Anderson, anthropologist

What does your experience as an anthropologist say about how Aboriginal art can be understood and addressed by non-Aboriginal people?
If you look at the methodology and the ways of learning of Australian anthropologists working in Aboriginal culture, a style that focuses on questioning is problematic. In all Aboriginal cultures that I'm familiar with, teaching is not done as a formal demagogic process where there's an interchange of question and answer. Learning is very much a process of experiencing, of watching patiently and quietly, and of absorbing. This is much more suited to the way Aboriginal people want to teach you things. Certainly in my own fieldwork that's the way I would work.

In looking at a particular painting, I wouldn't ask direct questions until I had visited the land. People will say, 'I can't really tell you about that because you haven't seen it.' That is, you can't really know anything of the place until you've seen it. After that essential, direct experience you may ask questions; you can't always wait to learn something that you need to know straight away. I guess it's an ideal that you attempt to achieve.

In one Aboriginal community I worked in for years, the term they used for me refers to the fact that I was questioning all the time. I have a nickname that means 'he asks questions about language and cultural matters'; they called me 'kukubaka.' 'Kuku,' meaning 'language' or 'word,' refers to the fact that I'm trying to learn about culture as well. The Aboriginal technique of teaching really fits very well into a basic anthropological methodology of participant observation and learning by absorption. That's very much in line with the Aboriginal method of teaching young people too. So I think there's a nice convergence of anthropology there with Aboriginal culture.

Have anthropologists always worked closely with the Aboriginal people, waiting and absorbing in this way?
Before Malinowski went to the Trobriands and immersed himself in Melanesian culture, anthropology was really very much armchair anthropology. Tylor and Frazer, early British anthropologists, were professors at Oxford, and they really just collated material from some missionaries and explorers, and whatever other source they could find; they weren't really concerned with the kind of personal presence I've been speaking of here. I mean, when Frazer was asked if he'd ever met a native, he said, 'Heaven forbid!.' That was the sort of attitude prevailing at the end of the nineteenth century. Although a lot better than that, Durkheim was still an office theoretician, only a French version. A little later, Malinowski pioneered the technique of actually learning the language and becoming immersed in everyday life as means of learning about culture and doing ethnography. And then verandah anthropology came along. I think this had a lot to do with colonial administration. The needs of the British Empire expansion were such that anthropologists were sometimes used to assist with colonial problems. Often they couldn't do that by staying in one place for several years, so they were called in on areas they might have known a bit about. Basically they would sit on a verandah and have people brought up for interview. Radcliffe-Brown did a lot of that in the early days in Australia, because he was interested in formal systems of knowledge and formal systems of culture, like kinship. You can sit down with somebody and actually chip through the kinship system systematically and learn how it operates. In fact, that is one good way of learning about such things. But it is a very alienating form of anthropology if that is all you do. A fair few people confined themselves to this kind of thing in those days. But there were other people, like Stanner and Donald Thompson, who were right in the thick of it, who were living in the bush and doing much of what I described to you earlier.

What, then, is your sense of what Aborigines are asking of those who view their art?
I've felt very strongly, in almost fifteen years of working as an anthropologist in Aboriginal Australia, that Aboriginal people are very aware of their own position in Australian society and that they use every opportunity avail-

able to them to push the cause of the validity of their own world view and culture to non-Aboriginal Australians. I think anthropologists are often prime people, who are co-opted to this purpose. My understanding of the people I know best, and of how they see me, is that they have given me an explicit, conscious brief: by teaching me, such knowledge will then be used by me to tell whitefellas about their way of life.

Quite often I've been in urban centres with Aborigines and the people have pumped them for answers about their culture. Once an Aboriginal woman, who didn't like anthropologists much, was interviewing two Aboriginal people from Cape York, and she asked me to leave the room. So I went out, but I could hear them. As soon as she started asking questions about the land of an elderly man with whom I'd worked the old man said, 'Well, you go and ask Chris Anderson, because he knows all about it; we told him about it and he can tell you, because we don't want to speak English.' It's quite apparent that they wanted me to present the case that they had presented to me. How could they possibly get across in five minutes what they had taken two or three years to give to me? I think that Aboriginal people in those settings find anthropology very useful. They use it for their own purposes.

I think that leads in then to what Aborigines are asking of viewers of their art. I think at one level Aboriginal people seem fairly pessimistic about the possibility of whitefellas really understanding anything about their way of life; they don't expect very much of white people because they know that white people don't understand and don't make the effort to understand. You get things like Michael Nelson saying to me once, 'You know, white fellow, he just put the picture on the wall and he looks at it. He doesn't understand. It's just a pretty picture for him.' Michael was being very frank there and I'm sure he's right because there's little chance that the fellow who buys a painting, however wonderful he thinks it is and however much he respects Aboriginal culture, can understand it. Understanding only comes with experience, with age, with a slow build up of learning, and it depends on who you are in the system. For some Aboriginal people in traditional societies, there are levels of understanding about a particular art work that they will never learn because it's inappropriate for them to learn that. The potential for learning really depends on your position within the whole

social business in the first place. As a European, as a non-Aboriginal person, if you're prepared to do things on the terms of Aboriginal people, then you might learn something about it. Otherwise, there's no way.

That's the bleak end of the scale. The other end of the scale is that I think Aboriginal people assume that there'll be a holistic absorption of the power of the art, which is the power of the Dreaming, and that that absorption will be a glimpse of Aboriginal world-views which will be useful for political purposes for Aboriginal people. People will say quite often, 'Well, you've seen that place; you've seen that painting; you should understand it.'

I think there are those two ends of things: there's the impossibility of my understanding, ever; but at the same time there's the idea that I can look at Turkey Tolsen's *Two Women Dreaming* and there's an assumption on Turkey's part that that whole cluster that's involved there – the songs, the ceremonies, the body painting, the ground painting, the place itself, plus the whole human heritage that's represented there, Turkey's and his father's lives – will be absorbed by experience of looking at it. So there are those two poles, which are opposite, but coexist in Aboriginal understanding of what whitefellas are on about when they look at the art.

Michael Nelson, like several other people in the Western Desert movement, is a professional artist and has specialised in acrylic art for years; he knows a lot about it. Michael, in particular, has a lot to do with white artists, like Tim Johnson: he's lived at Tim's place and done paintings with Tim; he's gone to white artists' exhibitions. He's very interested in it. Michael is also a master at being interviewed. He's been interviewed so much and he's skilled at developing certain lines of thinking that the interviewer is interested in. That's why he's on film so much, why he's involved with so many projects and articles and so on. I can remember four or five years ago sitting down and talking with him about it, and I think we discussed it in *Dreamings* (Sutton (ed.), 1988) – about how Michael plans out a painting in his mind and the relationship between the conceptual design of the painting and the body of knowledge that it relates to and what he actually does, as far as planning out the work. He is very much a designer. He will sit and plan a painting on the ground before he even starts on it, whereas

many of the older acrylic artists that I've watched engage in what's much more a burst of activity and a basic philosophy of 'We'll see what fits in.'

Where then do you see art as belonging within the context of Aboriginal peoples' lives?
I'll just speak about the Western Desert art because I don't know a lot about bark painting and I've never done any work in Arnhem Land. It's an amalgam of so-called 'traditional' forms–that is, body painting, ground design, rock painting, rock engraving–all of which are contemporaneous; there's no sense in which those forms are earlier or later, all of them co-exist. Acrylic painting, just in terms of the medium, has provided people with the means to refine the techniques that are already there in some of the other forms, like body painting and ground design. It has allowed a kind of development of technique and process, like the fact that acrylic paint can be used to do fine dotting and it dries very quickly, unlike the dotting that comes from body painting, which is just done with your fingers. So, there's that.

But at another level–one which I think is much more important–bark painting, acrylic paintings and even urban art (or whatever else you want to call it) really represent Aboriginal recognition of their place in Australian society. Something that I've been thinking a lot about recently is that those art forms are really attempts to colonise the European world-view, perhaps even to subvert it. Certainly I think Aboriginal art is best thought of in my mind as a wedge into the dominant world view of European society. It's not traditional, and it's not non-traditional; it's not authentic, it's not in-authentic; it's just Aboriginal reality today. Aboriginal artists understand much better than most Europeans their own position within Australian society. (I'm including here people who live 800 kilometres from any European settlement.) They know very well the position that they're in–their art is a sort of statement demanding recognition,and it's a statement of the legitimacy of their own world-view. It's a political act too, a deliberate political act to lay claim to land. Really, for contemporary art in any Aboriginal community, this is the best way to think about it. It's a nice coincidence that Europeans find it aesthetically pleasing as well, because that makes it much more effective politically. That's the main way that I would want to look at art in the context of Aboriginal lives today.

Does this art also belong, somehow, within the context of your own life?
Certainly art as such wasn't a topic of interest to me in my Cape York work and little art was done there. However in the last five years I've been working in the Western Desert and it's become a central part of that. At a personal level, I cannot separate out particular works from particular people and places. The teaching of a holistic viewpoint has worked for me. I cannot look at a painting if I know the artist, the community or the area well and separate it out from that: it's become an integration of my own experiences. Aboriginal art really symbolises for me this fantastic integration, this holistic aspect–all of Aboriginal life–which has rubbed off incredibly on me. I cannot look at paintings from an area that I know without thinking of the people that they represent–through time and over space and within the land itself. I think that's the most powerful thing that happens to me when I see a painting now. It is a part of my life, but this is so because the people that it represents are also a part and the land that they live in is a part.

I've always been politically involved in Aboriginal land rights–ever since I've had anything to do with Aboriginal studies. I was at Queensland University in the early seventies and Brisbane was probably by far the most radical campus in Aboriginal affairs. Certainly the Department of Anthropology that I was in was by a long shot the first one to have Aboriginal people actively involved in courses and doing studies and so on. Long before I had any interest in Aboriginal art whatsoever, I was heavily involved in Aboriginal politics. If anything the work in Central Australia has given me the other side of things: a much deeper understanding of Aboriginal religion which is, by definition, politics. There's no way to separate it out.

One of the conclusions that I've come to– and the reason that I got involved in art in the Western Desert–was that I was working on a project which was to discuss the custodianship of sacred objects that were in the collection of the South Australian Museum. All of the senior men I was working with also happened to be the main acrylic painters in the community, and the subject matter for sacred objects

was the same as that in the acrylic paintings really. That's why it was natural that I should be involved in art as well. But, in discussions and meetings on sacred objects, the overwhelming thing that struck me was the great mixture of reverence and humour. In the middle of something that is of unbelievable significance to people, and in which there is a large degree of awe and power, people can laugh and joke quite easily. I think that's an indication of a very mature civilisation, a very mature religion, one that's comfortable with itself. And it's a world view and a body of knowledge and a system of thinking about the spiritual world that's very much at ease with human society itself. I think Irish Catholicism is like that too: you're not scared of things, you know they're important, but you still feel comfortable when dealing with them in everyday life. There's not this separation of domains, where one day we're doing this, now we're in church and we have to be quiet, and when we're outside we can do what we like. That's really what has been one of the main things that has struck me, that mixture of reverence and humour.

As well, as many people have pointed out, there is no way that you can talk about a notion of Aboriginal religion as a separate category. Everyday life is so much bound up with ways of religious thinking that it's impossible to separate it out in any meaningful way.

Could you talk a bit about some specific art works included in this collection? I wonder how what you've said applies to particular works.
Perhaps if I take the works of Darby Jampijinpa Ross from Yuendumu or Paddy Jupurrurla Nelson–I know both of them well and I know their art well, so I can talk about that. The thing that I find very difficult once again is to look at a painting– and I'm sitting in my office looking at a painting of Paddy Nelson's now–and for me I see Paddy Nelson: I see his personality in the art; I see him as a man standing there in the painting. That is for aesthetic reasons that I don't fully understand, but at the same time it's that old thing of the integration of the art with the person with the world-view and so on. I look at the painting and I see the Yam ancestors, and Paddy Nelson will say, 'You know, I am that person, I am that old man that is a Yam Ancestor.' There's not a separation out of the

Dreaming ancestry and the present-day human beings; it's one and the same. Similarly, I'll see in Paddy Nelson's art that kind of network quality of land and people. Although many people have talked about the abstract expressionist nature of Western Desert art, I don't see it that way at all. I see it as very concrete art. I see the paintings as figurative and as concrete direct representations of geographic, religious and social reality. They're not abstract paintings at all in that sense. I see Paddy Nelson's painting (Plate 36) as almost a map at one level.

And then, the landscape. That's something we haven't touched on: the lack of distinction between nature and culture comes through very strongly. I've travelled across the landscape with Aboriginal men and someone will say, 'Oh, there's old Jungarrayi'. We're out in the middle of nowhere and I don't see old Jungarrayi, and suddenly I realise there's an eaglehawk flying over us. People know that's a bird and that Jungarrayi is back at Yuendumu but at another level there's a very real sense in which that eaglehawk representing that species and representing the whole of nature is one with that man and his human heritage. There's not a distinction to be made there. Similarly, that eaglehawk and that Jungarrayi represent that area of land and those sites, because their actions created it in the past and create it now. The art represents that merging of nature and culture. The painting embodies those people, that artist, in the same way that the Dreaming Ancestor who's depicted embodies that person too.

And Darby Jampijinpa Ross?
I know Darby well too, and I know his art well. One of the paintings in *Dreamings* (Sutton (ed.), 1988: 104) was by Darby. To me it was wonderful because the painting itself had about six different levels to it. There was a kind of superficial level, which meant that this is the story of Burrowing Skink Dreaming; and at another level it was a story of young men hunting in the bush and of old men cooking meat. And there are many levels below that which Darby told me about but of which he said, 'Look, you can know about this, but I don't want you to tell anybody else.' Really, that's another method of learning: where you know things but you can't really let anybody else know about them or even that you know about

them. That reflects Darby's personality also—there are many different levels to his personality. He's quite a famous character in the Western Desert and anybody who's ever gone to Yuendumu in the last thirty years has had things to do with Darby; he's a very important ceremonial leader. People experience him on different levels in exactly the way they do his art. On the one level, if you just meet him superficially as most white people do, he's a happy-go-lucky eccentric old man. If you get to know him and if you travel in the bush with him and let him guide you as to how you learn things, you just get taken down in the lift into those deeper levels. That's exactly the way the art is too. There are multiple levels—just like him as a person. Well, perhaps it should be 'up in the lift,' that metaphor!

Darby's *Rain/Water Dreaming* (Plate 35) has the same geographical realism that I described earlier. And the multiple religious or mythic levels are there with this painting too. Darby would hope, I think, that seeing this painting would be an absolutely convincing argument for non-Aboriginal people that the Australian landscape is inseparable from Aboriginal reality, past and present.

Christopher Anderson

Sharing the Land: Land Rights and the Spirituality of Aboriginal Art

'This is my country' is the artist's own description of many contemporary Aboriginal paintings. Many such paintings are no longer made for ceremonies, but for sale; no longer restricted to the appreciation of the initiated but revealed to the gaze of all, including art collectors in Tokyo and New York. Art has become the bridge of communication and commerce out of which has grown non-Aboriginal appreciation of the land and Aboriginal access to cosmopolitan goods and services. It is a strong bridge across the cultural gulf of different worlds. It is a new way of talking the history and acknowledging the present – a way that does not threaten the descendants of the European colonisers and that need not undermine the integrity of the Aboriginal landowners who have been dispossessed. It is a way of sharing the land through understanding and respect.

Traditionally there was no separate role description of 'artist.' The one applying the ochre was the Law Man or keeper of the secret, the one with power. Though every artist has an individual style, Aboriginal artists throughout Australia have developed in association with their local communities, which are the keepers of the stories and which recently have become schools of art. In many communities, art is the one substantive source of income additional to government grants and social security payments. It provides disposable income without strings attached and a good return for excellence and labour. Art has become creative work attempted by many who are seeking a better way than 'sit down money' and whitefella tasks dreamt up by government officers wanting to alleviate unemployment where no employment is to be found. The income has provided the wherewithal (including Toyotas) for a return to country (called 'outstations') from the administrative centres felicitously called 'communities' by public servants and missionaries. The artist is a recognised independent income generator and role model for others wanting to express themselves, freed from outside whitefella constraints.

The new quest for self-expression across cultural barriers has a pathetic 200-year history. The self-interested failure of colonists to recognise Aboriginal land rights was part of a cohesive policy aimed at reducing Aboriginal resistance to European progress, development and economic expansion (Reynolds, 1987; Brennan *et al.*, 1986). On the fringes of the new society built on their lands, Aborigines were marginalised from its benefits. The present generation of Aborigines is the first to know formal equality under the law (cf. Koowarta case, High Court, 1982), the first to enjoy the benefit of affirmative action programs – in housing, health, education and employment – aimed at overcoming past disadvantage and providing equality of opportunity (cf. Aboriginal Statistics, 1986; AGPS, Canberra, 1987). Their grandparents were supposed to die out; their parents were to be assimilated or at least integrated. They are now supposed to manage their own affairs and to become self-sufficient if not self-determining. They are recognised by *the others* in the land as people in their own right.

Since 1967, Aborigines have featured more positively in the Australian consciousness. Land has been won back. Land ownership has been recognised, respected and, in some cases, restored (*Commonwealth Aboriginal Land Rights (N.T.) Act, 1976*). The significance of Aboriginal country has been recognised by the post-colonial regime – a regime made increasingly accessible and participative for Aborigines through structures such as the Aboriginal and Torres Strait Islander Commission. Aboriginal artists are painting an eternal, indisputable reality of their consciousness, which has been recognised belatedly by those who embodied *the other*. The sacred had to be translated to the others in profane terms so that the violent law of a foreign culture might wrap a protective husk around the life-giving and death-dealing relationship of the Aborigine with clan, Dreaming and land. That relationship is law in its fullest sense, described by Mr. Justice Blackburn in the 1971 Gove Land Rights case as:

a subtle and elaborate system highly adapted

to the country in which people lived their lives, which provided a stable order of society and was remarkably free from the vagaries of personal whim or influence ... a government of laws and not of men. (17 Federal Law Reports 141 at 267)

Even Europeans of good will were uncomprehending in their attempts to close the gap that became known as 'the Aboriginal problem.' Committed to solving the problem, many sought the answer in education, the work ethic, health and cleanliness, a settled lifestyle and, of course, the Christian message. The Christ of the white man was proclaimed through exhortation and good example. Like all whitefellas, the missionaries were convinced they had to find the solution to the Aboriginal problem. Meanwhile the whitefella problem compounded itself with increased incursions, in good as well as bad faith, through aeroplanes, Toyotas, phones, videos, faxes, TV and the satellite. Occasionally a showdown was needed when the whitefella tried to defile previously unmolested country, usually when minerals were discovered. As at Noonkanbah, the showdown is a contest between the two laws, portrayed starkly by Mr Ginger Nganawilla:
If we are to allow Amax (the mining company) to return to Noonkanbah they must show us Law, not paper law. Paper is nothing. Paper can be washed away. Our Law, Aboriginal Law, will last forever. If Amax has this Law then they must show us. (Hawke and Gallagher, 1989: 193)

The artist drawing life from the 'mob's country' has been able to translate the Dreaming, revealing the sacred in the canvas of the marketplace. The land is the archetype and locus for all sacred business set down in space. The painting both tells the story and evokes it; it is the text and the visual aid; it is the map, the code and the very terrain under which lies buried a world of meaning that expresses values transcending all cultures and are embodied completely in this culture, fully accessible only to the initiated.

When the artist releases for sale the painting of 'my country', he or she decides to share the country and to reveal some of its power to the other. It is a new way of caring for the country, discharging the primary spiritual obligations for the land, rendering its beauty and power tangible to those who are 'tongueless and earless towards this other world of meaning and significance' (Stanner, 1979: 230), those who

need no country and yet have taken it at will. It is also a new way of harvesting the country. The artist who knows his or her country now receives more than spiritual benefit from it. The primary custodians of the only culture unique to this land have a rich heritage and an abundant resource which gives value to the political struggle, the physical labour and spiritual trauma of living in two worlds *on our terms, not yours*, on the artist's terms which are defined not only by the market's expectations and the preconceptions of the audience of others (of whom the writer is decidedly one).

The exhibition, 'Aboriginal Art and Spirituality', held in the High Court of Australia during the World Council of Churches Assembly, highlights to us who are other that law, religion and art are still one in the Aboriginal mind-set. The genius of this mind-set is summed up by Professor Bill Stanner:
It affirms reality as a necessary connection between life and suffering. It sees the relation as continuously incarnate and yet as needing affirmation. It celebrates the relation by a rite containing all the beauty of song, mime, dance and art of which human beings are capable. (Stanner, 1966: 56)

The market economy, while making more accessible the law and religion, together with the art, may also be straining Aboriginal people's unity. Individual artists would have no creative power and nothing to paint, separated from their country and their community. In the past that separation was forced by dispossession. In future, it may be chosen by the individual who knows fame and fortune. Aboriginal art has always expressed the cultural achievement of interaction between kin and country, set in the myth and ritual of the Dreaming. Now it provides even the remotest communities with immediate access to the other-world, which ascribes value through transactions.

Through negotiable relationships in the market place, in the galleries and on the airwaves, the artists are free to cross and recross the bridge they have built for their cultural survival. The return to country sustains and marks their art with a sacred character. The viewers are shown the extraordinary way that Aborigines have possessed the land – in their minds, through folkstories, taboos and song cycles – and made it part of the very fabric of their living. Invited to cross the bridge, the viewers can come to possess the land imag-

inatively, in very much the Aboriginal way. The sensitive viewer, like poet Les Murray, will conclude:

My affinity with Aboriginal art and thought is only partly elective, and goes into convergences I have yet to explore. The ground of integration, of convergence, is rocky and ill-mapped; sooner or later, I will have to give some blood for danc-ing there. (Murray, 1984: 27–30)

Neither artist nor viewer crosses this bridge without cost. Each is possessed by the land, moving unsurely between the dreaming places and market places which are contemporary Australia.

Frank Brennan

Responding to Aboriginal Art: A View from the Outside

'Outside'

Outside, outsider, a 'gubbah', what focus dare I bring? I am conscious of a history implicating white Anglo-Australians in two centuries of oppression. I cannot claim insiderness to a culture where floods and animals are danced, songs painted, and painting sung into being. Nor can I stand totally apart. My own religious heritage tugs at memory with echoing myth: 'rivers clap their hands, mountains shout for joy', and justice comes (Psalm 98). Perhaps here is a meeting point. Perhaps all myths call, ultimately, for justice and fullness and celebration. Most of all, however, I cannot stand apart because I am held by the paintings themselves; they will not let me go.

An outsider is a non-specialist. I read once of the Taos Indians' storytelling sessions. As a contribution to the evening, each child bore to the elder-storyteller two pieces of kindling for the fire. Coming to image and narrative, I bring only myself. I am not an artist, art critic, curator, ethnographer, linguist or anthropologist. Ordinariness is my vulnerability. I bring no assured pre-critical assumptions to what I see or to works that I experience, unexpectedly, as seeing me. Unlike many committed specialists, I lack extended immersion in Aboriginal community life, though I have sat at the feet of Koori lifetellers. To record a personal response to the paintings seems dangerous. Before speech, there must be silence; before statement, story; before explanation, attention; before naming, a journey. I know myself in so many ways as ignorant, an amateur.

But it may be that certain kinds of expertise also promote and reflect outsiderness. I appreciate all who nurture love and understanding of Aboriginal culture, who feed me with story and help me towards understanding. Yet there is always the risk of using white words and cultural power to trap the unknown within the known, of teaching before there has been space for learning, of presuming fragments of knowing to be the possession of knowledge. There is a kind of territoriality whereby a specialist seeks to assert ownership by establishing distance from the rest of us 'outsiders': he will declare that there is only one path to insiderness, or will insist that art is only rendered accessible when one knows, as he does, how to interpret the stories. Depth is confused, then, with obscurity. I believe it is wrong to impose such limits on myth. Similarly, I suspect any earnest evangelism which romanticises the lives of Aboriginal people, is indifferent to the concrete circumstances that demand myth to sustain life, and unwittingly trivialises what it sets out to respect.

An outsider, I remember that Aboriginal art has itself been decreed outside the 'mainstream', whatever that may be. Denial of the applicability of familiar Western aesthetic standards has sometimes led to a denial of the presence of any significant aesthetic qualities in Aboriginal art. This marks a controlling of the aesthetic which I believe the works themselves defy. In consequence, the potential for creative reciprocity between Western and Aboriginal art and artists has been ignored. In another separation, and perhaps to enhance the marketability of an alien culture to curious consumers, Aboriginal art is presented as traditional and not contemporary. Do we in the West claim a privileged aesthetic, and a right to impose our distinctions and criteria without question? Emphasis on outsiderness precludes creative conversation.

It seems I am indecisive. I want to do away with some forms of outsiderness and retain others. Or, rather, I want to name how outsiderness and insiderness function now, so that possibilities for interchange become apparent. For instance, when we gubbahs genuinely accept our outsider status, we will speak more tentatively of our own as well as of Aboriginal people's life-worlds and art. We will learn that there are valuable sources of knowledge different from our own. This will encourage closeness, not foster distance. Our assured pronouncements will become questions, and then our very questions will become questionable.

Looking

'Choose a few of the paintings from the exhibition, and offer one outsider's view of the art'– so went the brief. As it happened, and it was a happening, the paintings did the choosing. I arrived home clutching photographs of works by Hector Sundaloo (Plates 16 and 17) and David Downs (Plate 23), together with an image, plucked up last, of a long-necked turtle (Plate 22). I had no clear idea of the bases for my selection, only a sense that I could not *not* choose these images. Beforehand, quite deliberately, I asked no questions about the works, not wanting to be influenced initially by information and interpretation.

I remember one comparable experience. Wandering the Museum of Fine Arts in Boston, I found myself suddenly in a room dominated by a large painting from Senegal. 'Oh!' The exclamation was aloud and loud. It was as though the energy within the painting leapt out at me. For the next hour, I stayed where I was, looking.

If words falter in accounting for such an experience, it is because some kind of epiphany occurs, a showing that is not reduced to telling, that is of this moment and that endures. The power the Aboriginal paintings communicated renders attempts to describe them verbally, in terms like 'immediacy' and 'palpable presence', as little more than inadequate approximations. I am surprised at how sight claims language, too – startled to have used the one word, 'power', to refer to the rich vibrancy of *Moses and God and the Ten Commandments* as well as to the muted beauty of *The Dead Christ in the Tree*, yet I feel the strength of both these works, of the assertion and the whisper.

It is hard to detail without gush or cliché whatever it is that elicits such engagement, in which the viewer cannot be passive but is caught up in the work. Whatever occurs is not reserved, in my experience, only to encounters with Aboriginal art, and is certainly not my response to all works by Aboriginal artists. No, this is a response called forth by what I believe to be good, even great, art – not invariably, for we are sometimes blinded by the unfamiliar or temporarily seduced by the novel, but often enough, I think, to have significance. By whose criteria is this good or great art? By what criteria? I do not know. Yet I think many of us recognise and trust this experience when it happens. Such recognition may be dismissed as unreliably subjective whim; I ponder, however, connections between this kind of intuition, this deep-to-deep, and myth, meaning and the human spirit.

In the present instance, direct contact may owe something to the narrative quality of several of the works. Story invites and even summons entry. Within are different rooms and levels, strange places, unexpected reverberations. The lure to journey inward is often delightful in its suspense: the untold *something more* holds itself out not as deprivation but as promise.

For me, then, the initial exploratory act is of my being acted upon. It feels right to wait with the work, to receive with wonder and not to seek any other kind of precision. An outsider, I am content with this first exhilarating and sometimes playfully contemplative phase.

Looking at

I begin to consider each painting, to move from looking to looking at. My attention is captured by works at once Aboriginal and Christian: Hector Sundaloo's *The Dead Christ in the Tree* and *The Young Joseph and Mary*. Purportedly Christian-and-Aboriginal art I have seen in the past recalls an ancient Aztec depiction, rendered in poetry by Denise Levertov, of the 'carrion artist who makes things opaque, brushes across the surface of the face of things and so defrauds people' (Rothenberg, 1968). Like many others, I have been alarmed at this uneasy syncretism which deprives Aboriginal art of its depth and imposes Christian symbolism superficially, almost parasitically.

In Sundaloo's work, however, the true artist is evident. Poised between earth and sky, the body of the dead Christ nests in a tree, awaiting burial ceremonies. All is still, silent, focused. The land, the tree, the Christ, the sky – that is all and it is enough and it is everything. Even the colours are hushed: muted browns, death whiteness, the dark body; and the colours themselves belong to the earth: white clay, natural ochres.

The Young Joseph and Mary uses similar colour with very different effect. Again there is spaciousness and directed attention. Joseph and Mary stand back to back, each facing a large white bird, the male and female spirit respectively. White here becomes numinous; the shape of each bird swelling with as yet unsung song suggests promise awaiting fulfilment in the ceremonies to come.

Turning to a very different work, *Moses and God and the Ten Commandments*, I see stones

and tablets, Aboriginal Law and Mosaic Law, God and Moses, black footprints, journeys, a sundering and cementing of tablets and people, an encompassing oneness. Biblical story and Aboriginal story are not juxtaposed, the one hinting at the other. Instead, they are one. Again there is space and fullness. Darknesses glow; they are not empty but contain a great richness.

In all three paintings, the images belong and the perspectives – not Western perspectives – are true. They flow from the heart. These are not Aboriginal works with Christian themes, any more than Land is a theme in Aboriginal art. What is here is integral. I am reminded of how differently our cultures – my outsider one and the cultures of Aboriginal people – deal with truth. In Old English, *treow*, 'tree,' is one of the origins of the Modern English word, 'truth,' meaning 'that which is sturdily rooted, embedded.' The Greek word for truth is *alethia*, opposite of *Lethe*, name of the river in Hades that produced forgetfulness of the past. Remembering, in Aboriginal art, dissolves past and present in a timeless now for which my outsider culture has little that is comparable. Ours is often the truth of evidence, of the substantiated, of a more scientific ecology of reality, of *chronos* rather than *kairos*, of distinctions between the real and the imaginary that denude or distort myth. Perhaps our aesthetic participates in this stance too. Reflection on my outsider culture may here be too heavy, self-castigating, unjust to what many in my community profess as spirituality, or even a falsifying exaltation of what is 'other.' Yet I think it is a struggle for us to integrate or to enter into myth as readily as do these Aboriginal artists. (Indeed, for such artists, the task of integration does not appear to exist.) This does not mean that the door to understanding is closed so much as that we need to change our approach to understanding, and to know that having information is not the same as being formed within, *in-formed*.

One image remains to be looked at – *Turtle in the Water* (Plate 22), painted by a woman at Daly River. Lacking the stature of the works of Sundaloo and Downs, it is unpretentiously delightful. I savour its patterns, each tender and whimsical detail, the playful respect, the delicacy of colour. Is it totemic? What does it mean? I am reminded of what the poet Judith Wright once wrote after school children deluged her with requests for explanation of the snake in one of her poems. 'It is,' she said, 'a snake.' What is this image? It is, indeed, a long-necked turtle. Turtles, mud crabs, goannas, eagles – all creatures have their place and meaning; they speak, act, move, matter, are not located separately from humans. They do not have to symbolise; they are. Inhabitants of earth and myth, they could only be symbols in narrative of a different culture. Our outsider language will not fit.

In all of the images selected I notice a basic simplicity, a kind of economy. I believe there is a similar absence of clutter in myth and spirituality too: there is the sensuous, the rhythmically repetitive and intertwining patterning, yes; and there is complexity and sophistication; but there is a noteworthy and binding unity.

Looking with

Looking, and looking at, I have begun to learn to read. Now I want to learn more, but to learn in such a way that knowledge does not distance me. I want to stay an amateur, so that love, and not intrusion or arrogance, prompts the quest for insight. Most of all, I want learning as listening. I want to hear the story, to take tiny steps when and if I am graciously admitted a little further into myth and painting, to warm my heart and mind at the campfire, and even to find some pieces of kindling to bring as gifts.

Such learning is not a devaluing of what is good in my own culture, my own beliefs, the art and art forms of my own community. Rather, it reminds me of this goodness and urges me to be attentive to it. Looking, and looking at, however, I avoid easy comparisons. Looking with is not about contriving parallels that enable me to fit what I see newly into old and inappropriate frameworks. Looking with involves a quest to bring into conversation two worlds, to encourage reciprocity, and to unsettle fixed assumptions. To look with is to move with metaphor, to ask 'What if … ?' What if a Western aesthetic is not the only or the definitional aesthetic? What if we take more seriously the relationship of the creative and the religious? What if our truths are allowed to intersect and to complement one another? Is it possible? What if the difficulty in approaching Aboriginal art is not in its otherness but in us? What if … ?

To look with would be to pose such questions, such serious questions, lightly.

Margaret Woodward

Collectors and Enthusiasts

Margaret Carnegie

A failed painter myself, I became a collector of other people's masterpieces.

I was born acquisitive, with an insatiable curiosity. Every new acquisition led me on a journey of exploration, on a quest to discover the artist's motivation, where he or she fitted in a historical sense, and the inspiration behind the subject-matter. Visually oriented, I wanted to find a work's soul, to know whether, when I moved away and closed my eyes, I could see it and feel it speaking to me.

I formed my first collection when I left school: I paid Jeffrey Schreck, a violinist friend of my mother's, a pound or ten shillings each for about a dozen Japanese Ukiyo-e prints by Hiroshige, Hokusai and Utamaro. During the Second World War, my mother persuaded me to donate them to the Comforts Fund. Studying the Japanese prints opened my eyes to the influences they exerted on Matisse, Picasso and, indeed, the whole modern art movement.

Many other experiences were influential for me: a stimulating White Russian art teacher in Switzerland, who focused my interest on European art of the Renaissance; a month's tour of Italy; Paris, London, the Brighton Pavillion, galleries, museums, libraries. Mentors when I arrived home in Melbourne included Mr Gill from the Fine Art Gallery, from whom I bought a Streeton drawing, and Allan Henderson, then a trustee of the National Gallery of Victoria. I formed a collection of modern Australian paintings, exhibited on 27 October 1966 in the old National Gallery of Victoria.

Shortly after this, two Australian artists alerted me to the exciting world of tribal art. Leonard French and the late Fred Williams encouraged me to buy a Sepik River tile and an Aboriginal artefact. An absorbing world beckoned. Robert Edwards introduced me to the Papunya painting movement initiated in 1971 by Geoffrey Bardon. Kaapa Mbitana Tjampitjinpa's painting, *Corroboree and Body Decoration* (Plate 43) came from Bardon's collection. It possesses a heraldic quality and satisfies both my criteria: it has soul and packs a big punch despite its small size. Kaapa, an Anmatjira

Aranda clansman, is an important link painter between the world of Namatjira and his fellow Hermannsburg watercolour artists and the Papunya-Tula acrylic movement. Kaapa was at Papunya when Namatjira was exiled there in 1959, and he was one of the first to change from watercolours to acrylics after Geoff Bardon arrived (Bardon, 1981).

Namatjira has been praised for his ability to paint as a European, but his sad life could not destroy his Aboriginality or the love for his land and culture which shines through his watercolours.

I fell in love with the beautiful desert paintings which have their origins in the desert sand. They appear abstract at first but, with an understanding, reveal layers upon layers of meaning, many of them too sacred to be revealed to an uninitiated female. I began reading everything I could find on Aboriginal art and culture, while building a comprehensive collection. I shall never finish this study, for Aboriginal culture is so complex and has so much to teach. I came to the conclusion that Australian Aboriginal art is the first non-derivative Australian painting, and is the most important art being produced in the world today. It is an art which I believe will influence Aboriginal and non-Aboriginal urban artists world-wide.

What do I look for in buying a work? Content, soul – does it speak to me? When I close my eyes could I paint it? The work I usually buy is the one I remember during the night. I never take a catalogue and never ask who the artists are. This has been so since I began my Australian art collection. I had more time then because there was less competition. When I bought Drysdale's *Old Larsen,* I remember that people would come in the house and say, 'Who would have hands like that?' It is a fantastic portrait – I don't know what is fantastic about it – it still speaks to me.

I find *Three Corroboree Sticks* (Plate 48) historically interesting; they come from the time of Geoffrey Bardon, and were painted by my skin brother, Nosepeg. I don't know whether they are secret, because Frank Bronson Nelson

(Michael's brother) painted a similar one this year. I like its vibrant pinks and greens and orange colours. It's just–alive.

Anatjari Tjakamara's painting (Plate 50) is a marvellous, spiritual work. There's the circle, womb, the waterholes, so much in their mythology; this is a wholly satisfying painting.

I bought the Paddy Japaljarri Stewart and the Paddy Jupurrula Nelson works because of the artists' association with the famous Yuen-dumu doors. I find it not so much spiritually satisfying as historically interesting. I always collect something for each period and explore influences. I am a historian at heart. I collect around an artist: works influenced by and influencing that artist. That way I can trace an artist's development.

I'm convinced that Aboriginal art is the most exciting art in the world today. As for what has happened to me as a result of my involvement ... I don't mind being odd woman out when I am among my old friends. They still do not understand that we need a new perspective on historical facts–Australia was neither settled nor conquered but annexed.

Once I came back to Australia and saw what we had in this country, I needed no other interest in art. This is our country, our art, our wonderful landscape, and the Aboriginal artists are my friends. I am only a custodian of their work.

Janet Holmes à Court

How did you decide to become a collector?
When Robert and I first married in 1966, we lived in Darlington in Western Australia, which had a high population of artists. There was an annual exhibition of local work which we always attended, and we usually bought a couple of pictures to put on the walls. Gradually a passion developed, and we decided to upgrade what we had to a collection, but with one fundamental rule: we would only buy paintings that we liked. Our motive was never about money; it has always been about the beauty of the art.

Was that where it all began?
No. There was something in my background. My parents were book and music collectors and there were always galleries to be familiar with since I was a child. I grew up being able to recognise paintings–what I mean is that, even as a child I could recognise artists like Van Gogh and Monet; art was like a natural part of my environment. Then, when we first employed Roderick Anderson, he suggested that we look at a particular area of concentration–early West Australian art. Already there was a stirring of some interest in the early history of Western Australia, but the art of early West Australian artists had not been focused on to any significant degree. Our West Australian collection is of great historical interest; some of it is not great art. But it is extensive and contains, for example, more than fifty pictures of what Perth city has been and includes Frederick Garling's *View from Mt Eliza, Perth, 1927.*

You've one of the most–if not the most–important collections of contemporary Aboriginal art in the world. How did this collection begin?
I've been aware of Aboriginal art all my life because my mother taught in an Aboriginal kindergarten and one of her great friends, Betsy Linton, taught art in Fremantle gaol. So we were always aware, in the family, that Aboriginal people had great artistic talents. Robert and I had bought Aboriginal paintings from about 1980, but it wasn't until we bought the Papunya Tula Mr Sandman Collection that I became really excited. We bought the entire collection when we saw the photographs, but it wasn't until later that I saw the originals in the London Museum of Mankind when the show was on tour between 1981 and 1985.

How do you decide what to buy and what not to buy?
In Aboriginal art, the decision is extremely difficult. I hardly ever see anything that I don't want. So much of it has a deeply moving spiritual quality. I'm not a religious person but I find the spiritual impact of Aboriginal art deeply moving. What we've always tried to do is to look at three aspects: the quality of the work, its importance or potential importance, and the significance of the artist. As in our non-Aboriginal collection, we've also focused on individuals and movements. We've never collected quite haphazardly with 'one of these and one of those'; we've focused on artists that we liked more than others; and we've always considered that our prerogative as we were building a personal collection. We've also focused on specific areas.

Has this made any difference in your life?
I suppose life is always influenced by who and

what is around you. Collecting Aboriginal art has given me greater understanding of Aboriginal people and their questions and their particular problems, and it's also been for me a broadening experience of life. The more you learn about Aboriginal art, the more you learn about Aboriginal people.

For Aboriginal people to know that the work they produce is among the best in the world and is valued, increases their self esteem and enables them to carry on with some of the battles after 200 years of such maltreatment.

I invited a friend from New York, an authority in French Impressionism, to visit Perth and spend some time with Anne Brody (the curator of our collection) looking at Australian and Aboriginal art. At the end of his visit, he said that the most exhilarating aspect of the whole Australian experience was this introduction to Aboriginal art.

You have always been generous in making your collection available both within and outside Australia. Is this because you believe so strongly in the importance of the art both for the Aboriginal people and for its contribution to the contemporary art scene?

I believe that there is a great role for private collectors in these two ways. State galleries can only go so far in lending works from their collections, simply because they belong to the public and must be protected. Rightly so. Many curators feel that they should not take risks in the places where these works are to be seen outside the safety of the public gallery. I think that private collectors can and should be slightly more adventurous. In that way Aboriginal and other art can be seen and known beyond the confines of the state gallery ambience.

Could you speak about any one work in this collection? Perhaps about the 'Alhalkere Dreamings', the five panels by Emily Kame Kngwarreye (Plate 40)?

Emily's work is totally unique. She is a marvellous woman with a great sense of humour who paints one story – her own. The whole Emily experience was one of the most exciting that we've had but it was also sad. We had sponsored Emily Kame Kngwarreye and Loui Pwele, two Utopia artists for a year. In that way, we hoped, it would be possible for them to spend a year painting in their own country without the necessity to sell their work. At the end of the time they would be able to see a whole range of their own work, a year's painting, and to enjoy it themselves before it was sold. That never happened. Outside commercial interests moved in on the Utopia artists, and there was a lot of genuine distress. Many of Emily's paintings from that year did not end up in the exhibition.

Of course Aboriginal artists are not the only artists to be so exploited.

Ruth Hall

The first time I saw Aboriginal art was on television, in a program on sand painting. I was gripped by the scriptural quality of the images and by the power of the ceremony, the theatre: the preparation for the dance, the use of ochre and feathers, the actual performance. Here was something I could not pass by. My enlightenment began. I read and enquired about such painting, and soon discovered other forms of Aboriginal art.

At first I looked, contemplated, allowed the art to work upon and within me. Then I purchased a work by Michael Nelson at an exhibition in Ballarat. So strong was this moment that I still remember exactly where the painting was hanging – on a stairwell. It encompassed us. I don't recall whether we could afford it at the time. What I do recall and relive is the elation and how, on the return journey to Melbourne, my husband and I talked incessantly about our good fortune in finding such a painting. The excitement seemed to affect my whole being: my emotions, perceptions, language, imaginings.

I am increasingly intrigued by seeing work that has been produced within an Aboriginal communal ethos. I am interested in how Aboriginal people work as a family, a community: the singing, the telling and retelling of stories, seeing works that are the sons and daughters of other stories, the now of the Dreamtime made present in the paintings. There's a continuity – nothing is lost in what is forever living, contemporary and eventful. Permeating all the images and stories, there is the land, timeless and evocative.

Works such as these tap into my own feelings and respect for family and continuity. My family – four children, sister, grandparents too – are central to my life. Friday night is our communal night, our coming together, our

family time. Our bonding is affirmed and strengthened in a shared family meal; we consciously participate in a time established for affirming family. The practice has an historical sense, a cherishing of tradition codified in books like the Talmud and ancient Hebrew prophecies.

Attending, I discern some parallel with how it is for Aboriginal people. Their stories, which are largely transmitted orally, sometimes become an even more tangible presence when expressed in paintings. What I respect and feel an affinity with is that their work reflects not only the traditions themselves but also the artists' efforts at maintaining those traditions. For me, there is a biblical quality to all of this: a richness in the forms of their ancient languages and ancestral imagery which articulates the strength of their society. I believe that the Aboriginal people's sense of family, community, land and traditions allowed their skills to survive despite the last 200 years of white occupancy of this country.

For me, collecting respects such meanings, and is bound up with how our love of Aboriginal art can be shared with the community. We were able to give a Clarice Poulson, barks and a Yuendumu Emu Dreaming painting to the National Gallery of Victoria. I feel proud that such art is here, in Australia, and I want to urge people, 'Please, come, look and see!'

When it comes to deciding what to collect, I suppose I am a bit of a sparrow. I have to be aware that we are small collectors with a limited budget (many people think that because you love art and want to collect, you have an unlimited budget). I tend to prefer the more contemporary works with their special visual impact, but I also have those early Papunyas. I love all of the works that I am lucky enough to acquire, and hope some time to fill many of the gaps in our collection.

I think the Emilies (Plate 40) are among the great wonders; they have subtlety, strength, rhythm and a kind of eternal music. You can look at this art forever. It reminds me of a John Olsen painting which reveals the broad view of the landscape and then hones in on the particular. I think that Emily captures the sense of expansiveness of life and of the heavens here. Uta Uta (Plate 55) is also very powerful. Johnny Warangula Tjupurrula painted *Artist's Country* (Plate 51) for John Kean. It seems to be a reflective landscape. There's a quiet dignity and strength of design about it. It also has great poignancy that is truly touching, and a power that doesn't seek to overwhelm you.

The background of the Clifford Possum (Plate 47) reminds me of the uniform desert landscape in Australia, where one can drive for miles and the landscape never appears to alter—but it does. The central panel in this work is beautifully painted with abstract forms. The animated snakes exude an energetic presence; they almost seem to fling themselves out of that central panel.

Aboriginal art has given me much enjoyment and has certainly changed my life. I think especially of the dignity of the paintings, and continue to be awed by initial contact with a collection. The first view of such collections elicits spontaneous response to the more striking paintings. Then, however, I consider seriously the works that dwell in my mind, the ones that demand to be discussed in greater depth and, importantly, the ones I have to come to terms with … these are the ones that should be bought.

Three Aboriginal Voices—Three Aboriginal Artists

Michael Nelson Tjakamarra

Michael Nelson Tjakamarra has exhibited widely in Australia and overseas. I spoke with him at Gallery Gabrielle Pizzi on the day of the opening of his 1990 solo exhibition.

I always do my work and painting in my own community at Papunya. This is most important for me. I want to show my work to the world so that white Europeans can understand what it is for. Without this, they wouldn't understand us, but when they see my work on big canvases and they see that I am a good artist, they know my name, they invite me out to dinner. I once did a painting on a BMW car which made white people very interested.

Tell me about the place where you paint.
I'm still in my Papunya camp. There's still about 100 to 150 of us there, although most of the others have shifted to outstations. I usually paint with Two Bob (Two Bob Tjungarrayi) and Paddy Carroll.

My grandfather taught me sand painting, body painting and shield painting when I was very young, so I began to participate in the ceremonies with my grandfather, uncles and brothers. My mother taught my sisters and my daughters about women's painting and their ceremonies.

When I paint I always have my children around me. I talk to them, tell them stories about our country and the place where different things happen. We often sit around the camp fire telling stories. I want to pass on my culture. I'm proud of my work. I want to show it so that others can see what Aboriginal artists are doing.

All my paintings are spiritual and tell the stories of Ancestors. [He goes to one of his paintings.] This is of this kangaroo, these [pointing] are his tracks. You can tell he's a bit frightened. These are possum tracks [again pointing]. Here is a rainbow. In the old days, they did singing and dancing about the rainbows and then the rains came. It was a magic thing.

Do you still believe that?
We still sing songs and dance and paint our bodies. And the young look at us and fall in love.

Most Warlpiri and Luritja know these same stories and paint and dance them. Warlpiri and Luritja people would know all the stories in these paintings. I don't know Pintupi stories well, and they don't know ours.

We are not like American artists. American artists make the story up in their imagination. Ours are not like that. Our stories are given to us to carry and pass on to our children.

What hopes do you have for your children?
I have six daughters and one son. It is up to him what he does. In the old days, my father would take me to a big corroboree that would last maybe twelve months. I'll ask my son. I'll tell him, but I'll ask him. Nowadays the corroboree only lasts two weeks, not the same as in the early days. [At this point I showed him the images in this book to see if any were of any particular interest. Only the Central Desert work got any comment and then only in terms of knowing/not knowing the particular artist/story.]
[Going with him to a particular work in the exhibition.]

Could you talk about this? How did you begin?
I drew this straight on to the canvas with black paint and a brush. I drew in the story first with its main places: the rock, the circles that are the waterholes, the wild potato plant in the middle. Then I painted in the colours. Only four colours in this, plus the ones I got from mixing the black, red, white and yellow. I use the white to bring out different parts, sometimes the black too; it's very good space in this painting. [Pointing] This is the Ancestor, coming out here and here, some old people used to tell us that these dead people come back—come out again as spirits but I do not know. I think maybe finish, dead.
[We then moved to other paintings and again the talk was dominantly in terms of myths and stories with their language of transformation.]

Banduk Marika

Banduk Marika is a traditional Yolngu woman from Yirrkala in the Northern Territory. She is an artist and printmaker who has spent most of her adult life in Sydney. She has returned to north-east Arnhem Land where she is a Rirratjingu land-owner.

Banduk, could you talk a bit about your father's painting of the Crucifixion (Plate 9)?
My father's *Crucifixion* . . . I was eleven or twelve when he did those. A lot of senior men who were leaders became Christians. Every Sunday meant a change of lifestyle. Every Sunday we would help get the men ready, dress them up in white shirts, shorts, long socks – Sunday clothes.

Those were the times when the Church was trying to change my people's way. My father was a man very steeped in the culture, the law and the land. Our people were not ready for the change that the mission sought. Our people were in two worlds. Maybe the serpent in my father's *Crucifixion* is his way of saying that Aboriginal culture is still strong for him.

Of course, I cannot talk for my father. He was the leader of our group, the Rirratjingu; he was also the ceremonial leader. He would be the one asked to arrange funerals and circumcisions as well as those rituals which were held as long after the event as ten years. He was the law maker and peace maker. In tribal wars, he was the one who stood between – he was that sort of a man.

And the mission?
The mission brought about great change. Our people didn't have a choice, really. They were not physically forced to the mission but material things forced them: the store was at the mission. They tasted white flour and sugar. Once you taste things, you can't reject them. In subtle ways our people were made to feel ashamed of themselves. The Church mentality still hangs on here. For instance, women who wear shorts are made to feel uncomfortable. But the old days were the hardest. Our people were told how great life would be with Jesus God, but no explanations were given as to why we should leave our old ways.

Today many Aboriginal people are confused. When you bring in parasites from the outside worlds, like drugs and alcohol, and with them the obsession to have material things like stereos and cassette players, my people cannot understand all that is involved in this system. For instance, they might spend all their money on a cassette player and then share it around; within a couple of weeks it is broken and they go back for another, even though this money should be spent on food for the family. Money is not important to many of them; most do not save or try to make it last – the future is rarely thought about.

How do you see Aboriginal art today?
As one of the judges in the current Aboriginal Artists' Award, I realised just how out of place Arnhem Land bark painting had become. Central Australia desert painting in acrylics on canvas has been so strongly promoted. Buyers can more easily understand it as a contemporary art form whereas bark paintings appear to be so very simple – natural ochres and clay on natural materials. But our painting is just as complex to someone who does understand it. For Aboriginal people who know the land, it is like a map revealing our land, our boundaries, our sacred sites. It carries not just the history but also the spirituality of who we are.

What concerns you most at present?
I'm just back from Warrnambool where I went with another woman artist from here. Together we took classes in linocuts, in schools and with adult people. This is part of my job. I enjoy teaching and seeing people get very excited about how simple these things can be. This is very important for Aboriginal people, that we do this. I don't work for myself; it is for the community.

Art is something that opens up doors.
Art is my key.

Peter Skipper

This extract from an interview between Peter Skipper and Duncan Kentish was carried on in the style of Kriol in daily use in the Fitzroy Crossing area. The interview has been reproduced verbatim, on Duncan Kentish's recommendation, so that the poetry and style of the spoken word can be retained. The interview took place in Fitzroy Crossing in October, 1990.

My name is Peter Skipper. I'll tell him stories of the early days [Ngarrangkarni or Dreaming], when I been born in Desert Coun-

try. That one from where they been travelling from Broome–marsh, saltwater...they been go that way–karra [pointing east]. They been go-o-o-o-o–find him big mob Mangkaja [barn owls] sitting down in that hole. Right 'round been sitting down. Mangkaja–meat Mangkaja, that bird. At Wiringarrijati–they been sit down at Wiringarrijati. He got a corroboree–Tingari place. Alright, they been lookin at–straight way they want to knock him, got a stick. Alright, they been miss him, miss him all the way. Well, big mob been get out whole lot–fly away. One fella stop–they been miss him 'bout, miss him 'bout, he fly all the way. They been lookin at, lookin at...*long* way. Alright, let him go–they been let him go that bird. Alright, 'nother place he been land–at Mangkajakura–in a hole. Alright, not that place, me! That bird been miss him–me! there now, *still* there.

Your parents–mother and father–they come from Japingka?
Yeah, twofella from Japingka country.

They been born there?
They been born there! Mother, she belong Japingka. All my brothers, all the father, and grandmother, grandson and grandpa–whole lot all belong Japingka.

You talking about spirit born?
Yeah, all been sit down there murungkurr [spirit of unborn child]–all belong murungkurr country–that one. Living water [permanent spring]–you know? Japingka. They been born there all from country belong all about–biggest–Japingka.

Me–I'm belong Mangkajakura. Well mother and father, twofella coming round there. Alright, might be twofella get me there murungkurr, jarriny [totem, linked individually with birth]. Might be twofella get him that–ground seed–that Ngurjana–food–and flat stone that grind him up–that's a jarriny. Alright, twofella been go round e e e e ! finish. I been born this side here–'nother place–'nother place I been born.

What name?
Payinjarra. Still, I'm belong Mangkajakura. Alright. When I been big, twofella tell me, mother father tell me: 'You belong Mangkajakura country. Country yours Mangkajakura.

Here you jarriny. I been give you jarriny at Mangkajakura. Alright, you jarriny belong you Ngurjana–you jarriny for Ngurjana, you.' I got flat one here [on the upper part of his head]. Because they been do him 'bout me like that [grind the Ngurjana seed] when they make him Johnny cake. Same like a cake–good tucker! [A lengthy, poetic description followed of harvesting, winnowing, grinding, making dough and grinding it into Johnny cakes.]

That's the jarriny–Ngurjana. What about that murungkurr?
Murungkurr, where you walking round. Every sandhill country–all river–riverside–all murungkurr there. You can see him, afternoon time: 'Ah, somebody walking here.' Alright, you can't see him any more [becomes invisible]. Mother father been walking round Mangkajakura and tuck out that Nugurjana–that for me, jarriny. After, my father been see that murungkurr–dreaming, he been see me. That way now. Father look him. He jarriny he look him. Oh! He's there, murungkurr 'oh baby, he coming up' e e e e finish. Alright, he tell him mother, 'One boy been coming to me. Little baby, murungkurr.'

Well, talking about this Mangkajakura painting again. You painted all this sandhill coming this way–tight up?
Yeah–he got one jilji there [sandhill]–alright, Two man been coming round–walking round. Well he been climb that jilji–looking at that Mangkaja bird: 'What this sitting down in his hole?' Well twofella been looking at...twofella been call him name. That's a Mangkaja! that one me. Alright, twofella been go...and this Milparnta [pointing to the ovoid green form]. One old woman and one girl–mother been keep her. Mother she got a sore eye and she been sing out to her daughter:
Milparta Karlajangka puparnta [repeats]
[eyes pain–from west-call him up]
Go and call him that young maparn [doctor boy] camped on that big jilji. I've got sore eye. Might be he can touch me–take something away. Make me better [young boys sometimes have special healing powers]...alright, this one Malajabi [green form with cave-tunnel extensions]–he living there, wallaby.

Wallaby living inside?
Yeah, inside. When all the people coming and

cleaning that water – cleaning, cleaning – make him – call him name for every soak-water – every living water – alright, they tell him like that: 'You go every way, all the wallaby, you go every – every soak-water, every rock-hole water.' He call him like that. Alright, one fellow get up from here – all the people – young fella – they play with him e e e e finish. They digging him e e e e finish...

That Mangkaja bird in Mangkajakura, [is] he you or might be father for you?
No, I'm coming from Mangkajakura. I been just turn himself murungkurr – murungkurr from bird. He pirlurr [central essence or spirit]. I been shift from Mangkajakura and sit on a tall sandhill in the middle [the three waterholes actually form a triangular configuration]. Twofella get me right there in a sandhill – mother father...

Is that the same sandhill little Mapurn boy was sitting at?
Yeah, same sandhill. Old woman been send him one girl to me. She want to call him up me.

That boy, that you?
Yeah, where I been sit down that pirlurr there – murungkurr. Call him up that young boy – *me*.

But you not born then, eh?
No, I never born. Only that murungkurr... I been walking round that Mangkajakura country till I been man. They make me man on Canning Stock route – right at Warupulka. Mine country again. Make me man from kid. After that I been just think about I want to go to kartiya [white man] place – station. What kind they call him station? They tell me, 'You go see that kartiya. Big mob food. He got flour, tea and sugar and tobacco and all that cattle, bullock.' Alright, I been leave. That's the way I been coming here from desert country.

Alright, one boss coming from Adelaide. He tell me, 'You do him my picture.' I don't know that picture. I been just think about what kind I got to draw for him... I'll have to draw him that Japingka mine – and put him all that water – and all that sandhill there – everything. Keep going now, more and more idea. Manakajukura and all that soak-water – where that Two Man been see him that Mangkaja bird.

I paint him Mangkajakura – I paint him about Mangkajakura – and that Japingka-...Japingka and Mangkajakura. Special place –

where I been sit down that murungkurr there.

So when you're painting that one, you feeling good inside?
Yeah, you're right. When I been painting this one, I think about, 'Ah, that way I'll paint him.' My place. I know still – I think about – I still think about right back where I come from... I don't put him riverside, I can't draw him riverside. I want him that my side Desert. This one mine – I been walking round here. I can't paint him 'nother place belong another country. That's a danger. And I don't want to paint business way [secret designs].

Before the Christian mob been come, and old people still been stopping in the desert, what they thinking about that spirit – that pirlurr. When someone pass away, what place he got to go?
Oh, I been thinking about meself, in a desert country, you know? When I been kid – ah – somebody told me – might be mother of father, 'Some people on top there living – and behind of the sky'. In it? I been say, 'And 'nother people underground. We middle, walking round.' Somebody pass away, 'Which way he gone?' 'Oh, on top. He got somebody there.'

Well Mr Smoker [missionary] been come – got a two way picture... I believe God when I been coming from Cherrabun Station. Alright, I been at the mission. I know that language book. When I pass away, God might help me... I can't draw him picture – Cross or anything...

Lot of Catholic they painting that Christian story...
Not me. I don't want to muck round with God. I don't want to paint him everything there. No. Missionary, he might see him that picture: 'Oh,' he tell me, 'what for you muck around with that God?'

What about Church been talking 'no more law' [traditional law]?
I coming from Law – I come out from Law. Still today I think about Two Way. I go that kid line – make him man – different, different corroboree. In jilalong, Balgo and Mulin. I make him man – me! I been come back Desert from Missionary way. Ah, still two way. I think about. He main one – God. Main one. Well, what he want to say? Judgement time. Judgement time. That's all. That much word mine.

CATALOGUE

Cataloguing contemporary Aboriginal art poses particular problems associated with the political and social history of the Aboriginal people in Australia, the remoteness of the artists' communities, the restrictions often imposed on access to the full iconography of the work, and the fact that Aboriginal art has been, until quite recently, the preserve of anthropology rather than art history.

The format of this catalogue is a standard one used by many art historians, but with one addition: the classification Language Group has been included. This refers not so much to the day-to-day language spoken by the artist, although it may include that, as to his identity within a larger social grouping. In Aboriginal culture, language, clan or tribe and land are inextricably linked.

While much of the information in this catalogue is derived from other published sources, every effort has been made to check its accuracy with primary sources—with artists, linguistic centres, art advisors, anthropologists and others in the communities.

Artist's name: The names recorded in the catalogue are the common names used by the artist. These frequently include the *skin* or subsection name after the surname; in Yuendumu, the skin name precedes the surname.

Date of birth: Aboriginal persons born outside mission stations before 1967 often do not have recorded birth dates, thus 'circa' often precedes the birth date.

Language: This is the person's language of formal social affiliation (Sutton 1988); the clan may also be given.

Place of residence: This usually refers to the artist's place of residence at the time of the painting.

Title and date of work: Aboriginal artists do not usually name their works. Where works have been named, the title is usually descriptive of some element in the story or is the theme of the painting.

Measurements: Height precedes width.

Most entries are followed by comments that include some or all of the following: some biographical data; the iconography (story) as given by the artist and recorded in the documentation of the present owner; a comment where applicable on stylistic characteristics which link the work to other modern art in Australia or elsewhere. Authorship of the comments is indicated at the end of each entry in the following way: MAGNT (Museums and Art Galleries of the Northern Territory); RH (The Robert Holmes à Court Catalogue); RC (Rosemary Crumlin); JDD;DK (Jarinjanu David Downs and Duncan Kentish); PS;DK (Peter Skipper and Duncan Kentish); MR (Michael Rae); MM (Michelle Mackenzie); WA (Warlukurlangu Artists, Yuendumu); MC (Margaret Carnegie); PT (Papunya Tula Artists Pty Ltd, Alice Springs); LD (Lauraine Diggins Fine Art Pty Ltd); JK (John Kean); AK (Anthony Knight); T (Tandanya Aboriginal Culture Institute Incorporated, S.A.).

Bathurst and Melville Islands

Plate 1: **Unknown artist** (Tiwi, Bathurst Island). *Purukuparli Story,* wooden sculptures. Museums and Art Galleries of the Northern Territory.

This work depicts Waijai carrying her dead son. (Refer to 'How death came into the world', p. 18.)

Plate 2: **Unknown artist** (Tiwi, Milikapiti, Melville Island). *Sun Shining on Jinani c.*1970, ochre on bark, 700 mm x 450 mm. Museums and Art Galleries of the Northern Territory, Holmes Tiwi Collection.

This bark alludes to the death of Jinani, the young son of Purukuparlu and Waijai ('How death came into the world', p. 18)

Plate 3: **Agnes Carpenter** (Tiwi, Milikapiti, Melville Island). *Purikikini the Owl c.*1969, ochre on bark, 690 mm x 460 mm. Museums and Art Galleries of the Northern Territory, Holmes Tiwi Collection.

This painting refers to the Ancestral Owl, who instigated the first Kulama initiation ceremony. This is one of the major Tiwi ceremonies, and is also concerned with the promotion of people's health and the maintenance of natural resources. According to tradition, Purikikini taught people to sing the Kulama songs and perform the different stages of the ceremony.

Plate 4: **Tommy Mungatopi** (Tiwi, Milikapiti, Melville Island). *Sun Shining on a Coral Reef c.*1970, ochre on bark, 765 mm x 365 mm. Northern Territory Museum of Arts and Sciences.

Plate 5: **Tommy Mungatopi** (Tiwi, Milikapiti, Melville Island). *Moon and Stars c.*1968, ochre on bark, 840 mm x 340 mm. Museums and Art Galleries of the Northern Territory, Holmes Tiwi Collection.

Plate 6: **Kararunga (Lame Toby)** (Tiwi, Milikapiti, Melville Island). *Crocodile Painting c.*1965, ochre on bark, 675 mm x 480 mm. Museums and Art Galleries of the Northern Territory.

A salt-water crocodile is indicated by the white dots. The yellow dots represent swordfish. The crosses represent the crocodile's tracks and its jaws and teeth are illustrated by the lines with parallel bars. (MAGNT)

Arnhem Land

Plate 7: **Peter Marralwanga** 1916–1987 (Kunwinjku, Marrkolidban). *Two Yawk Yawk Spirits,* earth pigments on bark, 850 mm x 550 mm. The Robert Holmes à Court Collection.

This painting depicts two Yawk Yawk spirits from Yelelban, a major site for the Yirritja moiety Nadjalama clan. These women, mother and daughter, live in the large billabongs at this site. The hair-like projections from their bodies can be seen as water-weed at the site. The women are said to have been killed by Ngalyod for cooking too near the billabong here. This site is in the artist's mother's country and was shown to the artist and his brother when they were young men. Marralwanga was one of the major custodians of the site. (HC)

Plate 8: **Peter Marralwanga** 1916–1987 (Kunwinjku, Marrkolidban). *Yawk Yawk and her Daughter* 1983, earth pigments on bark, 850 mm x 550 mm. The Robert Holmes à Court Collection.

This painting shows a Yawk Yawk spirit and her daughter, from Yelelban in Nadjalama clan country. The fin-like projections on the hands and feet of the spirit help her swim in the Dreaming billabong. Her long hair is waterweed. (HC)

Plate 9: **Mawalan Marika** 1908–1967 (Rirratjingu, Yirrkala). *Crucifixion c.*1968, ochre on bark, 55 mm x 352 mm. Museums and Art Galleries of the Northern Territory.

This is a rare example of a Christian theme by an artist who traditionally painted the religious stories of his own clan group. The Christian influence on the lives of the people of Yirrkala does, however, go back to the establishment of the Methodist Mission there in 1935. At this time, the mission's superintendent, the Rev. Wilbur Chaseling, believed in encouraging people to paint their own mythologies, not just as a means of making money but also as a way of reinforcing the general value of religious principles and practice.

Mawalan was one of the foremost artists from this early mission period. His paintings are housed in many State galleries. Here he has depicted the crucifixion scene in the narrative style characteristic of this region. Below is Christ and the flanking thieves on their crosses, attended by two of the soldiers. Above is the image of Christ ascending to heaven with wings. In the top right hand corner, he is depicted in his tomb. The meaning of the serpent was not explained when the painting was collected. (MAGNT)

Groote Eylandt

Plate 10: **Naidjiwarra Amagula** (Anindilyakwa, Angurugu, Groote Eylandt). *The Crucifixion of Jesus* 1964, earth pigments on bark, 430 mm x 570 mm. Diocese of the Northern Territory, Anglican Church.

These three works were painted while Naidijiwarra was a lay preacher and reader of the Anglican Church Mission at Angurugu in 1964. They combine Christian and traditional Aboriginal motifs in story, style and technique.

They are all painted on natural eucalyptus bark which has been stripped from the trees in the wet season and allowed to dry flat by steaming it first and then placing it under weights. The pigments

used are natural ochres and manganese.

Stylistically, these paintings belong with other Groote Eylandt barks from this time. The size of the figures, the way the composition moves to the edge, the decorative 'infill' of fine lines which probably does not indicate body paint design, and the plain black ground are common features of bark painting from the 1960s on.

The figure of Christ dominates the Crucifixion. He is painted stark white, a colour of great respect, and his cross is lifted from the surface with fine white lines. He is flanked by two thieves. In the lower half the soldiers, carrying Aboriginal spears and with knotted hair, watch while Jesus' friends mourn and weep with gestures that are Aboriginal and ritualistic. The fingers are counted on in white strokes and the hair is represented similarly. (RC)

Plate 11: **Naidjiwarra Amagula** (Anindilyakwa, Angurugu, Groote Eylandt). *The Burial of Jesus* 1964, earth pigments on bark, 365 mm x 600 mm. Diocese of the Northern Territory, Anglican Church.

The Christ lies in the tomb, horizontal, wrapped in death between two angels. In this painting the Christ figure is not clothed in white; it is the angels who have white wings, haloes and fingers. As with the other paintings in this series, the figures have been drawn in first with brown ochre and then filled in with design. The white clay parts have been added last and over-painted in places to make them more solid. (RC)

Plate 12: **Naidjiwarra Amagula** (Anindilyakwa, Angurugu, Groote Eylandt). *The Ascension of Jesus* 1964, earth pigments on bark, 410 mm x 585 mm. Diocese of the Northern Territory, Anglican Church.

Although this is named on the back as *The Ascension of Jesus,* it may have been intended as the *Transfiguration,* for the figure of Christ is flanked by two figures (in this story, Moses and Elijah) and below three figures (in the story, Peter, James and John) kneel in worship (Mt 17,1–9). There were no witnesses to the Resurrection, and the account of the Ascension is differently described (Luke 24:46–53). As in the *Crucifixion* (Plate 10), the figure of Christ is central and glows, white. (RC)

Turkey Creek

Plate 13: **Rover Thomas** b. 1926 (Kukatja, Wangkajunga, Turkey Creek). *Wolf Creek Crater: Gundimulul,* natural ochres and bush gum on hardboard, 1097 mm x 697 mm. The Robert Holmes à Court Collection.

The inner circle depicts the grassy interior of the crater and the black band its outer edge. Wolf Creek Crater lies in desert country. (HC)

Plate 14: **George Mung** b. 1921 (Kija, Turkey Creek). *Ord River Country,* earth pigments on a wooden panel, 785 mm x 2300 mm. The Catholic Warmun Community, Turkey Creek, WA.

George Mung (Mung-Mung) is an elder and leader in the Warmun community. He is a consummate carver and a prolific painter of the country and mythical animals. With Hector Sundaloo (Plates 16 and 17), he goes back each day to the school and uses his paintings to pass on in word and song to the children the stories and myths of the traditional culture. (RC)

This is my Country Ord River.
Ord River is a big river with big water and big paper bark trees
standing at the side of the water.
There are two springs of water that feed into the river. (George Mung, 1990)

Plate 15: **George Mung** b. 1921 (Kija, Turkey Creek). *The Pregnant Mary,* wood with painting in natural clays and ochres, height: 640 mm. The Catholic Warmun Community, Turkey Creek, WA. This tree branch was cut deep in the Bungle Bungles during the Wet and then brought back to Frog Hollow near Turkey Creek for curing. Using a sharpened car spring, George Mung cut the figure from the single block.

The Pregnant Mary was meant to replace a plaster statue of Mary broken when it fell off a table during a prayer meeting. This was to be a 'Travelling Mary'–an Aboriginal Mary, pregnant with child and accompanied by a small carved bird, her guiding spirit.

The figure stands erect, the man-child is on a shield under her heart. Already he is an adult; his arms are outstretched to touch the edges of the womb. The figure of the Mother is painted with the body design reserved for young Aboriginal girls.

The Pregnant Mary is a work of immense power and deep spirit. It bridges two cultures and manages to communicate with both. Historically, it stands equal with the great religious images of Western culture–alongside the Lipchitz Madonna of Iona or the Richier crucifix at Assy. (RC)

Plate 16: **Hector Sundaloo (Djandulu)** b. 1927 (Kija, Mirriwong; Turkey Creek). *The Dead Christ in the Tree,* earth pigments on canvas board, 920 mm x 600 mm. The Catholic Warmun Community, Turkey Creek, WA.

Hector Sundaloo is a recognised Ngapuny man in the Warmun community. He leads religious services, composes hymns and teaches the children. He appears to live as comfortably with Christianity as with his traditional beliefs and values. He is a prolific painter and often works through the night creating paintings of deep religious feeling but rooted in the land.

The Dead Christ has been in the community for some years. It was created as part of the Easter ritual and is still used at that time. The Christ is dead, his body lying horizontal in a tree waiting for Aboriginal ritual.

The composition is simple and spare. The white areas are local river clay, the ochres he grinds from rock. Both are mixed with gum gathered in the bush 'a long way from here'.

Recently, Sundaloo has moved from figurative paintings like this to using large rock shapes over a deep brown base. The rocks are at once the land around Turkey Creek and the outstation, Frog Hollow, and also figures of people—Jesus, Mary, Joseph and local people—'you and me,' as he says shyly. (RC)

***Plate 17*: Hector Sundaloo (Djandulu)** b. 1927 (Kija, Mirriwong; Turkey Creek). *The Young Joseph and Mary,* earth pigments on canvas board, 600 mm x 920 mm. The Catholic Warmun Community, Turkey Creek, WA.

Rethinking and reimaging story in a different culture requires extraordinary insight and creativity. Within the history of Christianity it is rare. Hector Sundaloo has taken the Gospel story of Mary and Joseph and imaged it afresh within his own people.

The two figures are the young Mary and the young Joseph. They stand together yet apart, for within this Aboriginal group they would not be allowed to speak with each other until they come together in ritual. But each is accompanied by a holy Spirit—male for the male, female for the female.

Again Sundaloo reveals himself as a master at organising two-dimensional space simply and with very sparse means. *The Young Joseph and Mary* is a work of great religious power. (RC)

***Plate 18*: Paddy Williams** b. 1910 (Kija, Turkey Creek). *Christ and the Battle,* earth pigments on canvas board, 570 mm x 780 mm. The Catholic Warmun Community, Turkey Creek, WA.

Here a battle is taking place. It is in a great clear space surrounded by Kimberley hills. Men are killing each other for the rights to the land. In a gap in the hills stands a solitary boab tree, a heart painted on its trunk. 'That's Jesus', said Old Paddy Williams recently, 'telling them fellas to stop'.

Like Hector Sundaloo and George Mung, Paddy Williams is a consummate artist, constantly painting images of the land even though he is a great age and his eyesight is failing. (RC)

Daly River

***Plate 19*: Mary Kanngi** born *c*.1925 (Ngangiwumirri, Nauiyu Nambiyu, Daly River). *Mininjtjimuli,* synthetic polymer on canvas board, 610 mm x 450 mm. Private Collection.

'This is a painting about special food that grows on the hills around Daly River. The small circles around three sides are the flowers of the plant—purple is their true colour. On the left hand side are the leaves. The roots, represented by the heavy black line (in the yellow background) spread for some distance under the earth. The Aboriginal

name of the plant is "Mininjtjimuli." (This description was given by Mary Kanngi to Eileen Farrelly.)

***Plate 20*: Miriam-Rose Ungunmerr-Baumann,** b. 1950 (Ngangiwumirri, Nauiyu Nambiyu, Daly River). *Stations of the Cross,* synthetic polymer on board, 14 paintings, each 255 mm x 360 mm. Catholic Church Community, Daly River, NT.

Miriam-Rose Ungunmerr-Baumann is an artist, a School Principal and Council President of the Nauiyu Nambiyu Association of Daly River. She is a recognised leader among Aboriginal communities in the Northern Territory and deeply respected in civic and church circles. At Nauiyu Nambiyu she helped found the Majellan House Women's Centre which is now the creative centre of the community, producing and selling batiks, silks and paintings. It is also a place where the women can meet together.

These Stations of the Cross were commissioned in 1974, at the time of the rebuilding of the church. Her brief was to incorporate an Aboriginal point of view. Historically, this is an important work, well known and popular among non-Aboriginal people. For Miriam-Rose herself, these are now seen as a work of her youth. She is reflective and thoughtful about the complexity of including Aboriginal elements into non-Aboriginal traditions in this way.

Ordinarily the works hang sequentially in the church so that Christians in devotion can walk the Stations of the Cross. They are liturgical art and not studio or high art. (RC)

***Plate 21*: Miriam-Rose Ungunmerr-Baumann** b. 1950 (Ngangiwumirri, Nauiyu Nambiyu, Daly River). *Stations of the Cross* (detail—*The Burial*), synthetic polymer on board, 14 paintings, each 255 mm x 360 mm. Catholic Church Community, Daly River, NT.

This is the Fourteenth Station, The Burial of Jesus. The body of Jesus is carried to the tomb by six men, their faces and bodies ceremonially painted. Along the central figure of Jesus is a huge snake, a frightening yet mysterious figure in Aboriginal as well as in Christian iconography. It is the Rainbow Snake, the snake of the Garden of Eden, the treacherous water snake of the swiftly flowing Daly River. Here it is meant to symbolise (Ungunmerr-Baumann, 1984) the powers of evil overcome through the death of Jesus. (RC)

***Plate 22*: Brigid Julaluk** b. 1948 (Ngangiwumirri, Nauiyu Nambiyu, Daly River). *Turtle in the Water,* earth pigments on hardboard, 460 mm x 610 mm. Private Collection, Melbourne.

The long-necked turtle is a common source of traditional food in the Daly River area; turtles abound in the billabongs. Brigid Julaluk's painting in local materials reveals an easy familiarity with the form and a freedom in its representation. Such decoration, part symbolic and part simply space-filling, is typical of the present work of the women of the Majellan House Centre. (RC)

Fitzroy Crossing

***Plate 23:*Jarinyanu David Downs** born *c.*1925
(Wangkajunga, Walmajarri; Fitzroy Crossing).
Moses and God and the Ten Commandments 1989,
synthetic polymer with natural ochres on linen,
1830 mm x 1220 mm. The Robert Holmes à Court
Collection.

'Moses and God now worked on making the Ten
Commandments. This one Moses and this one God
[left and right forms respectively]. God he more big
because he more powerful. But Moses is little bit
like a God too, because he never die [assumed
bodily into Heaven]...Make Him again–finish!
[second version]. Well this one God been make him
and this one Moses make him [right and left as
above]. White dots, big stones all around'.

Downs locates the Moses story-cycle as being
part of Ngarrangkarni–the beginning of things. Not
surprisingly then, he employs imagery used in the
symbolic representation of the Nganpayijarra–the
travelling Two Men, archetypal witnesses to the
beginning of Desert Australia and responsible for
distributing 'special gear' throughout the region.
The parallels with the Nganpayijarra are several:
God is reckoned as being more powerful than
Moses, but Moses is seen as being *like* a God, as
evidenced by his special powers. Consequently
God and Moses are viewed more as older brother
and younger brother, as in the model provided by
the Nganpayijarra.

The resultant image is a potent icon of pure
duality: large/small, powerful/less powerful,
animate/inanimate, mountain/desert. These oppo-
sitions are expressed in terms of light and dark
colour contrasts–black and white, brown and pink–
the form and the void are distinguished by dotting
and undotting. And the transcendent image is given
a local focus through being placed on a ground of
Jarinyanu's dark red ochre from Christmas Creek
Station, where he worked as a stockman and raised
his family. (JDD;DK)

***Plate 24:*Jarinyanu David Downs** born *c.*1925
(Wangkajunga, Walmajarri; Fitzroy Crossing).
Nganpayijarra (Two Man Dreaming) 1987,
synthetic polymer with natural ochres on linen,
1220 mm x 1830 mm, The Robert Holmes à Court
Collection.

The Ngarrangkarni Nganpayijarra travelled Desert
Australia, creating their own sites and witnessing
into ordered existence the exploits, transformations
and names of other Ngarrankarni beings.

Here they have returned from the east, self initi-
ated, to Ngaiyirli, west of Balgo. Both are Maparn
or Doctor Men, though the older is 'more Maparn'
than his brother. They have painted themselves
with love magic symbols including the Yalpuru 'H'
design, on their chests; this is also the symbol of
their presence.

In this painting they are rendered symbolically
in the same manner, recalling the always related
landscape image of two boulders in close proximity.

The undotted areas represent campfires, while the
enclosing 'U' forms are windbreaks. To the right
stands their mother, Patuwapiwapi, restraining her
similarly named dog, and saying, 'These are my two
sons'.

After painting themselves up, the Nganpayijarra
are enormously impressed with each other's designs
and become very affectionate towards each other,
embracing fondly. The embracing is also partly
because there is no fire, and the two men are
hugging each other to keep warm. A song related
to this scene refers to 'big wind coming'.

The combination of symbolic and realist ele-
ments gives the image great iconic power, emphas-
ising the idea of transformational cross-over, and that
one is always inherent within the other. (JDD;DK)

***Plate 25:* Peter Skipper** born *c.*1929 (Juwaliny,
Walmajarri; Fitzroy Crossing). *Jila Japingka* 1990,
synthetic polymer on canvas, 2140 mm x 1370 mm.
Courtesy Duncan Kentish Fine Art.

Jila Japingka is a complex of spring soaks or jila,
known as 'living water' in English because they
never dry up–underscored by the active presence of
a water snake. Drift sand does have to be removed
occasionally before the water can be reached.

Japingka was created in the Ngarrangkami. As a
young man, Japingka travelled the desert visiting
other rain-water men and carrying sacred 'gear'
which was exchanged or stolen during these travels.
When the time came for him to finish, he lay down
in Jila Japingka, transforming into the big water
snake Kalpurtu. He is still living there and has a
backbone like a big rock.

This painting is an aerial perspective of Jila
Japingka country, combining cartographic and
symbolic forms. The cruciform Japingka is a lake
fed by underground streams from the cardinal points
of the compass. These are named after four distinct
rain seasons and have a counter-clockwise flow
cycle. The image can therefore be read as a calendar
of rains. The parallel forms with bulbous intervals
represent both sandhill ridges and cloud forma-
tions, while the surrounding groups of chevrons are
Yilpin, the ribs of the water snake.

Towards the end of the Dry, Jila Japingka would
be ritually remade in a ceremony emphasising a
complex web of interrelationships. This would
unsettle the snake and finally bring rain. (PS;DK)

Balgo

***Plate 26:* Tjumpo Tjapanangka** born *c.*1930
(Kukatja, Balgo). *Wilkinpa, Artist's Country* 1990,
synthetic polymer on canvas, 1200 cm x 1800 cm.
Private collection, Sydney.

The painting offers a panoramic view of the artist's
country in the remote area to the west of Lake
Mackay. All of the features represented were
formed by Tingari spirit-beings in the Tjukurrpa,
or Dreamtime. The area is marked by its many

small claypans (usually dry) and the row upon row of sandhills. The artist says that the area was important for men's ceremonial life and many people used to come. (MR)

Plate 27: Bridget Mudjidell born *c.*1934 (Ngardi, Balgo). *Kunakulu, Artist's Country* 1990, synthetic polymer on canvas, 1200 mm x 600 mm. Private collection, Sydney.

This painting concerns the myth of the local Ngardi people chasing away the other Kukatja, Warlpiri and Wangkatjunka people. The work also shows the main bush foods and water sources on this woman's land. Bridget Mudjidell lived here when young and visits the area regularly. (MR)

Plate 28: Bye Bye Napangarti, Jemma Napanangka, Millie Nampitjinpa; Kunintji Nampitjinpa (Ngardi, Yagga Yagga). *Tjibari: A Women's Healing Song* 1989, 1130 mm x 830 mm, synthetic polymer on canvas, Desert Women's Project, Balgo.

In 1989 the women of Balgo decided to do something to assure that the Women's Law belonging to the different Balgo groups was passed on to the young and to others who sought to understand. They chose to do this through story in paint, song and dance. This is one of four paintings (banners) created by them. This banner tells a Dreaming myth of the Ngardi group and was a group project by these four Ngardi women. It tells of a very long journey undertaken by two young girls to find living water–water which would never dry up. Along the journey they stopped at soaks, painted their bodies, danced and sang and rested and then moved on. Eventually they came to Kappurulungu, a spring that never dries up. They go underground forever (see page 13 for their own account).

At the bottom of the painting are the two women setting off on their journey, towards the top in the middle are the sisters at the journey's end; elsewhere are the body designs they painted, the digging sticks they used, and the places they passed (the circles).

This painting is meant to be a strong declaration of the importance and enduring quality of Women's Law, as Jemma Napanangka said:
'Women's Law, Women's Culture–
Yawulyu–we hold really hard.
We don't lose him or leave him
this culture for women
This is really strong, this Law for all
the women
this women's Law.'

At the Shinju Matsuri festival in Broome in 1989 the women sang and danced this painting into life. (MM)

Plate 29: Greg Mosquito and other Balgo men (Kukatja, Balgo). *Last Journey of Jesus* 1982, synthetic polymer on material, 1800 mm x 3810 mm. Balgo Catholic Community.

This banner was created by a group of Balgo men for the solemn Holy Week services of 1982. It is still used each year for that liturgy, so it is art which functions in the service of the sacred as an integral part of ritual celebration.

As in Miriam-Rose Ungunmerr-Baumann's *Stations of the Cross* (Plates 20 and 21), the subject matter is the last steps (Stations) of Jesus from the time when he was condemned to death until he was laid in the tomb. Each station here is marked by the same symbol, and joined by footprints. The journey twists snake-like through the painting. The background contains symbols from traditional Aboriginal mythology (emu, snake, footprints, fish) together with some common Christian symbols (chalice, crown of thorns, crosses, nails). (RC)

Plate 30: Matthew Gill Tjupurrula b.1960 (Kukatja, Balgo). *Motherhood* 1982, synthetic polymer on cotton duck, 2400 mm x 1190 mm. Balgo Catholic Community.

Matthew Gill was a leader among Balgo artists at this time and his hand is on many of the banners and in murals on school walls.

This strangely prophetic work, created and revered as sacred art in the church, emphasises the physicality of motherhood in an explicit way. The work usually hangs behind the devotional, German statue of the Madonna in the church. (RC)

Lajamanu

Plate 31: Abie Jangala born *c.*1920 (Warlpiri, Lajamanu). *Water Dreaming,* synthetic polymer on canvas, 915 mm x 1220 mm. The Robert Holmes à Court Collection.

The site for this Water Dreaming is not documented. However, meander lines in Jangala's Water Dreaming imagery generally represent water courses, while the straight bars represent clouds and rainbursts. (HC)

Plate 32: Lily Hargraves Nungarrayi (Warlpiri, Lajamanu). *Bush Tucker* 1987, synthetic polymer on cotton duck, 1260 mm x 810 mm. Private collection.

Plate 33: Llona Napurrurla born *c.*1923 (Warlpiri, Lajamanu). *Bush Tucker Dreaming* 1989, synthetic polymer on canvas, 1090 mm x 1770 mm. Private collection.

This is a painting concerned with women gathering berries and digging for yams. The circles are the campsites and between them are the digging sticks used to find the food. This is the most superficial level of meaning–that available to the uninitiated, the outsider.

Yuendumu

Plate 34: Michael Japangardi Poulson born *c.*1950 (Warlpiri, Yuendumu). *Yurrampi Jukurrpa*

(Honey Ant Dreaming) 1989, polymer paint on canvas, 910 mm x 910 mm. Manyuku, Melbourne.

'Yurrampi' is the Warlpiri name for the honey ant. The worker ants collect nectar from flowering plants and feed it to ants that store it in their abdomens and live deep underground. Women dig for yurrampi in summer, particularly after rains when the ants move closer to the surface. Their abdomens are squeezed and sucked. The nectar, having the consistency of very light honey, is considered a delicacy.

The Yurrampi (honey ant) Dreaming is well known as being associated with three desert communities: Papunya, Yuendumu and Yulumu (Mt Allen). The Dreaming path travels from the west through Yuendumu, while another Dreaming path travels from the south through Papunya to converge at Yulumu. From Yulumu the unified Dreaming travels further east towards Queensland. Michael has painted three different symbolic designs associated with the honey ant Dreaming. The cross-like design refers to the Dreaming beings sitting around a fire at the centre. When the rain came the fire was extinguished and so the beings started to travel in different directions, digging for honey ants as they went. The concentric circle in the central design also represents the beings seated around a fire. The sites referred to in the painting are Warluwangu, Yakurakajiand and Yulyupunyu. (WA)

Plate 35: **Paddy Jupurrurla Nelson** born *c.*1925, **Paddy Japaljarri Stewart** born *c.*1940 (Warlpiri, Yuendumu). *Bush Potato Dreaming* 1988, synthetic polymer on canvas, 1830 mm x 1220 mm. Margaret Carnegie Collection.

These two men have collaborated on a painting of the Puurda (Bush Potato) of which Japaljarri is kirda, or owner, of the Dreaming. The Dreaming is from the country north of Yuendumu on Mt Dennison station where there is a secret cave called Ngapiripunyu. Japaljarri has painted concentric circles to represent both features in the topography of the landscape and the Puurda plants from which extend the roots and edible vegetables. (WA)

Plate 36: **Darby Jampijinpa Ross** born *c.*1910 (Warlpiri, Yuendumu). *Rain/Water Dreaming* 1989, polymer paint on canvas, 3660 mm x 915 mm. Private Collection.

The Rain/Water Dreaming belonging to Jampijinpa Jangala subsection travelled to Polkipilki, creating many sites along the way (each concentric circle represents a site–from right to left). The journey starts at Warlura, east of Yuendumu. 'Warlura' is also the Warlpiri name for gecko. A Warlura ancestor's footprints were filled with the rainwater from a large cloud at Lapakura and Warlura, creating the rockholes at these two sites. The Dreaming goes on to Warankurlpu, a hill west of Yuendumu, and Yinjirriwarnu, another rockhole, where the rain reached flood proportions. In the centre of the painting is Wilpirri, where the lightning hit a gum tree, creating a soakage that never dries up. Then,

on to another soakage, home of the Kirrkarlani (whistling eagle) and Chinkiwarnu, a soakage near Mikanji, which was created as a blind cloud hit another tree. The next site is Jukajuka, a large rock formation which is said to have been left behind by the Kurdu Kurdu Mangkurdu (children of the Rain Dreaming, young clouds) who camped there one night. The journey ends at Pilkipilki, where the Jampijinpa/Jangala ancestors' spirits entered the Mulju (soakage) which was made by lightning. (WA)

Blackstone Ridge

Plate 37: **Kebbe Nelson** born *c.*1935 (Ngaanyatjarra, Blackstone). *Bigwater Campfires* 1990, synthetic polymer on canvas board, 406 mm x 508 mm. Private collection.

The big coloured circles in the middle represent the big waterhole, the smaller circles are the various campfires belonging to different groups. The lines between are the tracks made by different people as they move between camps.

The work carries a superficial but real resemblance to some of the post-German-Expressionist painting of artists like Paul Klee, as they moved with great sophistication and deliberation towards total abstraction. Nelson in this work is not concerned with levels of abstraction, nor consciously with formal qualities; the work is essentially narrative and symbolic and encodes the myth of his people. (RC)

Plate 38: **Kebbe Nelson** born *c.*1935 (Ngaanyatjarra Blackstone). Untitled 1989, synthetic polymer and oil on canvas board, 380 mm x 250 mm. Private collection.

Although the subject matter of this painting is not known, two visual factors warrant mention. Firstly, the artist has used oil paint as well as acrylic, which is most unusual among Aboriginal painters. Central Desert painting, which takes many hours, is dependent, in its present phase, on the availability of quick-drying colour and on ease of application. Acrylics satisfy these needs. Oils are more complex to use and slower drying, and thus more liable to collect red dust on their surface. Secondly, this work is reminiscent of some of the earlier Papunya painting, particularly that of Charlie Tararu Tjungurrayi, whose early work, for example, *Water Story* 1982 (Crocker, 1987:43) employs a similar meandering line but edged with white dots. The same visual device is frequently used today by the artists at Turkey Creek who still work with earth pigments and eucalyptus gum (Plates 13 to 18). (RC)

Plate 39: **Whisky Lewis** born *c.*1925 (Ngaanyatjarra, Blackstone). *Wati Kutjarra,* synthetic polymer on cotton duck, 860 mm x 555 mm. The Robert Holmes à Court Collection.

The story for this painting concerns the activities of two ancestral beings, the Wati Kutjarra, at the site at the western end of the Blackstone Ranges. (HC)

Utopia

Plate 40: **Emily Kame Kngwarreye** born *c*.1916 (Anmalyerre, Soakage Bore). *Alhalkere Dreamings,* synthetic polymer on canvas, five panels, each 1500 mm x 500 mm. The Robert Holmes à Court Collection.

The five panels form one work on the theme of the artist's Dreamings from Alhalkere country. (HC)

Emily Kame Kngwarreye, like many other women at Utopia, moved to painting with acrylics only in the last couple of years. Before that she had worked with batik on silk. All five panels of this work are meant to be viewed together. Her painting reflects the layered transparency of batik but her colour is translucent, and has been built up through many touches of paint which overlap and meet to create an illusion of depth and movement. Although these works relate visually to the modern art tradition that began with Seurat's understanding of the effects of light and has become familiar through the works of artists such as Robert Delaunay, Julius Bissier, Jackson Pollock and, more recently, Gerhard Richter, the resemblance is purely visual. The emphasis in Emily Kame Kngwarreye's work, however, is not primarily on the visual, for her world view is imbued with spiritual meaning that has a tradition many thousands of years old and that embraces the whole of life–story, myth, seeds, flowers, wind, sand–as she says, 'Everything'. (RC)

Plate 41: **Lyndsay Bird Mpetyane** born *c*.1935 (Anmatyerre, Mulga Bore). *Initiation–Old Fella's Dreaming* 1989, synthetic polymer on canvas, 2135 mm x 1320 mm. Private collection.

The old men sit on the ground and watch the initiation ceremony.

Lyndsay Bird Mpetyane is one of the few male painters at Utopia, where the women have taken the initiative from the beginning, especially through their batik work in silk, and more recently with series of canvases and boards. Lyndsay Bird Mpetyane moves with strength and confidence in these two works, orchestrating the colour and shape in sophisticated visual patterns that trap the eye and keep it moving within the space.

The subject matter is an initiation ritual. The figures of the old men who remember are symbolically represented around the bigger units. (RC)

Plate 42: **Lindsay Bird Mpetyane** born *c*.1935 (Anmatyerre Mulga Bore). *Initiation–Young Fella's Dreaming* 1989, synthetic polymer on canvas, 2135 mm x 1320 mm. Private collection.

Papunya

Plate 43: **Kaapa Tjampitjinpa** b.1926 (Anmatyerre, Aranda; Papunya). *Corroboree and Body Decoration c*.1972, synthetic polymer on board, 220 mm x 355 mm. Margaret Carnegie and Roderick Carnegie Collection.

This painting is part of a collection of works originally belonging to Geoff Bardon. Kaapa Tjampitjinpa, a senior Aranda man, was at Papunya when Albert Namatjira was confined there. He was already a painter of power when Geoff Bardon arrived. Kaapa told Daphne Williams of Papunya Tula that he was the first painter to work on the now famous *Honey Ant Dreaming* mural in the school.

According to Geoff Bardon's notes on this work, the red lines can be seen as the body painting done on males for the corroboree; the white lines represent those painted on the rock for corroboree.

This work, with its strong flat design and sharp special effect, resembles some of the effects created painstakingly by Op artists in the 1960s and 1970s in Europe and America. But the resemblance, although startling, is accidental. Kaapa's concern was with story and meaning: the surface pattern and even the power of the composition was created more instinctually and in the service of the symbolic layer of the work. The full meaning of the work is not accessible to the uninitiated. (MC)

Plate 44: **Tommy Lowry Tjapaltjarri** *c*.1935– 1987 (Pintupi, Ngardajarra; Kintore). *Tingari Dreaming* 1986, synthetic polymer on canvas, 1830 mm x 1525 mm. Gabrielle Pizzi Collection.

This painting depicts designs associated with the Moon Dreaming at the site of Yarratanya. At this place there is a large cave with waterholes.

The central roundel represents the stomach of the Moon Ancestor. The arcs show when the moon is small and also represent rib bones. The roundels on the outside of the painting show the camps of one lone man. He lived here, in the outstation of Kintore, without a wife and with only his dogs for company. (PT)

Plate 45: **Charlie Egalie Tjapaltjarri** (Warlpiri, Papunya). *Corroboree Dancing c*.1972, synthetic polymer on board, 775 mm x 430 mm. Courtesy Lauraine Diggins Fine Art Pty Ltd.

This is a very early Papunya painting, one originally collected by Bob Edwards from Geoff Bardon. Charlie Egalie Tjapaltjarri's country is north west of Alice Springs around Waite Creek in Central Australia; so his mythology is Warlpiri and particular to that area of country.

Corroboree Dancing shows figures around ceremonial fire places. They are seated in strict order. The spiralling lines enclosing these fire places are the patterns of the corroboree dancing. (MC;LD)

Plate 46: **Dinny Nolan Tjampitjinpa** born *c*.1946 (Anmatyerre, Aranda; Papunya). Untitled *c*.1977, synthetic polymer on canvas, 1890 mm x 860 mm. Margaret Carnegie Collection.

Plate 47: **Clifford Possum Tjapaltjarri** born *c*.1943 (Anmatyerre, Papunya). Untitled, synthetic polymer on composition board, 840 mm x 560 mm. Private collection.

Clifford Possum Tjapaltjarri was a teacher of carving in the Papunya school when Geoff Bardon arrived in 1971. He was also a stockman at Narwirtooma Station (Tandanya). Possum's painting carries the carver's attention to detail and a superb use of line to describe the figures; it also evokes the feeling of his story. Clifford Possum Tjapaltjarri is recognised as one of the outstanding painters of the movement. He won the Alice Prize in 1983.

Here the snakes rise and move in the front plane of the painting and form, with the waterhole and crevice, a strong cross shape which dominates the composition. The ochre shapes behind are the earth and rocks in the desert. (RC)

***Plate 48:* Nosepeg Tjupurrula** born *c*.1914 (Pintupi, Papunya). *Three Corroboree Sticks* 1971, synthetic polymer and water paint on composition board, 570 mm x 715 mm. Margaret Carnegie and Roderick Carnegie Collection.

Geoff Bardon bought this painting from Nosepeg Tjupurrula, one of the Pintupi leaders in Papunya in 1971. Bardon had given some purple, green and tangerine paint to Nosepeg and four others a couple of days before. They'd all done the same sort of painting as Bardon recalled: 'Three corroborree sticks surrounded by a sort of halo, and all in tangerine and green with a bit of yellow tossed in. I bought Nosepeg's because it was the political thing to do. He was the leader.' The thin paint and the simplicity yet sureness of the composition testify to Nosepeg Tjupurrula's maturity. The symbolic level of this painting cannot be revealed but it is clearly a work which easily communicates a sense of mystery and the spiritual. (MC)

***Plate 49:* Charlie Tararu Tjungurrayi** born *c*.1920 (Pintupi, Papunya). *Tingari Cycle* 1990, synthetic polymer on board, 1530 mm x 350 mm. Private collection.

According to Andrew Crocker (Crocker, 1986), who knows him personally, Charlie Tararu Tjungurrayi is a man of two cultures and his paintings are bridges between them. Tararu was twelve and living with desert Pintupi when he saw his first white person at Mount Liebig. During World War II, he worked with the Australian Army at Adelaide River and later worked as a dogger to provide rations for his family, who were still living traditionally in the desert. He was one of the labourers for the buildings at Papunya. In the late 1970s he moved back to Kintore, near his birth place, Tjitururnga. (RC)

In a fascinating traditional design of concentric circles, almost haptic in concept, the artist here depicts the Tingari Cycle associated with the travels of the Tingari ancestors west of Nyirripi. The roundels represent water soakages where the Tingari stopped to rest and drink during their long journey. (PT)

***Plate 50:* Anatjari Tjakamara** born *c*.1929 (Pintupi, Papunya). Untitled 1988, synthetic polymer on canvas, 1830 mm x 910 mm. Margaret Carnegie Collection.

Anatjari Tjakamara was moved in from the desert to Papunya in 1965. His was the last of the desert groups to be sent to this government settlement. In 1978 he moved to Docker River and then to a small outstation with his family group at Tjukula, south of Lake MacDonald, in traditional Pintupi country in Western Australia.

Anatjari is a successful contemporary painter with an international reputation. In 1989 the John Weber Gallery in New York City held a one-person exhibition of his work. He is represented in the collection of the Metropolitan Museum of Art, New York City. (RC)

This painting tells of the travels of the Tingari people from the site of Kulkuta, through Kiritji, to Tjukala north of Docker River. Because of the secret nature of the ceremonies associated with the Tingari cycle, the artist did not give any further information. (PT)

***Plate 51:* Johnny Warangula Tjupurrula** born *c*.1925 (Luritja, Papunya). *Artist's Country* 1979, synthetic polymer on canvas, 1280 mm x 2000 mm. Private collection.

Johnny Warangula Tjupurrula was born at Tjikari, an important cave site north-west of the Ehrenburg Range in traditional Luritja country. He is an esteemed elder, a Law man and a revered storyteller and painter among his people. He now lives a Yamunturrangy (Mt Liebig).

This painting depicts key sites and Dreaming trails in the artist's country. It was produced at Illupili outstation and reflects the artist's joy on returning to his country after spending years at Papunya.

The left panel depicts the Old Man Dreaming at Kampurapa. The Old Man is depicted as the single U-shape at the lower concentric circle. The women, with their coolamons filled with witchetty grubs, digging-sticks and hairstring belts, are shown around the uppermost concentric circles.

The centre left panel represents events at Tjikari. After the completion of ceremonies, Mala, the Hare Wallaby Men, chase Matinpilyangu, the Giant Dingo. Eventually they spear him and cry out loudly as he dies, then they eat him. Later, Lurnpa, the Old Kingfisher Man who is a doctor, finds Matinpilyangu's bones and magically brings him back to life.

Tjupurrula suggested another mythological thread as represented in this painting. It tells again of the adventures of Lurnpa, who was travelling with the Mala in the vicinity of Tjikari. The group was nearly perishing for it was a dry time and they were carrying no water. Because Lurnpa had the advantage of flight, it was decided that he should go ahead to look for minykulpa while the Mala waited in the shade of a tree. Minykulpa is a native chewing tobacco and is said to be very sustaining on long and tiring marches. However, Lurnpa betrayed the Mala and went to a rockhole where he drank the whole water supply.

The centre right panel tells of the Women who travelled from Kampurapa to Winpirri. Items associated with women are depicted.

The right panel depicts the Nyananana Men as they hunt for wallabies at Tjikari. The black patches are the burnt country left, as the Nyananana used bushfires to flush the wallabies from the spinifex. The men are the U-shapes at their camps (concentric circles) while their weapons, including boomerangs, are depicted, as are their pubic aprons. The footprints of the men as they track the wallabies are also shown. (JK)

Plate 52: Mick Namarari Tjapaltjarri born *c*.1930 (Pintupi, Papunya). Untitled 1987, synthetic polymer on canvas, 1490 mm x 350 mm. Private collection.

Mick Namarari Tjapaltjarri was moved from Haats Bluff to Papunya in 1959. He has painted consistently since the beginning of the movement in 1971. His style varies but is consistent in its brilliance of colour and execution.

There is no story available for this work, but it relates quite closely to his earlier *Hailstorm at Karraltingi*, 1983 (Kean, 1990) which portrays a Dreaming myth of two ancestors caught in a fierce hailstorm while camping at Karraltingi. (RC)

Plate 53: Mick Namarari Tjapaltjarri born *c*.1930 (Pintupi, Papunya). Untitled 1987, synthetic polymer on canvas, 1820 mm x 1220 mm. Private collection.

The Two Kangaroo Dreaming at the site of Watukarrinya, to the south-east of the Kintore Community, is depicted in this painting.

The roundel is a rockhole at the site. The straight lines are a windbreak and the rectangular shapes show where the Kangaroos slept.

Because of the secret nature of the ceremonies associated with this site, the artist did not give any further detail. (PT)

Plate 54: Maxi Tjampitjinpa born *c*.1945 (Warlpiri, Papunya). *Flying Ant Dreaming* 1985, synthetic polymer on canvas, 1325 mm x 975 mm. The Robert Holmes à Court Collection.

Maxi Tjampitjinpa came to Papunya in the early 1960s and was taught to paint by Old Mick Tjakamarra, the senior Warlpiri Law man at Papunya. He is generally esteemed as the most brilliant of the younger generation of artists, and his art reflects a broader range of techniques and colour. Maxi Tjampitjinpa won the Northern Territory Art Award in 1984.

This painting represents Watanuma or the Flying Ant Dreaming, associated with the site of Wantungurru. In this image the flying ants are shown swarming after rain. The white flecking is their wings which they shed at this time. (HC)

Plate 55: Uta Uta Tjangala born *c*.1920 (Pintupi, Kintore). Untitled 1988, synthetic polymer on canvas, 2430 mm x 1820 mm. Courtesy Gallery Gabrielle Pizzi.

Uta Uta Tjangala, a senior Pintupi Law man, now lives on his own country, the Muyinga in the Western Desert. He has always been an important and recognised leader within the Papunya movement.

The roundels in this painting represent the sites of Tjukaninna, Tjurpunga, Nyinanna and Tjiterulnga. In mythological times, an old man journeyed from Kamparapa, north east of Sandy Blight Junction through to Kunawirti, north of the Kiwirrkura Community. He made camp at these sites during his travels.

Uta Uta Tjangala's paintings are represented in Australian collections, both public and private, and in several private collections in the United States. Uta Uta was asked to represent Australia at the XVII BienNal de Sao Paulo, 1983 and won the National Aboriginal Art Award in 1985. (PT)

Plate 56: Michael Nelson Tjakamarra born *c*.1946 (Warlpiri, Luritja; Papunya). *Kangaroo Men Dreaming* 1988, synthetic polymer on canvas, 1520 mm x 950 mm. Alexander and Marjory Lynch Collection.

Michael Nelson has been living at Papunya and has been painting since 1983. His work is represented in major public collections throughout Australia, including the National Gallery. In 1984, Michael won the National Aboriginal Art Award, and in 1986 he exhibited in the Sydney Biennale.

Two Dreamings are represented in this painting. The central roundel represents a secret cave at Warlujarayi, near Mt Singleton. Two Kangaroo Men, indicated by the half-arrow symbols, inadvertently cooked and ate a joey, thinking it was a bandicoot, near this cave. Aroused by the cooking smells, Warnata, a serpent, came to investigate. Seeing that an offence was being committed, Warnarra was about to kill the Kangaroo Men, who luckily escaped death by fleeing into the cave. In the vicinity of Warlujarrayi, Possum Ancestors also passed. Their tracks are the flowing lines with adjacent small red pawprints. (PT)

Plate 57: Ronnie Tjampitjinpa born *c*.1940 (Pintupi, Kintore). *Water Dreaming at Marpurrinya* 1989, synthetic polymer on canvas, 1820 mm x 1520 mm. Peter Barro Collection.

Ronnie Tjampitjinpa is a Pintupi artist who was born in desert country, approximately 100 kilometres west of the Kintore Ranges in Western Australia. As a child he lived and travelled with his family in a traditional nomadic lifestyle, in the surrounding desert regions as well as in the Lake Mackay area.

Ronnie Tjampitjinpa commenced painting in 1976 and he was awarded the Alice Prize in 1988. His paintings are remarkable for their vigour, bold designs and sense of profound spirituality. He works with the concentric circles of the classic Pintupi iconography and maintains power and an

energetic rhythm throughout.

The Water Dreaming at the site of Marpurrinya, west of Lake Mackay, is depicted in this painting. Two snakes live at this place. The light areas in the centre are clouds and at the edges are the darker rain clouds. Marpurrinya is associated with the secret Tingari Cycle, therefore no further detail was given. (PT)

Plate 58: Joseph Jurra Tjapaltjarri born *c*.1953 (Pintupi, Kintore). *Women's Dreaming at Patji* 1987, synthetic polymer on linen, 1820 mm x 595 mm. The Robert Holmes à Court Collection.

This painting is a representation of Patji, a rockhole site in the Gibson Desert. At this place two ancestral women make fire in the traditional way using fire sticks. Their footprints and campsite (the black area) are shown. (HC)

Plate 59: Pansy Napangati born *c*.1949 (Warlpiri, Luritja; Alice Springs). Untitled 1989, synthetic polymer on canvas, 1830 mm x 1520 mm. Peter Barro Collection.

Pansy Napangati is a strong, gentle Aboriginal woman who now lives in Alice Springs but who paints in the Desert areas. She lays her often very large canvases on the desert floor and then begins to build her surface meticulously. She learnt first, she says, from her relative, Johnny Warrangula. She is the holder of the Dreamings for her family. Pansy Napangati is one of the outstanding innovative, present generation Aboriginal painters. She is also one of the few Papunya women to achieve eminence. She won the 1989 National Aboriginal Art Award. (RC)

In this painting the artist has shown designs associated with the mythology of Winpirri Rockhole. This is a rockhole site in a small rocky outcrop approximately 150 kilometres west of the Papunya Community.

In mythological times, Two Women travelled to this place; the roundel with adjacent U-shapes shows the two women sitting at the rockhole. The red sinuous lines represent the spun hair which is used during ceremonies. The sinuous lines with tufts at either end show the pubic belts worn by the women. The U-shape in two of the corners of the painting represent an old man who was also travelling in the area. He was calling out to the women, trying to attract their attention. However they took no notice of him, as they were not interested in his advances. (PT)

Ngukurr

Plate 60: Ginger Riley Munduwalawala born *c*.1939 (Mara, Ngukurr). *My Country* 1988, polymer paint on cotton duck, 1780 mm x 2470 mm. Anthony and Beverly Waldegrave-Knight Collection.

In this major and early painting, Ginger Riley Munduwalawala tells or recreates his entire story.

My Country is essentially a narrative painting, but is steeped in myth and tradition. Some of the painting is secret and its story cannot be told; but much of it can.

All the elements of the myth are present in this painting. It is a work of brilliant and daring colour, painted with great confidence. It is sacred and communicates an intense spirituality which is able to see the relationship between different aspects of life, and their meaning patterns in the personal history of the group and its given land.

The myth, as told by Ginger Riley, has not received close study by scholars but it may be that the dragon who rises from the sea to kill people and the cave that contains the bones of 200 people refer to the numerous systematic massacres by the white invaders in the thirty years before the establishment of the mission in 1908. (AK;RC)

Plate 61: Ginger Riley Munduwalawala born *c*.1939 (Mara, Ngukurr). *Keepers of the Secret* 1988, polymer paint on wooden panel, 900 mm x 910 mm. Private collection.

'Keepers of the secret' were the words Ginger Riley Munduwalawala used when describing this heraldic work. The two snakes, Garimala, one male and the other female, and the two figures guard the secret that is the Law. Above, the sun glows. The story is the same as in Plate 60, but this work is more solemn. This painting encodes the Law and, while it can be viewed by anyone and its aesthetic integrity and power appreciated, only those who are initiated in its secrets can enter fully into its meaning. (AK)

Plate 62: Wilfred Nalandarra born *c*.1940 (Ritangu, Walker River). *Fish and Birds in the Shallows* 1989, polymer paint on cotton duck, 1700 mm x 1810 mm. Private collection.

Wilfred Nalandarra is a senior Ritangu man who lives some kilometres from Ngukurr on the Walker River. This work is highly figurative, with fish, birds and animals in shallow water. The oblique strokes indicate that this is dirty water, but stylistically they link with the bark painting from Arnhem Land. It is not known whether the fish and animals in this and other of Nalandarra's paintings are totemic or are meant to evoke ancestor beings in stories. What is clear is that in its form, colour and composition this is a highly sophisticated work and reflects the long exposure to Western culture of the people of the Ngukurr area. (AK)

Plate 63: Willie Gudipi, born *c*.1916 and **Moima Willie,** born *c*.1935 (Ngalakan, Ngukurr). *Circumcision and Mortuary Stories* 1990, synthetic polymer on canvas, 1310 mm x 950 mm. Private collection.

Willie Gudipi paints with his wife Moima. Their work up to now has centred on initiation and mortuary rites, and the myths and stories surrounding them. The rainbow serpent is prominent and, like Ginger Riley's, often comes up out of the water to

devour people.

Story-telling in Gudipi's work is like an elaborate tapestry of colour and form. Figures, plants, animals and trees seem to move around the surface in a riot of colour and shape. The events take place on a predetermined pattern of colour, sometimes laid on in bands. On this, the events of the stories are painted.

Willie and Moima speak often about the Law and the necessity to record it in paint so that it can be passed on. To different people they will reveal different levels of meaning. Gudipi is a fine storyteller also and when he explains his painting, people – especially the young – gather to listen, ask questions and repeat the stories. (In this way, the tradition is safeguarded.) In the stories the animals and insects and plants speak and act as humans and often carry dilly bags, possibly in preparation for the Gabal rituals associated with the journey of Nayaran from the sea north of Oenpelli to the Roper area (Elkin, 1971). (AK)

Plate 64: Willie Gudipi, born c.1916 and **Moima Willie,** born c.1935 (Ngakalan, Ngukurr) *Rainbow Serpent Comes Out of the Water* 1990, synthetic polymer on canvas, 970 mm x 810 mm. Private collection.

Plate 65: Sambo Burra Burra b.1946 (Wagilak, Ngukurr). *Circumcision and Dead Men's Stories* 1990, synthetic polymer on canvas, 250 mm x 181 mm. Private collection.

Burra Burra is one of the main and most active painters at Ngukurr, and his earliest work reflected the techniques of bark painting in his use of cross-hatching and X-ray, with the images occasionally straying outside the perceived formal boundaries of the painting. Burra Burra has consistently depicted animals, which are explained as being totems for people, occasionally weapons and, infrequently, the human figure.

His stories are based on epic hunts and, it would seem, memories of intertribal wars. Burra Burra often explains a painting as being about 'this salt-water crocodile hunting this man', the man represented as a snake. The freshwater crocodile, being more docile, only hunts boys. As with most men of his tribal background, he is deeply interested in ceremonial life, and his paintings depict ceremonies surrounding circumcision and, as he puts it, 'dead men's songs'.

In common with most Aboriginal people, for Burra Burra the narrative sequence of events is as important as the visual content, and a good painting is one with an important story.

Burra Burra lives and works on an outstation, his country, with his wife, the painter Amy Johnson Jirwulurr. He is represented in many Australian collections, both public and private. (AK)

Plate 66: Amy Johnson Jirwulurr b.1953 (Wagilak, Ngukurr). *Some Animals Have Secret Songs* 1988, synthetic polymer on cotton duck, 900 mm x 1060 mm. Private collection.

Amy Johnson Jirwulurr often works alongside her husband, Sambo Burra Burra, and some of their work is similar in style. Both painters produce bold, confident and powerful work.

Some Animals Have Secret Songs is a title taken from a conversation with Amy Johnson about the meaning of one of her paintings. Animals, to her, have human characteristics; in a sense, they are human. Her own particular totem is a pelican. With other animals, it goes in search of sacred sites to enact the rituals surrounding circumcision and mortuary ceremonies.

Jirwulurr's handling of space in this, as in most of her paintings, is daring and assured. (AK)

Urban

Plate 67: Fiona Foley b.1964 (Hervey Bay, Queensland). *1788: Enter the White Savages* 1988, pastel, oil stick, pencil, collage and hair on paper, 1520 mm x 1020 mm. Courtesy Roslyn Oxley Gallery, Sydney.

Fiona Foley has a degree in Fine Arts from the Sydney College of the Arts and a Diploma of Education from Sydney University. She has spent time as artist-in-residence at Griffith University, at Maningrida and at Ramingining in the Northern Territory. She has participated in many important exhibitions and has a well-earned reputation as one of the foremost younger painters in Australia.

1788: Enter the White Savages is a strong political statement about ownership and possession of the land; it is meant to recall the savage injustices to Aboriginal people since the 'settlement' of Australia in 1788.

The use of Fiona Foley's own hair in this work is intended to be like a signature, a part of the artist left behind. Hair is also a powerful symbol in Western and Aboriginal cultures. Biblically, it is the sign of strength and seduction. In Aboriginal culture, Foley has said, a woman's hair is something that she must be very careful with, for if discarded hair (e.g. from a hair brush) falls into the wrong hands it can be used to sing a person to death or to love. (RC)

Plate 68: Gordon Bennett b.1955 (Brisbane, Queensland). *Perpetual Motion Machine* 1988 (Mimi Spirit Figures by Guningbal, Central Arnhem Land), synthetic polymer paint on cotton duck, 1780 mm x 2900 mm. Private collection.

Gordon Bennett has a Fine Arts degree from the Queensland College of Art. Since 1986 he has participated in important group exhibitions including 'Australian Art of the Last Twenty Years', MOCA, 1988, 'Perspecta', Art Gallery of New South Wales, 1989, and 'Paraculture', Artists' Space, 1990.

This picture was painted in 1988, the year of the Bicentennial celebrations in Australia when many were questioning whether or not there was much to celebrate. *Perpetual Motion Machine* is a strong political statement about the destruction that colonisation and Christianity have wrought in Australia. Gordon has written about this painting: 'This con-

cept of a perpetual motion machine I saw as a perfect metaphor for the Western capitalist system and its excesses... It ploughs ever onward convinced in its ethnocentric values which revolve ultimately around *Logos* – the word of God – colonizing the wilderness and 'civilizing' the indigenous inhabitants.

'The heads in the painting swing in the rhythm of perpetual motion. The heads bang together in the "healthy" competition of the capitalist system-... The machine inadvertently knocks over the group of "mimi" spirit figures, thus failing to recognize Aboriginal culture...

'Behind all this is written a passage from Genesis: "So God created man in His own image; in the image of God He created him; male and female He created them. God blessed them and said to them, 'be fruitful and increase, fill the earth and subdue it, rule over the fish in the sea, the birds of the heaven, and every living thing that moves upon the earth..."

'I saw this passage as the essence of Logos in relation to colonialism and the exploitation of nature. The crosses are the symbol of Christianity, but also relate to the graves of Aboriginal people in the Northern Territory which... are marked only by a simple cross and a number. Each cross has a number and may be seen as a metaphor for the dehumanizing process of this, our western culture'. (August 1988)

Plate 69: **Ian Abdulla** b.1947 (Barmera, SA). *Swan Reach, 1956* 1990, synthetic polymer on canvas, 1200 mm x 1820 mm. Courtesy Tandanya Aboriginal Cultural Institute.

Ian Abdulla was born at Swan Reach in 1947, one of seven boys and five girls. His mother was from Raukkan (Port McLeay) on the Lower Murray, while his father was a part-Afghan man from Hawker in the Flinders Ranges. He lived for ten years on the Gerard Mission before moving to Adelaide for two years. After returning to the Riverland he worked with the National Parks and Wildlife Service. He now lives at Barmera, where he is supporting his three children.

In 1988 Ian participated in a silk screen printing course at the Jerry Mason Senior Memorial Centre at Glossop where his first six editions of prints were produced. He began painting in September 1989 for Tandanya's 'Look at Us Now' survey exhibition.

Swan Reach 1956 was painted in 1990 as one of a long line of works in which Abdulla remembers events from his childhood. They are stories remembered and retold in Aboriginal tradition but they do not call on Ancestors. Their subject matter is the intricate events of a childhood spent in poverty. Often their themes are of survival – of picking up wool along fences, trapping and skinning water rats, clearing paddocks of glass, collecting horses' manure for sale. The Swan River features frequently in his work as it does in *Swan Reach 1956*, which shows the river, the hill on the far side and the simple houses in the foreground. Across the bridge the nuns are seen, no doubt coming to give religious instruction, but remembered by Abdulla as bringing lollies for the children. The story of the painting is written high in the sky. His eleven year old daughter, Tracey, writes the stories down and he incorporates the writing in the finished work.

Abdulla sees his work as a way to remember the past. As he said recently, 'When I finish – I don't think I'll ever forget again. I'll never forget. I know I won't forget. I just want people to know what I've been through since I was a boy. I tried to tell them before, but they wouldn't listen, so, only way I can do it is through my paintings... [then] I would not only have dealt with it, I would have achieved a satisfaction in my mind'. (Interview with Philip Jones, Adelaide, 1980) (T;RC)

Plate 70: **Lin Onus** b.1948 (Melbourne, Victoria). *Maralinga* 1990, fibreglass, perspex, black acrylic paint, height 1580.5 mm. Art Gallery of Western Australia.

The devastation and injustices of the atomic experiments at Maralinga in South Australia have angered Lin Onus for almost as long as he can remember. Despite protests from Aboriginal people that the site was their traditional country, and so sacred and also home to them, the experiment went ahead. This sculpture memorialises the moment of the explosion. A woman clutches her child as the atomic wind rushes at them. The cloud is of perspex with red, white and blue radiation symbols painted on it.

Each of his paintings is Lin Onus' declaration that his Aboriginality is important and that the Aboriginal voice must be listened to in Australia. The time he spends frequently with his 'other' family at Maningrida in Arnhem Land, and with Jack Wunuwun and John Bulun Bulun, is in the hope of coming closer to traditional values and spirituality, as he said recently, 'Aboriginal spirituality is something I'm learning more about. For Kooris who live in the south-east corner a great deal has been lost of the Law and the meaning of Land. We must relearn it. The time I spend in Arnhem Land with my family provides me with a new way of recharging batteries and a new way of looking at people and relationships. People there care for each other and family is not a small group of close relatives.' (Interview RC, Oct. 1990)

CONTRIBUTORS

CHRISTOPHER ANDERSON is Curator of Social Anthropology at the South Australian Museum.

CLARE AHERN RSJ, is Director of the Merrilingki Spirituality Centre, Turkey Creek. She has lived with the Warmun Community since 1978.

FRANK BRENNAN S.J. is Director of Uniya, a Christian Centre for Social Research and Action sponsored by the Australian Jesuits. A lawyer and adviser to the Australian Catholic Bishops, he has written extensively on Aboriginal affairs from a non-Aboriginal perspective.

MARGARET CARNEGIE is a sponsor and collector of Aboriginal and other Australian arts.

MAX CHARLESWORTH is Professor of Philosophy at Deakin University, Victoria, and is co-editor of *Religion in Aboriginal Australia* and co-author of *Ancestor Spirits: Aspects of Aboriginal Religion and Spirituality.*

ROY CHURCHER is an artist and educator with extensive experience in Aboriginal communities.

ROSEMARY CRUMLIN is the editor of this book and co-curator of the exhibition *Aboriginal Art and Spirituality.* She curated the exhibition, *Images of Religion in Australian Art*, and wrote the accompanying book.

EILEEN FARRELLY is Adult Education Coordinator at Daly River, Northern Territory.

FIONA FOLEY is one of Australia's foremost young artists.

RUTH HALL is a collector of Aboriginal and other Australian arts.

CHRISTOPHER HODGES is an artist and Director of Utopia Art, Sydney. He represents the Utopia artists.

JANET HOLMES À COURT is Chairman of Heytesbury Holdings Ltd, which includes The Robert Holmes à Court Collection.

DUNCAN KENTISH represents Aboriginal artists from the Fitzroy River area.

ANTHONY KNIGHT is a long-time collector of Aboriginal art and co-curator of this exhibition.

BANDUK MARIKA is a Yolngu woman, a print-maker and a traditional Rirratjingu landowner from Yirrkala in north-east Arnhem Land.

GABRIELLE PIZZI is Director of a Melbourne art gallery which exhibits contemporary Aboriginal art.

MICHAEL RAE is Art Coordinator at Warlayirti Artists, Balgo, W.A.

JUDITH RYAN is Curator of Aboriginal Art at the National Gallery of Victoria.

PETER SKIPPER is an Aboriginal artist from Fitzroy Crossing. His traditional country is the Juwaliny in the Great Sandy Desert of Western Australia.

LUKE TAYLOR is a curator in the Gallery of Aboriginal Art at the National Museum of Australia.

MICHAEL NELSON TJAKAMARA is a Warlpiri artist of the Central Desert.

MARGIE WEST is Curator of Aboriginal Art and Material Culture at the Museums and Art Galleries of the Northern Territory.

MARGARET WOODWARD writes and teaches in the area of the arts and social justice. She is currently Research Fellow with an Australian Research Council funded project on race relations.

FELICITY WRIGHT was Art Coordinator at Yuendumu from 1986 to 1988. She now represents Aboriginal artists through Manyuku, Melbourne.

SELECT BIBLIOGRAPHY

Aboriginal Statistics 1986. 1987. Canberra: AGPS.

Akerman, K. et al. 1989. *A myriad of Dreaming: twentieth century Aboriginal art.* Melbourne: Malakoff Fine Art Press.

Amadio, N. and R. Kimber. 1988. *Wildbird Dreaming.* Melbourne: Greenhouse Publications.

Artlink. 1990. *Artlink: contemporary Australian Aboriginal art,* 10, 1 & 2, Autumn 1990.

Anderson, C. and F. Dussart. 1988. 'Dreamings in acrylic: Western desert art,' in P. Sutton, *Dreamings,* 89–142.

Bardon, G. 1979. *Aboriginal art of the Western Desert.* Adelaide: Rigby.

Bell, D. 1987. *Daughters of the Dreaming.* Melbourne: McPhee Gribble.

Benjamin, R. 1990. 'Aboriginal art: exploitation or empowerment?', *Art in America,* 78, 7, 73–82.

Berndt, R. M. (ed.). 1964. *Australian Aboriginal art.* Sydney: Ure Smith.

Berndt, R. M. and C. H. Berndt. 1987. *End of an era.* Canberra: Australian Institute of Aboriginal Studies.

––––––– 1989. *The speaking land.* Victoria; Penguin.

Brennan, F. et al. 1986. *Finding common ground.* Victoria: Collins Dove.

Brody, A. M. 1985. *The face of the Centre: Papunya Tula paintings,* 1971–84. Melbourne: National Gallery of Victoria.

––––––– 1990. *Utopia: a picture story.* Perth: Heytesbury Holdings.

––––––– 1990. *Contemporary Aboriginal art from the Robert Holmes à Court Collection.* Perth: Heytesbury Holdings.

Butlin, N. 1983. *Our original aggression.* Sydney: Allen & Unwin.

Carnegie, M. 1989. *Pangana, Aboriginal art.* Unpublished lecture for the Australian Centre, University of Melbourne, 27 April 1989.

Caruana, W. 1987. *Australian Aboriginal art.* Canberra: Australian National Gallery.

––––––– 1989. *Windows on the Dreaming.* Canberra: Australian National University Press.

Caruana, W. and J. Isaacs (eds.). 1990. Supplement: the emergence of urban Aboriginal art, *Art Monthly Australia,* 30 November 1990.

Charlesworth, M. 1990. *Ancestor Spirits: aspects of Aboriginal religion and spirituality.* Geelong: Deakin University Press.

Charlesworth, M. et al. 1984. *Religion in Aboriginal Australia.* Brisbane: University of Queensland Press.

Cole, K. 1985. *From mission to church.* Bendigo: Keith Cole Publications.

––––––– 1988. 'Anglican missions to Aborigines,' in Swain and Rose (eds.), *Aboriginal Australians and Christian missions,* 174–184.

Cowan, J. 1989. *Mysteries of the Dreaming.* Dorset: Prism Press.

Crocker, A. 1983. *Papunya: Aboriginal paintings from the Central Australian Desert.* Sydney: Aboriginal Artists Agency and Papunya Tula Artists.

––––––– 1987. *Charlie Tjaruru Tjungurrayi: a retrospective,* 1970–1986. Orange, N.S.W.: Orange City Council.

Crumlin, R. 1985. *The Blake Prize for Religious Art. Catalogue.* Melbourne: Monash University.

––––––– 1988. *Images of religion in Australian art.* Sydney: Bay Books.

De Lorenzo, C. 1988. *A Changing Relationship.* Sydney: S. H. Ervin Gallery.

Durkheim, E. 1912. *The elementary forms of the religious life.* London: Allen & Unwin.

Edwards, R. (ed.). 1978. *Aboriginal art in Australia.* Sydney: Ure Smith.

Edwards, W. H. (ed.). 1987. *Traditional Aboriginal society.* Melbourne: The Macmillan Company of Australia.

Elkin, A. P. 1971. Yabuduruwa at Roper River mission, 1965. *Oceania,* XLII, 2, 112–164.

––––––– 1972. *Two rituals in South and Central Arnhem Land.* Sydney: Oceania Monographs.

Elkin, A. P. and R. and C. Berndt. 1956. *Art in Arnhem Land.* Melbourne: Cheshire.

Foucault, M. 1972. *The archaeology of knowledge.* New York: Harper and Row.

Fry, T. and A. M. Willis. 1989. 'Aboriginal art: symptom or success?', *Art in America,* July 1989, 108–16, 159–63.

––––––– 1989. 'Art as ethnocide: the case of Australia.' *Third Text,* 5, 1989, 3–20.

Groger-Wurm, H. M. 1973. *Australian Aboriginal bark paintings and their mythological interpretation. Vol. I.* Canberra: Australian Institute of Aboriginal Studies.

Hanson, L. and F. A. Hanson. 1976. *The art of Oceania: a bibliography.* Massachusetts: G. K. Hall and Co.

Hawke, S. and M. Gallagher. 1989. *Noonkanbah.* Perth: Fremantle Arts Centre Press.

Hercus, L. and P. Sutton. 1986. *This is what happened.* Canberra: AIAS.

Hocking, B. (ed.). 1989. *Aborigines and international law.* Sydney: Law Book Company.

Hoff, J. A. 1977. 'Aboriginal carved and painted human figures in north-east Arnhem Land,' in P. J. Ucko (ed.), *Form in indigenous art,* 156–64. Canberra: Australian Institute of Aboriginal Studies.

Isaacs, J. 1984. *Arts of the Dreaming: Australia's living heritage.* Sydney: Landsdowne Press.
———— 1989. *Aboriginality: contemporary Aboriginal paintings and prints.* Brisbane: University of Queensland Press.

Kean, J. 1989. *Ian Abdulla.* Adelaide: Tandanya Exhibitions Catalogue.
Kean, J. et al. 1989. *East to west: land in Papunya Tula painting.* Adelaide: Tandanya Aboriginal Cultural Institute.
Keen, I. 'Yolngu sand sculptures in context,' in P. J. Ucko (ed.), *Form in indigenous art,* 165–83. Canberra: Australian Institute of Aboriginal Studies.
Kemp, T. P. and D. Rasmussen. 1989. *The narrative path: the later works of Paul Ricoeur.* Massachusetts: MIT Press.

Marika, B. and M. West. 1990. 'An artist's project,' *Artlink,* 10, 1, 4–5.
Marks, R. 1988. *Yolngu, Aboriginal cultures of North Australia.* UK: The Royal Pavilion Art Gallery and Museums, Brighton.
Maughan, J. and J. V. S. Megaw. 1986. *The Dreamtime today.* Adelaide: Visual Arts Discipline, Flinders University.
Maughan, J. and J. Zimmer (eds.). 1986. *Dot and Circle.* Melbourne: Royal Melbourne Institute of Technology.
Megaw, J. S. 1986. 'Contemporary Aboriginal Art: Dreamtime discipline or alien adulteration?,' in J. Maughan and J. Zimmer, (eds.), *Dot and Circle,* 51–54. Melbourne: Royal Melbourne Institute of Technology.
Meggitt, M. J. 1962. *Desert people: a study of the Warlpiri Aborigines of Central Australia.* Sydney: Angus and Robertson.
———— 1972. 'Understanding Australian Aboriginal society: kinship systems or cultural categories,' in Edwards, W. H. (ed.), 113–137.
Michaels, E. 1988. 'Bad Aboriginal art,' *Art & Text,* March–May, 1988, 66–70.
Morphy, H. 1976. *Yirrkala art.* Canberra: Australian National University.
———— 1978. *Manggalili art.* Canberra: Australian National University.
———— 1981. *The art of Northern Australia.* Sydney: Australian Gallery Directors' Council.
———— 1984. *Journey to the crocodile's nest.* Canberra: Australian Institute of Aboriginal Studies.
Mountford, C. P. 1956. *Art, myth and symbolism.* Records, American–Australian Scientific Expedition to Arnhem Land, 1948, I.
Munn, N. D. 1986. *Walbiri iconography.* Chicago: University of Chicago Press.
Murray, L. 1984. *Persistence in folly.* Sydney: Sirius imprint, Angus and Robertson.
Musée d'Art Moderne, 1983, D'un et la Réel. Paris: Musée d'Art Moderne de la Ville de Paris.
Myers, F. R. 1986. *Pintupi country, Pintupi self.* Washington: Smithsonian Institution.

Nairne, S. 1987. *State of the art. Ideas and images in the 1980s.* London: Chatto and Windus/Channel Four.
Northern Territory Department of Education. 1985. *Stories from Lajamanu.* Darwin: N.T. Department of Education.

Pizzi, G. 1990. *Papunya Tula.* Melbourne: Gallery Gabrielle Pizzi.
Reynolds, H. 1987. *The law of the land.* Ringwood: Penguin.
Rose, D. B. 1987. 'Consciousness and responsibility in an Australian Aboriginal religion,' in Edwards, W. H. (ed.), 257–269.
Rothenberg, J. 1969. *Technicians of the sacred.* New York: Anchor Doublebay.
Rowley, C. D. 1986. *Recovery: the politics of Aboriginal reform.* Ringwood: Penguin
Rubin, W. (ed.). 1984. *'Primitivism' in 20th century art: affinity of the tribal and the modern.* New York: The Museum of Modern Art.
Ryan, J. 1989. *Mythscapes.* Melbourne: National Gallery of Victoria.
———— 1990. *Paint up big.* Melbourne: National Gallery of Victoria.

Schmied, W. 1990. *Gegenwart Ewigkeit.* Berlin: Martin-Gropius Bau.
Shapiro, W. 1979. *Social organization in Aboriginal Australia.* Canberra: Australian National University Press.
Stanner, W. E. H. 1963. *On Aboriginal religion.* Sydney: Oceania Monographs.
———— 1979. *White man got no Dreaming.* Canberra: Australian National University Press.
Stanton, J. E. 1989. *Painting the country.* Perth: University of Western Australia Press.
Sutton, P. 1987. 'From horizontal to perpendicular. Two recent books on Central Australian Aboriginal painting.' *Records of the South Australian Museum,* 21: 161–65.
Sutton, P. (ed.). 1988. *Dreamings: the art of Aboriginal Australia.* New York: Viking.
Swain, T. and D. B. Rose, 1988. *Aboriginal Australians and Christian missions.* South Australia: Australian Association for the Study of Religions.

Taylor, L. 1984. *Dreaming transformations in Kunwinjku bark paintings.* Paper presented at 1984 Biennial Conference of the Australian Institute of Aboriginal Studies.
———— 1986. *Seeing the inside. Kunwinjku paintings and the symbol of the divided body.* Paper presented to 1986 World Archaeological Conference, Southampton.
———— 1987. *The same but different. Social reproduction and innovation in the art of the Kunwinjku of Western Australia.* Ph.D. dissertation, Australian National University.
———— 1989. 'Bark painting in Arnhem Land,' in

Akerman, K. et al., *A myriad of Dreaming*, 15–19.

Taylor, P. (ed.). 1988. *After 200 years*. Canberra: Aboriginal Studies Press. I.

Turner, D. 1988. The incarnation of Nambirrirrma, in Swain and Rose (eds.), 470–483.

Ungunmerr-Baumann, M-R. (sometimes Ungunmerr, M. R.). 1984. *Australian stations of the cross*. Melbourne: Collins Dove.

———— 1989. 'Reverencing the earth in the Australian Dreaming', *The Way*, 29, 1, 38–45.

Warlukurlangu Artists. 1987. *Kuruwarri: Yuendumu Doors*. Canberra: Australian Institute of Aboriginal Studies.

West, M. 1987. Declan: *A Tiwi artist*. Perth: Australian City Properties Ltd.

West, M. (ed.). 1988. *The inspired dream*. Brisbane: Queensland Art Gallery.

Willis, A-M. and T. Fry. 1989. 'Thinking in the shadows of neo-colonialism', *Praxis*, 25, 4–12.

Wollheim, R. 1987. *Painting as an art*. New York: Princeton University Press.

Woodward, M.

———— 1987. *The arts and education for justice: theory and practice*. Ph. D. thesis, Monash University.

———— 1989. *THE WAY supplement: Spirituality and the artist*, Autumn 1989, 106–115.

INDEX